Virtual anxiety

MANCHESTER
UNIVERSITY PRESS

THE CRITICAL IMAGE

'From today painting is dead': a remark made by the French artist Paul Delaroche on first seeing a daguerreotype in 1839.

'I can see it's the end of chemical photography': a remark made by the British artist David Hockney in 1990 on the likely effect of computer-generated imagery.

'The Critical Image' series aims to develop the subject area of photographic history, theory and criticism. It explores the historical and contemporary uses of photography in sustaining particular ideological positions. Photography is never a straightforward 'window on the world'; the meanings of photographs remain unstable, depending always on usage. Chemical and lens-based photographs are now antique forms of image production, while pictures made in computers are not strictly photographic since there is no necessary link between images and what-has-been. The series engages with both chemical and digital imagery, though new forms of representation do not obliterate older forms and ways of looking that persist through custom and practice. The term 'representation' is not simply another word for picture or depiction, but hints at the management of vision. Representation is a matter not just of what is shown but of who has permission to look at whom, and to what effect. The series looks beyond the smooth narratives of selected 'masters', styles and movements. It aims to discuss photographic meanings produced within the complex social formation of knowledge. To situate photography in its intellectual context, the series cuts across disciplinary boundaries and draws on methods widely used in art history, literature, film and cultural studies.

SERIES EDITOR

John Taylor
Department of History of Art and Design, Manchester Metropolitan University

Already published

Jane Brettle and Sally Rice (eds) *Public bodies – private states: new views on photography, representaion and gender*

John Roberts *The art of interruption: realism, photography and the everyday*

Lindsay Smith *The politics of focus: women, children and nineteenth-century photography*

John Taylor *A dream of England: landscape, photography and the tourist's imagination*

John Taylor *Body horror: photojournalism, catastrophe and war*

Virtual anxiety

photography, new technologies and subjectivity

SARAH KEMBER

MANCHESTER UNIVERSITY PRESS
Manchester and New York

distributed exclusively in the USA by St. Martin's Press

Published by Manchester University Press
Oxford Road, Manchester M13 9NR, UK
and Room 400, 175 Fifth Avenue, New York, NY 10010, USA

Distributed exclusively in the USA by
St. Martin's Press, Inc., 175 Fifth Avenue, New York, NY 10010, USA

Distributed exclusively in Canada by
UBC Press, University of British Columbia, 6344 Memorial Road,
Vancouver, BC, Canada V6T 1Z2

British Library Cataloguing-in-Publication Data
A catalogue record for this book is available from the British Library

Library of Congress Cataloging-in-Publication Data applied for

ISBN 0 7190 4528 2 *hardback*
 0 7190 4529 0 *paperback*

First published 1998
05 04 03 02 01 00 99 98 10 9 8 7 6 5 4 3 2 1

Designed and typeset by Lionart, Birmingham
Printed in Great Britain
by Redwood Books, Trowbridge

Contents

List of figures and plates

Figures

Plates

Plates will be found between pages 54 and 55.

Acknowledgements

I would like to thank those members of the police force who took a great deal of time and trouble to help me with my inquiries into the use of new imaging technologies, especially John Jack and Nick Craggs at Sussex Police and John Royle at Merseyside Police. Particular thanks go to Peter Bennett of Aspley Limited for providing access to the E-FIT system and so much useful information and material.

My research into the Visible Human Project was supported by a travel grant from the Media and Communications Department at Goldsmiths College and greatly assisted by Dr Michael Ackerman at the United States National Library of Medicine in Maryland.

Thanks to John Taylor, Martin Lister, Lindsay Smith and Alex Warwick for their editorial comments on the whole or parts of the book. I am very grateful to Blake Morrison for his helpful and encouraging remarks on the James Bulger material and the conclusion.

I am indebted to Anna Ruthven for giving me the opportunity to speak at the Wired Women conference at Portsmouth University on international women's day. I would also like to thank the other speakers and conference delegates. It was an excellent event and your comments and feedback were greatly appreciated.

Friends and colleagues at Goldsmiths College have given invaluable support, and I would particularly like to thank Lisa Blackman and Valerie Walkerdine. Tim LeLean provided the main title of the book (for

just a few beers) and Carey Smith has offered friendship and fresh ideas over a number of years.

Special thanks to Yvonne Tasker and Helena Reckitt for reading and commenting on the typescript.

The ultimate acknowledgements are always of family and friends: Ann Kember, Rachel Hall, Bec Hanley (without whom) and Yvonne Tasker. Thanks to Ann Davey, Tessa Hodsdon, Ian McGuire, Lester Mills and Phil Terry – not only for talking to me about things like books and vampires.

Finally, I would like to acknowledge the input of undergraduate and postgraduate students, particularly those who have contributed to my course on Gender, Photography and New Technologies, where the dialogues have been most stimulating and rewarding.

Excerpts from 'New imaging technologies in medicine and law' first appeared in 'Medical Diagnostic Imaging: the Geometry of Chaos', *New Formations*, 15, 1991 and in 'Medicine's New Vision' in Martin Lister (ed.) (1995). '"The shadow of the object": photography and realism' was first published in *Textual Practice*, 10,1, 1996, and was reprinted in the Spanish journal of photography *Papel Alpha*, 2, 1996. 'Surveillance, technology and crime: the James Bulger case' was first published in Martin Lister (ed.), *The Photographic Image in Digital Culture*, Routledge, 1995.

Introduction

This book was written in the context of media and academic debates about the future of societies, cultures and identities in the most recent period of technological change and development. This period covers, for example, the change from analogue to digital imaging technologies; the development of digital and electronic forms of imaging in the press and institutions such as medicine, law and the family; the increased use of electronic surveillance in public spaces; the development of virtual reality technology and the Internet; the increasingly widespread use of information technologies; the domestication of video and computer games and advances in biotechnology.

Reactions to these new technologies have at times been apocalyptic – digital images, for example, mark 'the end of photography as we have known it' (Ritchin 1991:8) – and have signalled a rupture not only between new and old technologies, but between familiar forms of society, culture and identity and any which may succeed them. At the extreme end of such apocalypticism are claims that we are entering the 'final phase of human history', a phase of chaos and runaway, self-organising technologies where 'rotted by digital contagions, modernity is falling to bits' (Plant and Land 1994). Where it is possible to detect a certain anarchistic pleasure in writing such as this, it seems to me that, in general, there has been a high degree of anxiety and expectation expressed in relation to recent technological developments, and that

these mixed feelings have been manifested in dystopianism on the one hand and utopianism on the other. In science fiction, dystopias and utopias are post-apocalyptic futures, and today it might easily appear that the distinction between science fiction and social reality has collapsed. The division between dystopias and utopias is driven to an extent by technophobia and technophilia respectively, and both forms of futurism have tended to be technologically deterministic.

Virtual Anxiety grew out of, and away from, a PhD on discourses of the body in photography and new imaging technologies in medicine and law. This looked at new technologies in specific social and historical contexts and argued that principal discourses (of domination and reform) were largely continuous over time, but nevertheless subject to transformation.[1] This book maintains a socio-historical perspective which aims to dispel uncontextualised and technologically deterministic claims and to review hopes and fears about the future in the light of cultural constraints and conventions of the present and past. One of the things the past reveals is that many of the present reactions to new technologies are not in themselves new. Where digital imaging allegedly poses an apocalyptic threat to photography by collapsing the authority of photo realism, so photography at its inception seemed to pose an equivalent threat to painting by cornering the market on realism. Earlier forms of utopianism and dystopianism are allied to specific societies and historical periods which promoted widespread technophilia (such as Technocracy Inc. in the United States during the 1930s) or technophobia (for instance, concerning the disasters at nuclear power plants at Long Island, Windscale and Chernobyl). As the impact of, for example, virtual reality technologies is as yet unknown, there does not seem to be a dominant ideology which veers either to the negative or to the positive pole with regard to new technologies, but rather, opinions remain divided and extreme. There is, however, a great deal of research being undertaken on the effects of specific technologies, and where results are emerging they tend to follow arguments established in earlier work. Studies of the effects of video and computer games on children inherit some of the methods, terminology and findings of earlier research on the effects of video and television viewing on children.[2]

So technologically deterministic hopes and fears for the future are not new (any more than the ideology of progress is new), but by viewing some of the new technologies in specific contexts, I separate the hopes and fears from the technologies themselves and trace them back to the

subject, and to social and psychological *investments* in science and technology. By focusing on the investments which the social subject makes in science and technology, I am rejecting not only technological determinism but the ideology of scientific and technological universality and neutrality. I am arguing that science and technology are fully cultural and ideological processes (Ross 1991) which are therefore also tied to the conscious and unconscious agency of social subjects. What I reject above all is the abdication of responsibility to machines which is implicit in either form (utopian or dystopian) of determinism. In my view we clearly are and should be politically and socially responsible for the futures we create with or without technology, and the politics with which I choose to be responsible in my analysis of current technologies and in my own visions of the future are socialist and feminist.

There is a very strong tradition of socialist feminist research on science and technology, which grew out of the radical science movement of the 1960s and was influenced by Marxist philosophy (Rose 1994). More recently, Foucault's critique of Enlightenment rationality and his formulation of knowledge as power have been used by feminists to expose the gendered hierarchies of western scientific knowledge, and the continuity of a discourse of domination by masculinist science over nature symbolised as the female body (Merchant 1980, Jacobus *et al.* 1990, Jordanova 1989). The supposed neutrality of mainstream science has been effectively undermined on the level of power and knowledge. Science's complicity with capitalist and patriarchal ideologies has been exposed, along with the hierarchical binarism of Cartesian rationality which privileges mind over body and masculine scientific culture over a feminised nature. For me, some of the most interesting and productive ideas have come from feminist work on epistemology in the natural and social sciences. This offers a critique of positivism in conjunction with humanism, and has envisioned a grass-roots change in the form of feminist research, epistemologies and successor sciences (Stanley 1990, Harding and O'Barr 1987, Haraway 1991a). It is, I believe, at the level of epistemology that science and culture in general are most able to secure the continuity of their structures and status over time, and consequently where the most significant interventions and transformations may take place. It is within interdisciplinary feminisms that a large part of the project of transforming epistemologies is taking part.

This book is concerned with continuities and transformations in the

structure of knowledge, power and subjectivity in contemporary technoscientific culture. I ask whether, how and where structures of knowledge and power may be reformulated in order to challenge what Donna Haraway calls the 'matrices of domination', and build towards a better future than that which mainstream progess has become. What kinds of subject are we (who will inhabit this future) becoming, and what kinds of subject do we want to be? In chapter 5, I look at Haraway's theorisation of the cyborg as a hybrid human/machine entity which embodies a transformative relationship between the subject and object of both epistemology and ontology. In other words, both what it knows and what it is go against the grain of positivism and humanism. In Haraway's cyborg feminism and feminist science, the rationalist subject and his object (nature and/as the female body) have been reconstituted as a genderless ideal given to building affinities with others rather than dominating them, and to producing local, partial and accountable knowledges. Being genderless, the cyborg is not so much a subject as a set of possible subject positions: in an interview with Andrew Ross and Constance Penley, Haraway (1991b) explained that she chose to avoid the problem of subjectivity because of the problem of psychoanalysis and the limited selection of available theories of the subject. For Haraway, psychoanalysis is another masculine, hierarchical and discriminatory science within which women (posited as lack in relation to the source of all meaning and desire – the phallus) get a pretty raw deal. Although I agree with this analysis I have chosen, perhaps rather audaciously, to reduce psychoanalysis to a story 'about where the wild things are' (Phillips 1993) – things like fear and desire which are hard to describe without it. As fiction, not fact, and as a partial and accountable rather than universal discourse, psychoanalysis offers up useful concepts such as fetishism, which in the process of translation from Freud to Lacan to feminism can be seen to trouble the terms of domination and even to serve in the cause of something like a successor psychoanalysis (De Lauretis 1994). For this reason and in this way I have used pyschoanalytic theories of the subject and take responsibility for the limitations and contradictions as well as the possibilities this has afforded me. Although I have faith in the ability of feminists to come up with more alternative stories about the subject, subjectivity and the unconscious, we are still largely constrained within the (seemingly separate) spheres of Foucault and Freud, and so by theories which are gender blind and discriminatory. I regret the traces of a discriminatory

discourse which I have left in the book in order to make some very limited but committed gestures towards a theorisation of the subject in contemporary culture.

My work has drawn on theories of photography which have used Foucault, Freud and feminism to provide a critique of photographic objectivity and to show that embedded within photographic realism is a discourse of mastery and control over the photographic object where that object is nature (the real) or the body. Inscribed as it is within the terms of positivism (where the methods of the natural sciences are transferred to the social sciences), the photographic gaze is discriminatory – it privileges the viewing subject over the viewed object and is intolerant of difference or otherness, which is frequently coded as monstrosity. Critics such as John Tagg (1988) and Allan Sekula (1989) have used Foucault's concepts of surveillance and panopticism in order to demonstrate how realist photography became a tool of social control during its early development in nineteenth-century disciplinary institutions such as hospitals, prisons, asylums and workhouses. Others have drawn on feminist psychoanalytic theories, and in particular the concept of scopophilia (pleasure in reducing another person to the object of your gaze), in order to demonstrate how the photographic gaze is also inscribed by hierarchies of gender, class, race and sexuality (McGrath 1984, Marshall 1990, Mercer 1986). Here again, difference is coded as deviance within a structure of empirical knowledge which is binaristic and hierarchical.

From this work, to which I have many points of allegiance, I have retained a particular interest in the concept of photographic fetishism – again as it has travelled from Freud to feminism via Lacan – and in as far as it relates (through the affiliation of surveillance and scopophilia) to the terms of mastery and control. Fetishism for Freud is a perversion based on the male subject's castration anxiety. It is predicated on the construction of the woman's body as lack (lacking a penis). For Lacan, fetishism is not a perversion but a cultural and gendered way of seeing the feminine other (who is still coded as lack). In the hands of feminist psychoanalytic theorists (perhaps beginning with Laura Mulvey's seminal article (1975) working particularly in the area of film, the term begins to be used against the viewing subject as a critique of the male gaze. In this concept of fetishism the male subject compensates for a perceived threat posed by the difference of the woman's body. His fetishistic mastery of the body is provoked by his own fear of loss. As

the subject's fear of loss overshadows any supposed lack in the object, the biologistic basis of fetishism fades and the loss feared by the subject may be of many manifestations of sovereignty and not simply of the penis. At this point the subject position becomes properly gendered rather than sexed and may be occupied by any subject, not just male. It is here that we can suggest that women and other others can be fetishists and that fetishism is about compensating for fear or anxiety provoked by the subject's *perception* of the object.

Christian Metz (1985) has written about photographic fetishism in Freudian terms which nevertheless resonate with the non-Freudian account of photography given by Roland Barthes in *Camera Lucida* (1980) and with some of the views expressed by Susan Sontag in *On Photography* (1979). What emerges from these accounts is a picture of photography as a means of representation and a mechanism of knowledge and power which allows the subject to compensate for a perceived loss, absence or threat in the object world and for the feelings of anxiety, fear or despair which are thereby provoked. This may include a loss of power over the object, the absence of a loved one or the threat of difference. A photograph is a small, tangible object, a trophy or a token which defies the passing of time and insists on the presence of that which it depicts. It offers up a scene or event to perpetual scrutiny and immortalises the subject's perspective. For both Metz and Barthes photography defies death, and yet, as Sontag says, photographs do eventually fade and they contain within them the constant reminder of that for which they compensate. Fetishism is always an inadequate and unstable means of control precisely because it is a compensatory mechanism. The fear which stimulates it remains embedded within it, and the fetish object (in this case the photograph) is always marked by the absence behind the presence and the fear behind the desire (to eradicate it).

So, fetishism is a key concept in my analysis of photography and new imaging technologies as compensatory mechanisms for the viewing subject (chapter 1 and 2). Fetishism is common to investments in photography and new imaging technologies alike. It is a manifestation of the subject (of humanist subjectivity) which lies behind a positivist epistemology which photographic realism shares with other sciences. I am referring to a photography whose object, like that of science in general, is nature and the (female) body and whose subject is coded as masculine and sovereign.

It is within the gendered and hierarchical relationship between the subject and object of photographic and other sciences and technologies that my argument about the virtual nature of anxiety resides. I am talking about the anxiety of the masculine subject in the face of an object which is perceived to be threatening or elusive, and the way in which technology is employed to counter and alleviate this anxiety. The object in question is the original object: nature, the female body or its epistemological equivalents which are other than the privileged and normative subject. The way in which the subject's anxiety is projected onto the object which is then constructed as being monstrous, dangerous, lacking or out of control certainly displaces it, but virtual anxiety ensues when the object appears to infect or become synonymous with the means used to contol it – technology. Technology can offer a fetishistic means of control but, not least because of the inherent instability of fetishism, it can also become overrun with the fears it is employed to conquer. In chapter 4 I discuss reproductive technologies and how, within feminist debates, they have been regarded as a means of controlling the female body in its reproductive role – a role traditionally regarded with both fear and fascination in medical science. And yet, in media and academic fields, and as recent television programmes such as 'Dr Satan's Robot' demonstrate very clearly, there is considerable concern about advances in reproductive science and technology. which, in themselves, are deemed to be potentially dangerous and out of control.[3] Where some of these concerns clearly have ethical and political merit (for example, concerning cloning and the genetic selection of embryos), some (such as concerns about the proliferation of artificial wombs) may also signify a conflation of 'women-out-of-control with technology-out-of-control' (Penley 1992: 180). In which case, fear of science and technology being out of control relates back to an original fear of the female body, and anxiety is virtual in so far as it is not real, or not really about technology but about the subject and object relations which technology mediates. In chapter 4 I consider the way in which technoscientific fears are transformed into fantasies – specifically omnipotence fantasies – which means, in the context of medicine, that science appears to be acting out a fantasy of autonomous creation (of being able to father itself) as a form of compensation for its fears concerning the reproductive status of women. So the prospect of artificial wombs and of transplanting a uterus into a man (also discussed in 'Dr Satan's Robot') seems to do away with the

troublesome object (the female body), but still revolves around a cycle of fear and fascination which is displaced from the object onto the artificial and simulative properties of technology itself. Technology in this case is virtually female and the anxieties and expectations which surround it stem from the site of human origin.

Virtual Anxiety traces questions about the future and evolution of humans back to the question of origin and the idea that nature and the (specifically) maternal body are the foundation of all (scientific) knowledge and desire (see chapter 4). The problem for feminists who are concerned with questions of science, technology and philosophy is that western science and epistemology structure a hierarchical relationship to origin as the original other. Since the inception of modern science, and from the beginnings of philosophy, nature and the maternal body have been constructed as (in various ways) deficient in relation to scientific culture and deviant from the masculine norm. What ensues is a negative construction of difference and the conceptualisation of a monstrous feminine other, which for me is encapsulated in the story of *Frankenstein* and the myth of Frankenstein's monster – who is monstrous only in so far as he is created as such by a science which is arrogant and overreaching.

In response and in opposition to such creations, feminists are coming up with their own more responsible and accountable visions which take the form of figurations. Figurations are alternative utopian images or political imaginaries which embody a shift in the terms of knowledge, power and subjectivity. They are being put to work in the context of contemporary technoscientific culture, where their main mode of operation is parody. Instead of offering technologically deterministic outcomes and relying on either technophobia or technophilia, they are working towards a better future by strategically situating themselves in the present and negotiating with the constraints of social division. They figure a contest for power and a change which is both here and not here, and which will be slow to emerge and hard won. Haraway's cyborg and Braidotti's nomadic subject are, for me, key figurations, and Braidotti's formulation of new desiring subjects – who negotiate between conscious and unconscious impulses with political commitment and who retain their gender without becoming fixed and polarised within the subject/object structure – has been useful to me in thinking about alternative registers of desire and knowledge. These alternatives break free of the (sadomasochistic) master/slave register and

the production of omnipotence fantasies and move towards something more like intersubjectivity (Benjamin 1988).

To summarise then, my standpoint in *Virtual Anxiety* is feminist, cyborgian, grounded and utopian. By using the term 'grounded' I am referring to the social and historical contextualisation of science and technology which militates against the myth of scientific universality and neutrality and against the political pitfalls of technological determinism. I draw my ideas from interdisciplinary feminisms and from debates on photography, science and technology. In the course of writing chapters 4 and 5, I rediscovered an interest in Gothic fiction which began (what at least feels like) a long time ago when I was an undergraduate and which has been useful here in providing another framework within which to talk about unconscious fears and desires, the machinations of projection and, most importantly, the interplay of imaginary and cautionary tales. It seems to me that this particular interplay is of principal importance when considering the future of technoscientific culture and its inhabitants, and when dealing with millennial hopes and fears. It enables us to gain access to what Dick Hebdige has referred to as 'the virtual power of metaphor' without forgetting the 'dull compulsion of sociological probabilities' (Hebdige 1993: 272, 278). Rosi Braidotti discusses 'the potency and relevance of the imagination, of myth-making, as a way to step out of the political and intellectual stasis of these postmodern times'. She describes her nomadic subject as an 'iconoclastic, mythic figure' which struggles against the conventions of theoretical and philosophical thinking and is a materially inspired metaphor – 'inspired by the experience of peoples or cultures that are literally nomadic, the nomadism in question here refers to the kind of critical consciousness that resists settling into socially coded modes of thought and behaviour' (Braidotti 1994: 4–5).

It is important for me to state that my own parodic figuration – the vampire – is strictly a metaphor for the kind of transformation in knowledge, power and subjectivity which western rationalist culture articulates only as horror and monstrosity. I wanted to take up (figuratively) another position of monstrosity – one that is at least granted the status of being (over)actively desiring. Historically, female desire has been both repressed and pathologised within white western and other cultures, but women's engagement with, and resistance to, this are as multiple and diverse as the category which is a non-category of 'woman'. My inevitably partial (partial in the sense of being incomplete,

finite and far from neutral (Haraway 1997)) location as a lesbian feminist contributes significantly to my investment in finding a figuration of transgressive desire, and vampires are nothing if not transgressive. The construction of victims (often women in low-cut frocks who are subseqently turned into vamps) in vampire stories is of course problematic when trying to combat the master/slave structure of desire. But this is why my vampire is parodic. It is in a sense a figuration for the victims of another's dominant desire who do not, or do not wish to, see themselves as such. It is a figuration for the 'others' – no surprise then that it is a resonant image in gay and lesbian culture. For women in particular, I see the vampire as a figuration not of the monstrous other but of the monstrous (transgressive, transformative, desiring) self which overrides the constraints of tradition and the rites of blood:

> I know a secret as old as the world, a secret as deep as the ocean and as dark as coal. I know how vampires are born. I also know what you are thinking right now: you think of the bite, the blood. But it is not blood that makes a vampire. No. It is the wanting ... What else will you ask? Holy water, the sign of the cross ... I have not found them deadly. But the Christians have good reason to call us enemies, for their faith is founded on denying one's desires, delaying one's gratification. For us, that is our life. We live for desire eternally. (Tan 1995: 77)

The book is divided into five chapters and begins with an assessment of the status of photographic realism in the context of digital and electronic forms of imaging. Chapter 1, ' "The shadow of the object": photography and realism', offers a critique of the technologically deterministic split between photography and new imaging technologies and of how, as Martin Lister puts it: 'the vexed and often tedious argument about something called the *photographic medium* is now being cast as a debate *between* photography and the digital image' (Lister 1995: 9). In particular, the chapter is critical of Ritchin's argument that we are facing 'the end of photography as we have known it' and interprets this position, and others like it, as a panic over the loss of the real (in realism). The advanced and undetectable techniques of manipulation and simulation made available with new imaging technologies appear to undermine the realist status of the photographic image. Where photojournalists and documentary photographers have an ethical and professional investment in the status of photographic realism, this

chapter argues that it is only by investigating a more widespread social and psychological investment that we may come to understand the current anxiety over the real which decades of semiotics have shown to be always already lost to photography. The chapter traces the connection between photographic realism, positivism and humanism and argues that contemporary concerns about the loss of the real mask more fundamental fears about the status of the humanist self, and the way in which the subject uses photography to understand and intervene in the world. Positivism and humanism are the traditional forms of knowledge and subjectivity inscribed within photo realism, and they provide for the viewing subject (at the very least) a reassuring relationship to the object world. But the terms of positivism (and humanism) are hierarchical and binaristic and therefore the subject's relation to the object world is structured by domination. Photo realism offers to make us masters of all we survey and, I suggest, it also structures an unconscious investment defined as the fantasy of omnipotence. But I argue too that there is another unconscious investment in photo realism in which the shadow of the object (understood as the real) falls on the subject, producing a transformation in the self (Bollas 1987) and structuring a pre-verbal, non-hierarchical relationship (or connection) which may form the basis of another way of thinking (knowing and being) in and through photography. This would not be a positivist way of thinking, but one which broke with traditional hierarchical structures and redefined our relationship to nature/the real/origin. The real in this account does not exist in the image but is experienced by the subject through the medium of the image. So whether the image is mechanically or digitally produced is irrelevant. However, I do argue that an increased cultural awareness of how images are produced differently may facilitate a process of rethinking the medium (as well as rethinking through the medium) so that positivist knowledge, which hides its hierarchies in universal and disembodied truth claims, might be replaced by something like Haraway's partial knowledge. Here, images would be 'newly authored' (Ritchin 1990) or claimed by the photographers/compositors as their own perspective and could therefore offer a more responsible and accountable objectivity.

In '"The shadow of the object"' I argue that technological changes have stimulated a degree of uncertainty and anxiety about the nature of photography and the status of our traditional investments in photo

realism. Yet this anxiety may be useful in formulating a new concept of the medium and a new relationship to the real/mother nature/origin with which it has a special connection. Electronic and digital images, like the photographs with which they are in many ways continuous, may therefore serve as what Bollas calls 'transformational objects' – enabling us to think differently about the realm of the self/other which for Bollas is 'thinking the unthought known' (Bollas 1987: 13–29, 277–83). Images may be(come) structured by a register of knowledge which is based on love (Barthes 1980) and not on domination and the hierarchical division of the subject and object. All this may sound utopian and to an extent it is. But it is also based on a reading of one way (if not the dominant way) in which we have already related to photography and to others through photography.

Chapter 2, 'New imaging technologies in medicine and law', considers the relationship between photography and new imaging technologies in the contexts of medicine and law, and is largely a technical chapter which nevertheless raises questions about continuities and transformations in knowledge, power and subjectivity. These questions are considered in more detail in chapter 3, which offers a case study of the role of new imaging technologies in law, and in chapter 4, which looks at new imaging and reproductive technologies in medicine. In chapter 2, I examine the development of imaging technologies in the police force. These range from traditional photographic mug shots to PhotoFIT (photographic facial identification technique) and E-FIT (electronic facial identification technique). I suggest that, concomitant with these technological developments, there is an increased uncertainty in positivist forms of knowledge, and with this the criminal object becomes more elusive to perception and the role of the eyewitness is problematised. New imaging technologies in law appear to expose and compensate for a heightened awareness of the fragility of optical empiricism. Similarly, in the context of medicine, the human eye is the bug in the otherwise total optical machines of medical diagnosis. I examine some of medicine's most advanced forms of imaging including computed tomography (CT) and magnetic resonance imaging (MRI), and argue that they also compensate (fetishistically) for the apparent decline of the medical gaze. Where the continuities in legal forms of imaging are relatively easy to trace, new medical imaging technologies produce extraordinary (often extraordinarily aesthetic) representations of the body which, rather than being fragmented by the visual codes of

photography, appears to be rendered whole in an analogical relationship with space. Bodily innards, I suggest, resemble objects from outer space – not least because medicine and astronomy have similar processes of visualisation, and in some cases the same computers. This chapter concludes with the question of whether, or to what extent, medical epistemology and the structures of power in medical vision are similarly transformed.

In chapter 3, 'Surveillance, technology and crime: the James Bulger case', I develop the idea that advances in surveillance technology can appear to threaten rather than guarantee the relationship of power between the viewing subject and the criminal object. In the James Bulger case, a significant amount of the anger and dismay which surrounded the tragic abduction and murder in 1993 of two-year-old James by two ten-year-old boys (Robert Thompson and Jon Venables) was directed at the security-camera images which 'captured' the abduction. These images were widely represented in the media and contributed to what was frequently perceived as a moral panic about child crime.[4] I argue that media reports of the case, most of which centred on the security-camera images, generated a discourse of control around surveillance technology and child crime in which both children and technology were seen to be out of control. The quality of the images, particularly the one taken from outside a construction firm, was poor, whereas our expectation of surveillance images (established by the codes of photography) is one of maximum clarity. More importantly, there seemed to be a feeling that the images and the technology which produced them had somehow failed to fulfil a role invested in them – at least by the public. It is not just that they forced us to observe a crime which we could do nothing to prevent however desperately we might want to – we all became voyeurs of a tragedy that had already happened. Part of what these images did was to shatter an illusion that security cameras are there to protect people. They exposed what Jamie Wagg refers to as 'the lie of safety in "security"' (Wagg 1996). Or as Mark Cousins put it, 'The object of security is property' (Cousins 1996). The controversy which surrounded Jamie Wagg's exhibition of images from the James Bulger case[5] (which included one of the security-camera shots) must I think have stemmed in part from the feelings of outrage which already surrounded the two pictures most used by the media. I agree with Mark Cousins that the security pictures confused familiar distinctions between people and property and between the public and

the private gaze, but I also think that Wagg ran into trouble because he removed the pictures from a context in which their meanings could be made relatively safe. The media may well have generated a moral panic and a discourse of childhood subjectivity and technology out of control, but the media could offer what John Taylor has referred to as narratives of 'restoration' as well as 'disintegration' (Taylor 1989) by debating causation, legislation and retribution. In this chapter, I argue that the case stimulates epistemological and psychological uncertainties and anxieties – that it threatens our familiar categorisations of both children and technology, resulting in a process of projection and the splitting of good and bad children, good and bad technology, which is evident in the way in which the media used images pertaining to the case. This process of splitting, I suggest, restores a semblance of control to the viewing subject. But Jamie Wagg removed the pictures from this context and its restricted connotations, and by exhibiting them in a gallery he picked up another set of connotations pertaining to art and artists (including perhaps individualism and self-expression) which undoubtedly cut across the political message he had intended to communicate and which did nothing to reassure the viewer.

Chapter 4 on 'NITS and NRTS: medical science and the Frankenstein factor' further explores the questions raised in chapter 2 concerning the degree of continuity and transformation in medical epistemology and structures of power, particularly from the nineteenth century when photography was used in diagnosis and classification. The chapter gives a gendered account of knowledge and power and focuses primarily on imaging technologies in a reproductive medical context and on the (largely) feminist argument that a masculinist science seeks to maximise knowledge and power, and to fully limit and control nature/the female body by attempting to father itself. The stories of Frankenstein and a contemporary medical imaging project (the Visible Human Project) undertaken in the United States, where 'Adam' and 'Eve' are re-created in cyberspace, are used to demonstrate the continuity of the quest for autonomous creation in medical science. But I argue that autonomous creation is ultimately a fantasy; a defence against the anxiety provoked by the masculine subject's ongoing fear of the female body read in terms of its reproductive status. The female body (of nature) is the original monstrous other, and this, I suggest, goes some way towards explaining Mary Shelley's sympathy with Dr Frankenstein's monster/double. I also look at what Rosi Braidotti refers

to as 'the configuration of mothers, monsters and machines' (Braidotti 1994: 76) and begin to consider how otherness, or difference, can be represented or thought of differently.

The monstrosity of the feminine other has been associated with anatomical deficiency, morphological uncertainty and libidinal excess. And as one way of beginning to think differently is to think parodically, I choose to turn the monster myth inside out and regard it as a feminist figuration. In chapter 5, '"The blood is the life": cybersubjects and the myth of the vampire', I use the vampire myth as a feminist figuration because anatomically, morphologically and libidinally it is the essence of monstrosity and allows for the possibility of a transgressive, transformative and desiring self (not other). I also use it because it offers me a way of discussing the irrational dimension within contemporary debates on information technologies – which are the subject of this chapter. I argue that these debates figure an elision between life and information (the body and the machine) and produce the fantasy of an autonomous, self-organising, 'living' information technology as a projection of a feared or wished for undeath. Being no more than information-processing systems, and no different from other information-processing systems, we are figured, in these discourses, not just as cyborgs but as the undead, as metaphorical vampires, hooked on the flow of information which substitutes for the blood of life. In chapter 5, I look in particular at the discourse of contagious information technology, which prevailed during the 1980s, and at connectionism, which has emerged in the 1990s and which is derived from debates in artificial intelligence and artificial life. Both are informed by a concept of information as boundaryless and free flowing, and the boundaryless 'nature' of this free-flowing metaphorical blood carries with it, I suggest, connotations of the other and of intersubjective relations. Within the discourse of contagion, connection with the other is feared and information exchange brings with it the threat of disease, the threat of the virus. The subject responds defensively with fantasies of boundary reinforcement, or alternatively disembodiment, and these fantasies give rise to the immortal fight-or-flight cyborgs of popular culture. Through connectionism, immortality or undeath is figured through merging and the subject retreats into the womb-like environment of an all-encompassing technological organ(ism).

So information technologies are invested with a metaphorical vampirism which betrays underlying fears and desires about organic not

technological others. In parodying the vampire myth and turning it into a figuration of the monstrous desiring self, I wish not only to dispel the myth of the monstrous (feminine) other but also to create the space for more consciously irrational and more politically accountable investments in information and other technologies.

Notes

1 See 'Chaos and Reform: Discourses of the Body in Photographic Representation', University of Sussex.

2 Like television and video in early research, computer and video games have been discussed in relation to the 'hypodermic-syringe' model of media effects on the audience. This model constructs the idea of a passive audience which is influenced directly by media messages (for example, violent programmes cause violent behaviour). Children are perceived as being particularly vulnerable to this influence, and have supposedly copied violent sequences from games and become addicted to playing them. This argument has been debated within psychology, media and communications research. See, for example, Griffiths (1993).

3 *Dr Satan's Robot*, Channel 4, 15 December 1996.

4 See, for example, Hay (1995).

5 Jamie Wagg, '*History Painting': Shopping Mall* and '*History Painting': Railway Line*, Whitechapel Art Gallery, 1994.

1

'The shadow of the object': photography and realism

> The question at hand is the danger posed to *truth* by computer-manipulated photographic imagery. How do we approach this question in a period in which the veracity of even the *straight*, unmanipulated photograph has been under attack for a couple of decades? (Rosler 1991: 52)

Martha Rosler exposes the paradox which is at the heart of debates about the current status of photographic realism. Computer manipulated and simulated imagery appears to threaten the truth status of photography even though that has already been undermined by decades of semiotic analysis. How can this be? How can we panic about the loss of the real when we know (tacitly or otherwise) that the real is always already lost in the act of representation? Any representation, even a photographic one, only constructs an image-idea of the real; it does not capture it, even though it might seem to do so. A photograph of the pyramids is an image-idea of the pyramids, it is not the pyramids. Semiotics is at large outside of the academy. It informs a variety of cultural practices including advertising and photography itself, and it may well have slipped along a chain of signifiers from Marlboro to Mazda into a collective cultural awareness. But it is not necessary to be a semiotician in order to know that photographs, much as we might choose to believe in them, are not 'true'.

This is a particularly thorny issue for photojournalists, who have an ethical and professional stake in the truth status of the photograph and resort in some cases to semantic and logical gymnastics in order to defend it. Before the threat posed by new imaging technologies to photographic realism had become apparent, Harold Evans stated that: 'The camera cannot lie; but it can be an accessory to untruth' (Evans 1978: Introduction). In his more recent book addressing 'the coming revolution in photography', Fred Ritchin argues that photography is indeed an 'interpretation' of Nature, but one which remains 'relatively unmediating' and therefore 'trustworthy' (Ritchin 1990: 2). Ritchin disavows his knowledge of photography as a language, a form of representation, in order to assert that computer-imaging practices pose a fundamental threat to the truth of the image and indeed that they signal 'the end of photography as we have known it' (Ritchin 1991).

Following on from these issues, this chapter sets out to do two things: first, to explore the paradox of photography's apparently fading but always mythical realism, and to suggest that the panic over the loss of the real is actually a displacement or projection of a panic over the potential loss of our dominant and as yet unsuccessfully challenged *investments* in the photographic real. These investments are social and psychological. They exist in the terms of power and knowledge and in the terms of desire and subjectivity. What I will argue is that the current panic over the status of the image, or object of photography, is technologically deterministic and masks a more fundamental fear about the status of the self or the subject of photography, and about the way in which the subject uses photography to understand the world and intervene in it.

The second aim of the chapter is to examine the subject's social and psychological investment in photography in some detail and to suggest ways in which the reappraisal of photography brought about by technological change has made possible a different investment in the medium and a transformation in the terms of knowledge, power and subjectivity.

Digital iconoclasm:
the pyramids, the Queen and Tom Cruise

Icons are doubly valued: for their realism, and for their reverence toward a sacred object. Traditionally, they are representations of Christ,

angels and saints. Contemporary secular icons may include members of the royal family, politicians and film stars, and more often than not they are photographic. Photographic icons appear to be representationally faithful to the object, and photography is a cheap and efficient means of promoting secular-sacred objects for mass consumption.

Digital images would seem to be inherently iconoclastic – unrealistic and irreverent. Three instances of digital iconoclasm which I want to look at are Benetton's blackening of the Queen's face, *Newsweek*'s unconventional portrait of Tom Cruise and Dustin Hoffman, and *National Geographic*'s manipulation of the pyramids at Giza.

The Italian clothes company Benetton blackened the Queen as part of an advertising campaign which addressed issues of race (plate 1). Prior to the publication of the image the *Guardian* reported that 'Her Majesty's nose and lips have been broadened in the computer-aided photograph, which will appear with the words "What if?".' The newspaper also mentions the other photos due to appear in the Benetton catalogue *Colours:* 'the Pope as Chinese, Arnold Schwarzenegger as black and Michael Jackson and Spike Lee as white' (*Guardian* 27 March 1993). The lack of amusement reported from Buckingham Palace was not overtly about the image itself, but about its use to promote products (presumably other than the usual royal family paraphernalia).

Ritchin (1990) discusses the issue of *Newsweek* which ran a feature on the film *Rain Man* and included an image of Dustin Hoffman and Tom Cruise apparently shoulder to shoulder in their cameraderie over their joint box-office success. Only the story and sentiment seem fake when it emerges that the image was composited from two separate photographs. Apparently the actors were not in the same place at the same time when the image was made; one was in Hawaii and the other in New York. Ritchin argues that the caption, which merely read 'Happy ending. The two "main men" of "Rain Man" beam with pardonable pride', does not 'explain that this image was not the photograph it seemed to be' (*ibid.*: 9).

The actors' complicity in this fake, but not unusual, sort of image renders it iconoclastic for Ritchin, who also finds his belief in the factualness of the photograph and the immutability of the observable world 'extraordinarily shaken':

> Certainly subjects have been told to smile, photographs have
> been staged, and other such manipulations have occurred, but
> now the viewer must question the photograph at the basic

physical level of fact. In this instance, I felt not only misled but extraordinarily shaken, as if while intently observing the world it had somehow still managed to significantly change without my noticing. (*ibid.*: 9)

The case of the moving pyramids is already well documented.[1] In February 1982 *National Geographic* published a 'photograph' of two of the pyramids at Giza on its front cover. The image had been digitally altered in order to obtain the required vertical format from the original horizontal format photograph. The alteration involved moving the two pyramids closer together. As Fred Ritchin points out, this move 'has been talked about a great deal in photojournalistic circles' (*ibid.*: 14) and the editor's reference to it as 'merely the establishment of a new point of view by the retroactive repositioning of the photographer a few feet to the side' (*ibid.*: 17), though totally credible, did nothing to lessen the talk. Despite the time-honoured and generally acknowledged tradition of manipulating or staging press and documentary photographs, this act of digital manipulation appears to have overstepped the ethical mark. Ritchin does not exactly specify why, but goes on to discuss the fate of the photographer's valued ability to capture the 'decisive moment' of a scene or event. Henri Cartier-Bresson defines the decisive moment as the point at which 'a scene is stopped and depicted at a certain point of high visual drama' and this, according to Ritchin, has been destroyed by the ease with which an image can now be 'retroactively "rephotographed"' (*ibid.*: 17). The photographer can effectively be repositioned in relation to the subject or vice versa. Existing elements of the picture can be removed, and samples can be imported from other photographs and thereby from another space and time.

Along with the decisive moment, then, there seems to be a threat to the integrity of the original photograph, to the subject and object of the photograph, and to time and space itself. For Martha Rosler 'the pyramids are the very image of immutability – the immutability of objects' (Rosler 1991: 52). She is referring to natural objects, the object of nature, and she goes on to ask what moving the pyramids 'as a whim, casually' (*ibid.*: 53) tells us about ourselves: 'are we betraying history? Are we asserting the easy dominion of our civilization over all times and all places, as signs that we casually absorb as a form of loot?' (*ibid.*: 55). If this is the case, then the looting of time and space, of places and

objects, is what has become more apparent with the advent of new imaging technologies, and some photojournalists at least do not like it. They want their external world to stay where they imagined it was, to be there for them (to represent). However, photography was considered to be the means of representing this reassuring world in which everything appeared to stay in its time, space and place.

The technical procedure for digitally manipulating photographs is also well documented[2] and is not of primary concern here, except in as far as a brief sketch serves to reinforce the sense of an object world made newly mutable. The process of manipulation, then, involves scanning a photograph, translating it into digital information (or number codes) and feeding into a computer. On the computer screen the photograph is broken down into pixels, or picture elements – very small squares that can be changed individually or collectively. Colour and brightness can be changed instantly, and areas of the photograph can be either deleted or cloned. The borders of the image can be either cropped or extended and other images or text can be seamlessly incorporated. Whereas retouching a photograph by conventional means is time-consuming and detectable, these changes are immediate and effectively undetectable.

Techniques of scanning, sampling and 'electrobricollage' (Mitchell 1992: 7) differ fundamentally from the techniques of traditional realist photography where the impact of light onto film at one specific moment in time and space 'faithfully' records a scene or event for posterity. For Andy Cameron the new techniques and technologies of image-making transform photography from a modernist to a postmodernist practice (Cameron 1991: 6). Mitchell also locates this transformation in the development of technology itself. He argues that the tools of traditional photography were appropriate to what he calls the 'high modernist intentions' of photographers such as Paul Strand and Edward Weston, and he defines high modernism as a quest for objective truth 'assured by a quasi-scientific procedure and closed, finished perfection' (Mitchell 1992: 8).

But the most striking facility of new imaging technologies is their ability to generate a realistic image out of nothing – to simulate it from scratch using only numerical codes as the object or referent. Tim Druckrey gives the example of a press 'photograph' of a fighter plane crashing in Finland. Although there was a plane and it did crash, there was never a photograph as such. The image was simulated, assembled by a computer on the basis of eyewitness descriptions (Druckrey 1991:

17). The techniques which enable 'photographs' to be simulated also form the basis of other modes of image simulation, including virtual reality. Here, the object world is regarded as being not simply mutable but totally malleable. It no longer exists as something exterior, but marks the realisation of the subject's desire and imagination.

From a technologically deterministic viewpoint this malleability signals a revolution in image-making and the final demise of photography. If a completely simulated computer image, or even a digitally manipulated photograph, can masquerade effectively as a straight photograph, then surely the authority and integrity of photography are always going to be in question? This is certainly so if you accept the prior existence of straight photography and an unmediated real, and if you only consider change wrought by technology itself. But photography is clearly much more than a particular technology of image-making. It is also a social and cultural practice embedded in history and human agency. Like any other form of technology it has neither determined nor been wholly determined by wider cultural forces, but it has had its part to play in the history of how societies and individuals represent and understand themselves and others. I agree with Kevin Robins (1991: 55) that 'the question of technology … is not at all a technological question', and that new imaging technologies are informed by the values of western culture and 'by a logic of rationality and control'. This wider framework undermines technologically deterministic and apocalyptic claims and presents us with 'the continuities and transformations of particular dynamics in western culture' (*ibid*.: 55). Also, as Robins further points out, underneath the logic of rationality and control that informs the development of technology there are 'powerful expressions of fantasy and desire' which reveal the presence of the subject behind the rhetoric of objectivity (*ibid*.: 57).

According to Mitchell (1992), the alarm occasioned by digital imaging is the result of a breakdown of the boundaries between objectivity and subjectivity, causality and intentionality. What he refers to as 'the smug apartheid' (*ibid*.: 16) between objective, scientific photographic discourses on the one hand, and more subjective and artistic discourses on the other, is in danger of having to be more modest.

Mitchell states that 'the distinction between the causal process of the camera and the intentional process of the artist can no longer be

drawn so confidently and categorically' (*ibid*.: 30). What the loss of such a distinction signifies is not only an instability in the terms of photographic representation, but an instability in the epistemological foundations of photography – its structures of knowledge and thought. What is more, epistemological uncertainty undermines the stability of the subject.

I can't think therefore I don't know who I am

> We have faith in the photograph not only because it works on a physically descriptive level, but in a broader sense because it confirms our sense of omnipresence as well as the validity of the material world. (Ritchin 1990: 132)

Realist photography is traditionally informed by a scientific system of thought fashioned in Enlightenment philosophy and by Cartesian dualism and perspectivalism. Cartesian thought splits and privileges the mind over the body, the rational over the irrational, culture over nature, the subject over the object and so on along an infinite chain which continues to structure western epistemology. Feminist work on philosophy, epistemology and the history of science has established that these dualisms are value-laden and specifically gendered.[3] The female body of nature emerges as a symbolic construct in Bacon's writing[4] and serves as the object of scientific inquiry (and of the rational, masculine scientific mind). Nature in Bacon's account is at times quite an elusive object, and he employs a rhetoric of domination and control in order to demonstrate the process by which scientific knowledge is to be obtained. Nature must if necessary be 'forced to reveal her secrets' – and even 'raped'.[5] Bacon's use of language exposes the fault lines of power and desire which underlie and ultimately threaten his apparently value-free, neutral method of scientific inquiry.

Inductivism is a means of acquiring knowledge through detailed observation and experimentation in the natural world. It is opposed to deductivism – a method of trying out preconceived ideas, of testing a hypothesis, of imposing a theory rather than exposing a fact. Inductivism was Francis Bacon's preferred method because it was a supposedly truer way of gaining knowledge about the natural or object world. But it is clearly not commensurate with the use of force. Inductivism is premised on a passive, willing, submissive sort of nature,

but it is clear that Bacon's concept of it was fundamentally split. The presence of such a split in his theory is perhaps not suprising since nature, for Bacon, had symbolically acquired a female body, and the female body in Christian discourse was either pure or impure.

Ludmilla Jordanova (1989: 89) has identified the eroticism of images and metaphors of unveiling in early modern science and particularly medicine. Nature, personified in the body of a woman, is figuratively unveiled or undressed before science (*ibid.*: 87). Female corpses are stripped of their skin in anatomical drawings and paintings (*ibid.*: 104). Dead or inert nature is unveiled. Wild or untamed nature is subjected to a greater force of power and desire because it takes more effort to master and threatens to deny mastery altogether. Nature, for science, was always an unstable object, encompassing elements of elusiveness and availability which somehow could not be held together in one image, but became split off in an attempt to divide and rule.

Bacon's inductivism was one of a number of seventeenth-century scientific developments which marked a major epistemological shift away from the holistic world view of the Middle Ages. Elsewhere, I have referred to this as a shift from an analogical to an anatomical world view, and one which encompasses the 'discoveries' of Copernicus and Vesalius.[6] What these explorers in outer and inner space discovered is that the geometry of what Burgin (1990: 105) calls 'classical space' could not be upheld. Microcosm and macrocosm do not accurately map each other or the universe, and as Leonardo da Vinci found out, 'the veins of the centenarian were in fact not a bit like the rivers of Tuscany' (Kember 1991: 58). The geometry of classical space is the geometry of concentric spheres where earth and man are the stable focal point of a closed and complementary system. The geometry of classical space is displaced by that of modern space, and this takes the form not of concentric spheres but of the 'cone of vision' (Burgin 1990: 104). Imagine a circle within a circle, then imagine occupying the inner circle and looking outwards. The cone of vision represents the way you see when you take up your previously figurative position at the centre of the universe. You see space extend infinitely from the fixed point of your eye. For Burgin, the Euclidean geometry of the cone of vision maps out 'the space of the humanist subject in its mercantile entrepreneurial incarnation' (*ibid.*: 108). This space is not infinite, however – it only appears to be. Modern space reaches an end point; it implodes and is reformed in postmodern space 'traversed by electronics' (*ibid.*: 108).

The authority of photographic realism is founded on the principle of Euclidean geometry (the cone of vision) and on the application of scientific methods to forms of social life. When light is refracted through the lens of a camera the cone of vision is inverted – just as it is through the lens of the human eye. This is how we obtain focused images.

Victor Burgin (1990: 106) points to the connection between Euclidean geometry and the concept of perspective in the history of art, and in an article on the politics of focus, Lindsay Smith states that 'in histories of documentary photography, "focus" has been instrumental in confirming a belief in the sovereignty of geometrical perspective' (Smith 1992: 238). The focused image is geometrically and therefore optically 'true'. It is an 'authoritative mapping of the visual' (*ibid.*: 238). Smith points out how 'a deconstruction of the "truth" of documentary ... has grown out of a recognition of the historical, material, ideological and psychic complexities implicit in Barthes's now familiar coinage, "the evidential force of the photograph"' (*ibid.*: 238). But Smith remains critical of recent photography theories which fail to recognise the instability in the optical truth status of photography since its inception in the nineteenth century. She is also critical of the way these theories remain unaware of the gender politics of focus in early photographic practice. They seem to her to accept tacitly that in the nineteenth century the ungendered, universal humanist subject was unproblematically centred in the field of photographic vision. She is referring in part to the work of Allan Sekula and John Tagg, who have used Foucault's concepts of surveillance and control to problematise and politicise the scientific status of nineteenth-century medical and legal photographs, and social documentary photographs of the 1930s.

It seems to me that the crucial term which displaces and then effectively replaces the authority of geometrical perspective in Foucauldian accounts of nineteenth-century photography is not so much panopticism as positivism. The panopticon is an architectural model which comes to structure and universalise the operations of the camera. But positivism is the philosophy behind panopticism, and one which structures and universalises the operations of the human eye and the humanist subject in its quest for knowledge. Positivism (after Comte) holds that the (inductivist) methods of the natural sciences may be transferable to the social or human sciences. Like the sciences it derives from, positivism assumes the unproblematic existence of an observable external reality and a neutral, detached and unified observing subject.

The sovereignty of this universal humanist subject is centred and affirmed in positivism through the retention of Cartesian hierarchical dualism.

Positivism is regarded as photography's originary and formative way of thinking. It appears to transcend historical and disciplinary boundaries and constitute the stable foundation of realist and documentary practices. I have suggested that the gendered and unconscious relation between the photographer and photographed can be seen to destabilise both epistemology and subjectivity, not least through the constitution of the photographed object as a fetish (Kember 1995). Similarly, Lindsay Smith outlines the existence of 'difference in vision' in the nineteenth century and demonstrates how a gendered politics of focus and a variation in practice enact 'a critique of the ahistorical, "disembodied" subject perpetuated by "Cartesian Perspectivalism"' (Smith 1992: 244). She compares the work of Julia Margaret Cameron with that of Lewis Carroll and finds that whereas Cameron contests the authority of focus and 'the ideology of perceptual mastery' (*ibid*.: 248), Carroll retains the authority of focus and thereby 'mobilises processes of fetishism' (*ibid*.: 256) as a defence against the object which threatens him with the loss of his own power and authority (a loss symbolised by the threat of castration).

Smith is careful to acknowledge that Foucauldian debates on nineteenth-century photography apply only to specific institutional practices such as medicine and law, but is right to insist that they are nevertheless woefully ungendered and fail to give an account of contesting practices or dynamics (Sekula does problematise the authority of optical realism, however). This, I would add, is largely a facet of the uncomplicated importation of Foucault's early, monolithic and also ungendered account of power and the docile body.[7] What this use of Foucault fails to do for photographic theory is to give an adequate picture of the instability in the terms of photographic realism and its positivist and humanist base that was always already there.

Foucault exposes the ideology of positivism and humanism and provides an invaluable critique of the Enlightenment with his formulation of knowledge as power. But this formulation is frequently re-presented in photographic theory as an almost unshakable formula of perceptual mastery and control. However, the gendered and unconscious relation between observer and observed, knower and known, constitutes an inherent weakness in the formula, a weakness

manifested through sexual difference and through fear and desire.

Psychoanalysis provides a means of inquiring into the unconscious aspects of subjectivity, and for Adam Phillips (1993: 18), a psychoanalytic theory 'is a story about where the wild things are'. It is undoubtedly problematic as a fiction which functions in truth (Foucault 1978) and as one wrought with hierarchical binaries and gender discriminations (see Haraway 1991b). But I would maintain that it is nevertheless the most illuminating story about the wild things like fear and desire, which by comparison are inadequately accounted for elsewhere. And I support the call of Haraway and others to persist not only in our consideration of psychoanalysis as a story, but to dare to imagine new and better ones.[8]

Fetishism is a resonant concept within psychoanalysis and one which originates in Freud's story of castration and the Oedipal complex. Fetishism is a scopic mechanism of defence based on the male child's identification of the mother's body as castrated. He defends himself against the threat of castration by creating a fetish object. The fetish object serves as an unstable defence – as both a compensation for and a reminder of the terrifying space of absence. Fetishism may be tied to the Oedipal and to the concept of the female body as lack, but it can be reconceptualised through alternative psychoanalytic stories and it is useful as a means of discussing other objects, cultural objects, which are used as a way of defending the subject against a perceived threat, or of compensating the subject for a felt or imagined loss.

A photograph can be, and has been, regarded as one such object.[9] Photography, as Susan Sontag now famously stated, 'is mainly a social rite, a defence against anxiety, and a tool of power' (Sontag 1979: 8). Family photographs 'restate symbolically, the imperiled continuity and vanishing extendedness of family life' and tourist photographs 'help people to take possession of space in which they are insecure' (ibid.: 9). They are not only forms of power/knowledge but also reactions to fear (Phillips 1993: 18). They supply the 'token presence' of that which is lost or absent, and 'give people an imaginary possession of a past that is unreal' (Sontag 1979.: 9). They are able to do this by means of their status as small, tangible, collectible objects.

Yet photographs are fragile not only as material objects 'easily torn or mislaid' (ibid.: 4), but as compensatory or fetish objects:

> Photographs are a way of imprisoning reality, understood as recalcitrant, inaccessible; of making it stand still... But ... To

possess the world in the form of images is, precisely, to reexperience the unreality and remoteness of the real. (*ibid.*: 164)

So the photograph as an object which contains the subject's conscious and unconscious investments in the external world both embodies and shatters the realist enterprise and its positivist and humanist baggage. At its most grandiose, says Sontag, the photographic enterprise gives us 'the sense that we can hold the whole world in our heads' (*ibid.*: 3), but this same enterprise generates objects that remind us that the whole world only ever exists in our heads.

What happens in the transition from analogue to digital photography is that this reminder is underlined, the constructedness of the real becomes far more visible. One response to this increased awareness is a refetishisation of the photographic image-object as evidence.

In this context, it is clear that despite his acknowledgement that 'photography's relationship with reality is as tenuous as that of any other medium' (Ritchin 1990: 1), Ritchin finds it fundamentally reassuring in its ability to confirm human perception in 'the quasi-language of sight' (*ibid.*: 2). He also makes it very clear that once this apparent confirmation is removed, the subject can be left with a considerable amount of anxiety. While travelling on the New York City subway, Ritchin imagines that the advertising photographs inside the train are 'unreal' and that 'everything depicted in them had never been'. The result is quite striking:

> As I stared more, at images of people in business suits, on picnics, in a taxi, I became frightened. I looked at the people sitting across from me in the subway car underneath the advertisements for reassurance, but they too began to seem unreal ... I became very anxious, nervous, not wanting to depend upon my sight, questioning it. It was as if I were in a waking dream with no escape, feeling dislocated, unable to turn elsewhere, even to close my eyes, because I knew when I opened them there would be nowhere to look and be reassured. (*ibid.*: 3)

Ritchin finds that he is trapped in his own head, unable to rely on what he sees to confirm his or another's existence in the external world. His

anxiety about what is real is experienced as a feeling of 'dislocation', and it is experienced psychologically and emotionally.

It is then apparent to him that an image which depicts something that has never been (that has no connection with the external world) is a projection, a facet of desire and of the subject's interior world rather than of the exterior world of objects. And what is worse, 'the viewer cannot tell what is being depicted and what projected' (*ibid.*: 5). Ritchin encounters both fear and desire in the experience of new imaging technologies, and in the perceived loss of photography's epistemological and psychological certainties.

In response to his experience, he seems to go in two different directions. On the one hand he is willing to accept the projective status of the image in general, and to envision a reappraisal of the photograph as an image-statement which the photographer is made newly responsible for. On the other, he seeks to reinstate the photograph as depiction. As a photojournalist he is concerned to maintain the integrity of photographic practice, and such a concern tends to lead to a re-fetishisation of the photograph as evidence. But there is also a concern in Ritchin's work – one which is related but somehow separate – to maintain the integrity of a certain experience which is unique or essential to photography. This can be described as 'a sense of being there' (Ritchin 1990: 116) – or as affectivity.

The aesthetic moment: photography as a transformational object

Ritchin is not alone in his presentation of Vietnam war photography as having a special status in the history of photojournalism. Photographs of Vietnam were images 'that contradicted official thinking and challenged the legitimacy of the American-sponsored war' (Ritchin 1990: 42). They preceded a time when 'greater corporate control was exerted on publications'. He is referring to a set of images which are still widely known and reproduced: the little girl running away from a napalm bomb; a Buddhist monk self-immolating; and a member of the Viet Cong being shot in the head at close range (*ibid.*: 42).

Susan Sontag compares the impact of photographic images of the war with television coverage and suggests that photographs are more memorable than moving images 'because they are a neat slice of time, not a flow' (Sontag 1979: 17) and can be kept and pondered over.

She says that photographs like that of the South Vietnamese girl sprayed by napalm 'running down a highway toward the camera, her arms open, screaming with pain – probably did more to increase public revulsion against the war than a hundred hours of televised barbarities' (*ibid.*: 18) (figure 1).

Photography's status as a portable object is a means to both avowal and disavowal, memory and forgetfulness. According to Sontag, what sticks in the memory does not filter into sustained political and ethical consciousness because photographs offer only uncontextualised, fragmented bits of information:

> The camera makes reality atomic, manageable, and opaque. It is a view of the world which denies interconnectedness, continuity, but which confers on each moment the character of a mystery. Any photograph has multiple meanings; indeed, to see something in the form of a photograph is to encounter a potential object of fascination. (Sontag 1979: 23)

These war photographs, then, deliver a short, sharp but undirected shock. They resonate in the subject's memory but perhaps more at an unconscious than at a conscious level. What they capture becomes mysterious and they become objects of fascination. It may be said that the photographic image is not merely memorable but that it mimics memory. Harold Evans (1978) has pointed out that it is generally easier for people to remember somebody or something by calling up a single image in the mind's eye. It is easier to concentrate on one image than on a sequence of images and 'the single image can be rich in meaning because it is a trigger of all the emotions aroused by the subject' (Evans 1978: 5).

This affective capacity of the photograph may be accidental or sought after. In *Camera Lucida* Barthes describes his own exploration and experience of what he calls the power of 'affect' (Barthes 1980: 21) which functions as the essence or 'aesthetic moment' of photography (Bollas 1987). In order to arrive at this essence or to experience the aesthetic moment Barthes finds that he must reject all means of classifying the image (for example, aesthetically as 'Realism/Pictorialism' (Barthes 1980: 4)) and all theoretical disciplines, including semiology, which he was so central in establishing. Barthes declares his 'ultimate dissatisfaction' with critical language (*ibid.*: 8)

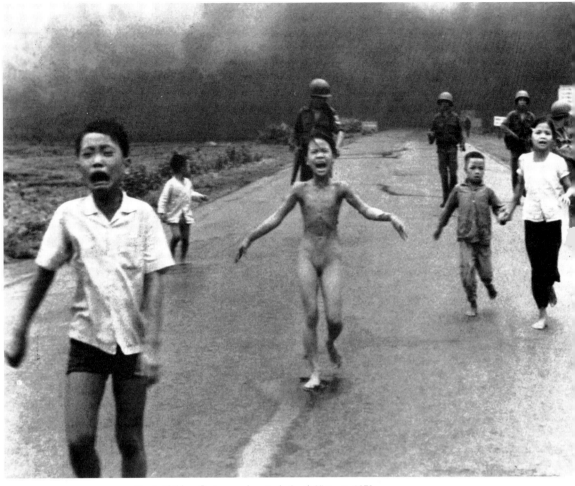

Fig. 1 Children fleeing napalm attack, South Vietnam, 1972

and so resolves to 'make myself the measure of photographic "knowledge"' (*ibid.*: 9). 'What', he asks, 'does my body know of Photography?' (*ibid.*: 9).

Barthes experiences the power of affect in his being – more in his body than his mind, and more in emotion than in thought. The affect is ultimately non-verbal: 'what I can name cannot really prick me' (*ibid.*: 51). The power of affect in photography seems to derive – perversely – from the 'real' that critical languages can reason away but cannot finally expunge from the subject's experience of photography. That is, we can know the impossibility of the real in representation (as Barthes clearly does) but we can nevertheless *feel* its presence. And here I agree with one

of Ritchin's final points, that the photograph, 'held up as the more efficient inheritor of the replicating function', has in fact survived the advent of both Freud and Saussure, psychoanalysis and semiotics. I think it is true to say that the authority of photography, 'its reputation for fidelity', remains 'largely intact in the popular imagination' (Ritchin 1990: 143).

But perhaps it is intact at a level other than that of knowledge and understanding. The action of knowledge is, for Barthes, a secondary action, but a photograph 'in effect, is never distinguished from its referent (from what it represents), or at least it is not *immediately* or *generally* distinguished from its referent' (Barthes 1980: 5). Barthes chooses the term 'punctum' to describe the immediacy of a photograph's affect on him. The punctum is that element of the photograph that does not belong to language or culture, and it is more accidental than sought after: 'it is this element which rises from the scene, shoots out of it like an arrow, and pierces me' (*ibid*.: 26). As the punctum can be a detail or 'partial object' it shares some of the qualities of the fetish, but it becomes apparent in the context of the affect Barthes seeks from a photograph of his mother that he is seeking something more like avowal than disavowal, more like memory than forgetting. In this case, the photograph is functioning as something other than a fetish object for Barthes.

Barthes wrote *Camera Lucida* shortly after his mother's death, and shortly before his own. Ostensibly, he seeks a photograph of his mother which will enable him to disavow her death, and in a sense, bring her back for a moment:

> There I was, alone in the apartment where she had died, looking at these pictures of my mother, one by one, under the lamp, gradually moving back in time with her, looking for the truth of the face I had loved. And I found it. (Barthes 1980: 67)

What he found was a photograph of his mother aged five, taken in 1898. She was standing in a conservatory or 'Winter Garden' with her brother and 'holding one finger in the other hand, as children often do, in an awkward gesture' (*ibid*.: 69). Here Barthes 'at last rediscovered my mother' in one true or 'just image' (*ibid*.: 70).

Even if this photograph does function in some way as a fetish object, it also functions more profoundly as what Christopher Bollas (1987) terms a 'transformational object'. A transformational object is

one through which the adult subject remembers 'not cognitively but existentially' an early object experience (Bollas 1987: 17). The object here is the infant's primary love object – the mother. What stimulates this memory is an 'intense affective experience' or an 'aesthetic moment', and what is being remembered is 'a relationship which was identified with cumulative transformational experiences of the self' (*ibid.*: 17).

So the mother is the original transformational object, and it is the infant's transformational experience of her that is sought through the adult's search for subsequent objects, which may, according to Bollas, take the form of the analyst or of the aesthetic experience of 'a painting, a poem, an aria or symphony, or a natural landscape' (*ibid.*: 16) – or presumably a photograph.

The concepts of the transformational object and of the aesthetic moment shed a new light (not an Enlightenment light) on our not altogether rational insistence on the separateness and integrity of an object world. Not only do 'our individual and collective sanities' depend on it, as Bollas (*ibid.*: 30) suggests, but there are occasions when we actively seek the moment when we feel with 'absolute certainty' that we have been 'cradled by, and dwelled with, the spirit of the object' (*ibid.*: 30). Such moments are 'fundamentally wordless' and they are 'notable for the density of the subject's feeling and the fundamentally non-representational knowledge of being embraced by the aesthetic object' (*ibid.*: 31). Despite Barthes's attempts to put his experience of the Winter Garden photograph into words, as it were retrospectively, the experience itself is wordless and so unique to him that he sees no point in reproducing the photograph in his book.

Because aesthetic moments are non-verbal, or rather pre-verbal, they constitute part of what Bollas (*ibid.*: 277–83) terms 'the unthought known'. That is, they are part of the essential or 'true self' which is known but has not yet been thought – brought into consciousness and into representation. The transformation which the subject seeks through a transformational object or an aesthetic moment is of the unthought known into thought. And this transformation occurs when the shadow of the object falls on the subject, or when the mother's presence is felt.

For Barthes the maternal replaces (is exchangeable with) the real, or the referent. Nature, the object and the female body are (still) aligned, but the relation he seeks with them is originary and undifferentiated. It is not caught up in the dualistic terms of knowledge and representation.

It is symbiotic, not split and hierarchical – an encounter with origin that facilitates a certain evolution, a transformation of the self and of the unthought known into thought.

Barthes's search for the place where he has been is related to his concern with 'that-has-been' – a quality which he considers to be essential to photography. He reproduces a photograph of an old house in Grenada where he would like to live (Barthes 1980: 38–9). He describes this 'longing to inhabit' as 'fantasmatic, deriving from a kind of second sight which seems to bear me forward to a utopian time, or to carry me back to somewhere in myself' (*ibid.*: 40). Landscapes like this give him a certain sense 'of having been there or of going there' which he relates to Freud's 'heimlich' (*ibid.*) and the uncanny.

The Winter Garden photograph presents him with the mother-as-child, and it is the experience of his dying mother as being like a child which seems to transform and bring into thought Barthes's sense of his own death. Shortly before he found the Winter Garden photograph, Barthes nursed his weak and dying mother. He tells how 'she had become my little girl, uniting for me with that essential child she was in her first photograph' (*ibid.*: 72). This experience of her as his 'feminine child' provided him with a 'way of resolving Death' (*ibid.*: 72). Childless himself, he had engendered his mother, and 'once she was dead I no longer had any reason to attune myself to the progress of the superior Life Force (the race, the species) … From now on I could do no more than await my total, undialectical death.' This, he says, 'is what I read in the Winter Garden Photograph' (*ibid.*: 72).

I am suggesting, then, that for Barthes (in *Camera Lucida* (1980)) the photograph has a dual function. It is (at once) a fetish object and a transformational object (the two may be closer together than they appear in Oedipal terms). The photograph is also the means by which the shadow of the object understood as the real (and, symbolically, the mother) falls on the subject. The moment in which the shadow of the object falls on the subject may be understood as the aesthetic moment of photography, and the affect of this moment is of a transformation of the unthought known into thought.

It may be said that this transformative experience of the self based on an uncanny encounter with the real has been at the heart of our persistent (but irrational) faith in photography. It is a faith which precisely cuts across our more rational investments in, and our knowledge about, the truth status of photography – because it is placed

in a real located ultimately in our own interior worlds rather than in an exterior one.

I have argued that digital images pose a threat to our investments in photographic realism. These investments are in a sense of mastery and control over the object world which is secured (unsafely) by postivism, and conversely in a transformative experience of the self which occurs in a non-hierarchical relationship to the object world. Because positivism obscures the presence of the subject in photography, its guarantees and reassurances are ultimately illusory and were always already lost. Positivism is, it would seem, a faulty way of thinking which maintains that the real is representable rather than experiential – located in the exterior world rather than the interior world of the subject. Our investment in photography as a transformational object is an investment in our experience of the real, and it implies a different, non-positivist way of thinking. This other way of thinking which is latent in our experience of photography as a transformational object is, of necessity, coming nearer to being thought through our experience of digital images, and our awareness of their constructedness.

Digital images may be regarded as partial rather than universal forms of knowledge, and as image-statements rather than truths. Ritchin recognised that they may become newly authored and situated in language and culture (1990: 88, 99) and that they 'represent both openings to new knowledge and an invitation to its constriction' (*ibid.*: 144). In her reappraisal of the epistemological foundations of science and technology, Donna Haraway argues that 'only partial knowledge guarantees objectivity' (Haraway 1991a: 192). Similarly, when Ritchin acknowledges the possibility of a radical reappraisal of image-making, he maintains that images should be a means for 'exploring territories that exist independently of us' and wonders whether we will 'use photography to respect and value the complexity of the other, whether another person, place, people, idea, or the other that exists in ourselves?' (Ritchin 1990: 146).

An epistemological shift in the terms of image-making involves a transformation in the relationship between the subject and object of the image, or between the self and other. The object is no longer understood as being wholly separate from the subject, but retains an equivalent status and integrity. This subject–object relation is inherent in our experience of photography as a transformational object and it may be continuous, I would argue, with a reappraisal of photography in the

light of digital imaging.

Notes

The chapter title is taken from Bollas (1987).
1 See, for example, Ritchin (1990) and Rosler (1991).
2 See Mitchell (1992).
3 See particularly Harding and Haraway (1991a).
4 See Jacobus *et al.* (1990).
5 See Merchant (1980).
6 Kember (1991).
7 Foucault (1977).
8 See Haraway (1991b) and Braidotti (1994).
9 Metz (1985).

2

New imaging technologies
in medicine and law

This chapter will give an account of some of the main forms of contemporary computerised medical and legal imaging. The aim here is to explore such things as body scanners and computerised facial recall systems in enough technical detail so that some of the central questions of this book may be addressed through them. These questions include: is photography now redundant and if not what is the role of photography in relation to these new technologies? How does the use of new medical and legal technologies relate to the use of photography in the nineteenth century, and where are the shifts, if any, in the terms of knowledge, power and subjectivity typical to the medical and legal institutions?

I will argue that there are significant continuities between old and new forms of legal imaging, notably in the sustained use of photographs and facial coding techniques. However, the continuity in legal forms of representation is undermined by a shift in the way in which these representations are understood. Alongside the introduction of electronic imaging technologies and the use of psychology in criminal identification procedures, representations of the criminal body have come to be understood outside the terms of positivism. That is, the role of the subject in criminal identification has received more attention and this has produced less certainty around the authority and status of the image. To some extent, as I will demonstrate, this uncertainty always

existed but it has become more apparent in the epistemological procedures and assumptions of current police work. The computerised image of the criminal is less certainly an emanation or trace of the criminal object itself, and is more clearly constructed from the projection of a mental image from the mind's eye of the witness onto the screen. This inevitably generates a degree of anxiety around the loss of the criminal object, and it is exacerbated by an awareness of the psychological limitations of eyewitness evidence and of the fragility of optical empiricism. New criminal identification technologies both expose and seek to compensate for the limitations of the eyewitness and the loss of the criminal object.

The human eye is similarly regarded as the bug in the machine of contemporary computerised medical imaging practice. Current medical imaging technologies supersede the capacity of the human eye in diagnosis and offer a visionary form of compensation, which allows the subject to retain an illusion of control over the object in representations that appear to colonise the interior of the body through an analogy with outer space. The object which appears to elude the unassisted medical gaze reappears as an object which is transformed by a technologically assisted astro-medical gaze.

The body is turned inside out, organs resemble objects from outer space and so there is no boundary, no limit and no loss to vision. There is also no apparent continuity between contemporary computerised medical imaging and medical photography. There is, for example, a significant shift in attention from exteriors to interiors which began at the end of the nineteenth century with the invention of the X-ray. And where medical photography fragments the exterior of the body (facilitating scopophilic investments such as voyeurism and fetishism) computer images appear to make the body whole, not least through the analogy with space. Foucauldian concepts of surveillance and panopticism have been used to analyse nineteenth-century medical photographs (notably by John Tagg), and Roberta McGrath (1984) aligned the concepts of surveillance and scopophilia in her article on 'Medical Police', which tied nineteenth-century medical photographic codes ('before and after', 'more or less than') to a social and psychological discourse of control over the diseased or deformed body.

The concepts of surveillance and scopophilia have been used in conjunction with the notion of a gendered, hierarchical and dualistic

medical epistemology, and so the question I will raise at the end of this chapter and address in chapter 4 is whether or not new imaging technologies in medicine signal a paradigm shift or a transformation in the terms of medical epistemology.

Contemporary legal imaging

The role of the eyewitness and of eyewitness evidence is central to the task of criminal identification, which is of course itself central to police work in general. But since the development of a modern police force in the nineteenth century it has been clear that verifying both the experience of the observer and the identity of the observed is problematic.

In an unpublished paper on the development of identification systems Detective Sergeant Peter Bennett suggests that the modernisation of the police force following the 1829 Metropolitan Police Act highlighted three specific problems of identification: (1) how to identify habitual criminals; (2) how to identify suspects unknown to the police; and (3) how to identify murder victims whose bodies had degenerated or been damaged beyond immediate recognition (Bennett, unpublished: 1). He goes on to show how technology, beginning with photography in the nineteenth century, has been used to try and combat these problems.

It was the French anthropologist Alphonse Bertillon who, in the nineteenth century, developed a system for identifying habitual criminals using a standardised photographic procedure along with the 'portrait parlé and anthropometric measurements of the body. The 'portrait parlé' or verbal portrait consisted of the image plus a short description of the subject. According to Bennett there were also two German anthropologists whose work on skin-tissue depths at the end of the nineteenth century paved the way for research on facial reconstruction and the identification of dead bodies (ibid.: 5).

Although Alphonse Bertillon developed 'the first effective modern system of criminal identification' (Sekula 1989: 353) through the use of photography, Allan Sekula points out that in doing so he also discovered the limitations of photography and of optical empiricism.

As criminal portraits mounted up, the police were confronted with 'a massive and chaotic archive of images' (ibid.: 357) which then needed to be classified. Bertillon found that the police were having to compare

the one hundred individuals arrested daily in Paris against one hundred thousand photographs collected by the Paris police during the period 1881–91. This was time-consuming and led to errors which Bertillon proposed to overcome by applying the classificatory methods of the natural sciences to the new social science of criminology:

> the search demanded more than a week of application, not to speak of the errors and oversights which a task so fatiguing to the eye could not fail to occasion. There was a need for a method of elimination analogous to that in use in botany and zoology; that is to say, one based on the characteristic elements of individuality. (Bertillon in Sekula 1989: 357)

His positivist method included 'anthropometrics, the optical precision of the camera, a refined physiognomic vocabulary, and statistics' (*ibid*.: 358). That is, he took eleven measurements of each criminal's body on the assumption that two individuals were unlikely to share exactly the same features. These measurements were accompanied by a verbal description of distinguishing features and frontal and profile portraits. Details were recorded on index cards which then needed to be organised. As Sekula points out, in order to do this Bertillon utilised 'the central conceptual category of social statistics: the notion of the "average man"' (*ibid*.: 354) and the mathematical expression of social aggregates – notably the bell-shaped curve. For Adolphe Quetelet, cited by Sekula as the reinventor of the concept of the average man, the curve expressed a fundamental social law:

> In an extraordinary metaphoric conflation of individual difference with mathematical error, Quetelet defined the central portion of the curve, that large number of measurements clustered around the mean, as a zone of normality. Divergent measurements tended toward darker regions of monstrosity and biosocial pathology. (Sekula 1989: 355)

What facilitated the proposal of this law was a general climate of belief in physiognomy and phrenology. Physiognomy analysed the head shape and facial features 'assigning a characterological significance to each element: forehead, eyes, ears, nose, chin, etc.' (*ibid*.: 347). Overall character was judged through the combination of features. Phrenology analysed the topography of the skull and its correspondence with

localised mental faculties. Together, physiognomy and phrenology constituted an empirical attempt to understand the mind. They and the social statistical methods derived from them had political as well as epistemological implications in so far as the average man – the norm – was constituted as an ideal social type, and difference was understood as deviance.

Bertillon's use of the concept of the average man, and his use of the bell-shaped curve, enabled him to separate and organise measurements of the criminal body into average, below average and above average categories. He devised a filing system which matched this categorisation, and he considered that his system was infallible (*ibid.*: 358). It was, however, a system which subordinated the use of photography to statistics. As Sekula points out, he was 'one of the first users of photographic documents to comprehend fully the fundamental problem of the archive, the problem of volume' (*ibid.*: 358) and also the limitations of photographic evidence. Bertillon standardised the photographic process by using a fixed focal length and flat lighting, but the photograph was only ever 'the final conclusive sign in the process of identification' (*ibid.*: 358) – it was not a strong enough form of evidence in itself. This also delineates the limitations of optical empiricism and the importance of statistics and classification in the social sciences.

By the turn of the century, when fingerprint classification also came in to use, two out of the three problems of identification had already begun to be addressed and the methods for solving them had been established. Photography and 'portrait parlé' still form the basis of witness albums and hence of eyewitness evidence. However, as Bennett suggests, there is still the problem of how to identify suspects unknown to the police, and as Shepherd and Ellis point out in *Processing Images of Faces* there is still – and perhaps always – the problem of 'limitations at the witness end' (Shepherd and Ellis 1993: 142). Attempts to resolve these two remaining problems have led in the latter half of this century to the development of computerised face-recognition and recall systems.

Shepherd and Ellis (*ibid.*) state that when an eyewitness comes forward to give evidence about a suspect to the police, there are a number of methods available for obtaining an image of that suspect. Some methods are based on witness recall and some are based on recognition. In either case a verbal description must be obtained first. Witness recognition methods are used when the suspect is not known to the witness but may be known to the police. These include the use of

photographic witness albums and identification parades. As English police forces keep photographs of everybody who is convicted of an offence, any one force depending on its size will have a significant number of photographs. A witness may have a special album of photographs made up according to the type of crime, age or sex of the suspect but, according to Shepherd and Ellis, may still be asked to view up to a thousand photographs in a single search. This process is time-consuming for the police and can produce serious consequences because of witness fatigue:

> Although there are very few studies looking at this problem, there is sufficient evidence from laboratory investigations to suggest that, as the size of the set in which the target is embedded increases beyond a hundred or so, there is an increase in the number of misses and false alarms, indicating some change due either to fatigue, interference, or shift in criterion. (*ibid.*: 130)

Shepherd and Ellis go on to suggest that the 'witness problem' can be minimised by reducing the number of mug shots viewed whilst being careful not to eliminate the image of the likely suspect. The development of a computerised mug shot retrieval system which might help to resolve the problem depends on a system of coding images of faces for storage in the computer database. Faces can be coded geometrically or syntactically. Geometric coding involves taking measurements of facial features from the images and harks back to Bertillon's system of classification. One of the problems of geometric coding is deciding which measurements will remain constant through the ageing process and represent the dimensions of the face accurately. Another problem is that the coding based on these criteria may not be relevant to what eyewitnesses actually notice – for example, hair length and colour. Syntactic coding makes use of descriptions rather than measurements of faces and is more closely related to the kinds of observation witnesses make: 'high forehead', 'long nose', 'short hair'.

Once the database is set up, any new set of measurements or descriptions is subject to either a sequencing or a matching search. In a sequencing search the new face is compared to each of those in the database and ranked according to the accuracy of fit. A matching search works more by a process of elimination and produces a small number of fits.

A prototype mug shot retrieval system, FRAME (face retrieval and matching equipment), was developed at the University of Aberdeen and was based on syntactic coding and a sequencing search system. Although geometric coding was used, it was then translated into syntactic coding. Facial measurements were converted to more descriptive parameters in order to make them more accessible to witnesses. The database consisted of photographic images of one thousand male subjects. As with the traditional mug shot, each of the men was photographed full face and in profile. Semi-profile shots were also taken. Unlike traditional mug shots, however, the computerised versions could be altered in response to feedback from the witness. Any feature which did not match the suspect's face could be changed. When the FRAME system was compared with the traditional mug shot album procedure it was found to be more accurate and to improve witness performance only when the target faces were 'non-distinctive' (no beard, glasses or other noticeable feature which would make them easier to identify) or were positioned towards the end of the mug shot album where the eyewitness would be subject to fatigue.

Results were promising enough for the system to be tested operationally under the title FACES (facial analysis comparison and elimination system). Shepherd and Ellis report that the FACES system seems to produce a greater number of identifications than conventional mug shot systems but that what is 'difficult to evaluate is whether the identifications are "true", since this depends on the subsequent arrest and disposition of the subject' (Shepherd and Ellis 1993: 140). They also suggest that a number of cases may be missed if the witness fails to remember the suspect accurately or if the suspect has no previous convictions and so is not in the database.

Computerised mug shot retrieval systems are designed to improve criminal identification rates by assisting witnesses with the process of recognition. They are neither wholly distinct from earlier photographic systems, nor wholly superior. They have one specific context of use – the identification of suspects known to the police – and clearly cannot override the limitations of the witness's visual memory.

These limitations are still more apparent when there is no available mug shot of the suspect for the witness to try and recognise or match with a mental image, and when an image is generated purely from recall. This may be done by means of an artist's sketch, manual composite systems such as Identikit and PhotoFIT, or computerised composite

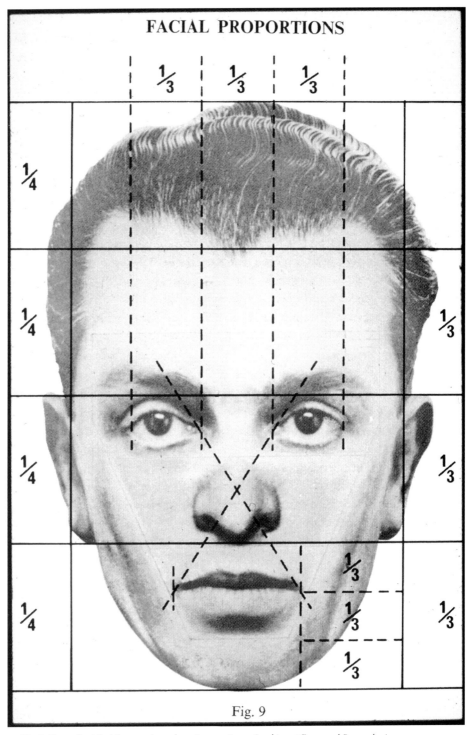

Fig. 9

Fig. 2 Normalised facial proportions, from Jacques Penry, *Looking at Faces and Remembering Them. A Guide to Facial Identification*, 1971

systems like ComphotoFIT, E-FIT and CD-FIT.

Identikit is one of the earliest recall systems and was developed in the late 1950s. It consists of line drawings of individual facial features which are printed on acetate sheets. The image of a face is built up using the layers of acetate, and the final composite can be altered by sketching over it.

PhotoFIT came into use in 1970 and consists of photographic images of five features (hair and forehead, eyes, nose, mouth and chin) printed separately on card and combined in a frame to produce a face. Alterations can be drawn on acetate and placed under the cover of the frame. The PhotoFIT idea originated in a child's game by Waddingtons, who then continued to manufacture it as a recall system for police use. The PhotoFIT pack contains about a hundred examples of each of the five features plus a number of accessories. The total number of face combinations is extremely high and it is interesting, when considering the more contemporary computer composites, that there is both a male and a female 'database'. However, the inventor of PhotoFIT and 'facial topographer' Jacques Penry avoids making gender (or racial) distinctions about facial topography, which is presented in terms of universal attributes.

Faces, according to Penry, are either rounded or angular in shape. Although the rounded outline presents a 'soft' impression, and the angular outline gives a 'hard' effect, 'the term "soft" does not imply "baby face" effeminacy in a man any more than the angular "hard" pattern in a woman presupposes a masculoid nature' (Penry 1971: 32). Facial proportions as well as facial outlines are presented as being universal and are measured against a norm. In a face which has normal proportions:

(a) The *head* is divided into four equal parts: i.e. from top of head to normal hairline; hairline to brows; brows to base of nose; bottom of nose to base of chin.

(b) The *face* is divided into three equal sections: normal hairline to brows; brows to bottom of nose, and base of nose to base of chin.

(c) The *ear* measures one-third of the facial length, its top rim being on an imaginary line with the brows and its lobe on a line with base of chin.

(d) The *mouth* closure-line is approximately one-third of the distance from base of nose to base of chin. Its width is

approximately one-third of the facial length. (An imaginary diagonal line from the inner corner of eye traverses the outer part of the nostril to the outer corner of mouth.)

(e) The space between the eyes measures the width of one eye. (Penry 1971: 29)

Penry uses these normalised proportions and measurements (figure 2) as the basis of the syntactic classification of features in PhotoFIT (for example, high foreheads, receding hairlines, mis-shapen mouths). The measurements themselves are based on the physiognomic and typological principles espoused in the nineteenth century. According to Penry, human faces are only unique in as far as they are unique combinations of universal outline, proportion and feature types. Penry's book *Looking at Faces and Remembering Them. A Guide to Facial Identification* (1971) actually only refers to the faces of white men, which are therefore implicitly taken as the norm. What is more, or what is more alarming, he makes links between facial features and personality. This recalls the physiognomic idea that the outer features bear the signs of inner character. Physiognomy informed the medical and representational practices of key nineteenth-century scientists and social scientists such as Francis Galton, Havelock Ellis, Hugh Welsch Diamond and Alphonse Charcot. It constituted a pre-psychological, pre-psychoanalytical way of knowing and regulating the mind through the body.

Galton was a cousin of Charles Darwin and he believed in the hereditary nature of human characteristics. He held that these characteristics could be read physiognomically and he utilised the concept of the average man and the bell curve to generate composite photographs of ideal and deviant types. The composites were constructed by exposing a number of images successively on one plate, the exposure time being a fraction of the total number of images exposed. Only shared features remained visible and so Galton believed he had visualised a statistical average. As Sekula points out, 'Galton believed that he had invented a prodigious epistemological tool' (Sekula 1989: 367). Galton was a biological determinist and this fed into a political programme of eugenics. Eugenics was concerned with improving the species through breeding, and eugenicists 'justified their programme in utilitarian terms' (*ibid.*: 367). They sought to reduce and

ultimately eliminate those people they considered to be predestined to crime, poverty, disease or madness and thereby to save them from themselves. But as Sekula points out, the eugenics movement founded by Galton took hold in a particular social and historical context defined by rapid urbanisation and middle-class fears of a 'degenerate urban poor' (*ibid*.: 365). Criminals, for Galton, were of a type with other 'degenerates' – racial, sexual and social – and as twentieth-century history demonstrates, 'eugenics would operate with brutal certainty only in its negative mode, through the sterilization and extermination of the Other' (*ibid*.: 373).

Sekula concludes that both Galton and Bertillon attempted to maintain an 'optical model of truth' in the face of a historical movement towards 'abstract, statistical procedures' in the social sciences (*ibid*.: 373). He also points out that optical empiricism retained a 'lingering prestige' and that 'unfortunately, Bertillon and Galton are still with us':

> 'Bertillon' survives in the operations of the national security state, in the condition of the intensive and extensive surveillance that characterizes both everyday life and the geopolitical sphere. 'Galton' lives in the renewed authority of biological determinism, founded in the increased hegemony of the political Right in the Western democracies. (Sekula 1989: 376)

Galton also survives, as we shall see, 'in the neoeugenicist implications of some of the new biotechnologies' (*ibid*.: 376). Just as Sekula objects to the concealed heritage of Galtonian ideology in the contemporary computer composites of Nancy Burson (*ibid*.: 377), I would want to object to the absence of ideological awareness in the work of contemporary criminal identification procedures such as PhotoFIT and in the work of other artists and practitioners of computer composites, such as Benson and Perrett (1991).

I would also support Sekula's suggestion that despite an early awareness of the limitations of optical empiricism, the authority of the photograph survives with 'the shadowy presence of the archive' (Sekula 1989: 377) in contemporary practices. This is apparent in computerised medical and legal contexts, and I will demonstrate how it operates in relation to new attempts to map the human body in chapter 4.

Returning to Penry's work, it can be seen that he draws first on biology and then on a form of common-sense psychology in order to

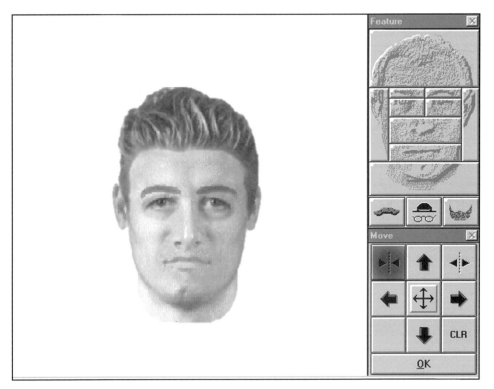

Fig. 3 E-FIT image

support his claim that there is a link between facial features and personality. He argues that:

> There is nothing haphazard about the origins of patterns in facial structure and the kinds of personality they reflect. The facial pattern as part of the whole physique is a result of glandular chemical functioning (adrenal, thyroid, pituitary, thymus, etcetera), which controls all bodily growth, shape, strength, sensation and mental activity. (Penry 1971: 16)

He then goes on to describe individual facial features and says that the mouth, for example, 'shows, in its development from infancy to old age, the physical effect of a perpetual contest between mental discipline and shifting emotion' (*ibid*,: 42). Mouths which have downturned corners and thin lips reveal 'a continual habit of repressing pleasant, carefree feelings, and dwelling instead on the sterner aspects of life', while mouths with upturned corners tend to have perpetually cheerful owners, and 'a full, fleshy-lipped or loosely moulded mouth in itself suggests a

basic general lack of control over emotional urges' (*ibid*.: 42).

Penry attributes these doubtful and dubious characteristics to face and feature shapes which have been measured against a geometric norm. They are legitimated by claims to scientificity. As the purpose of his whole book is to teach prospective eyewitnesses how to observe and recognise faces more accurately, Penry reminds his readers of what he considers to be a valid scientific approach.

Where Penry employs a layman's psychology of faces, work which developed from criticisms of his PhotoFIT recall system concentrated more on the psychological experiences and difficulties of the eyewitness. Penry's book is about how to look at faces and remember them. He implies that if the prospective witness looks properly he or she will necessarily remember accurately. Whether or not anyone ever did learn to look the Penry way (and his work is not at odds with some popular and institutional ideas), it is clear that accurate facial recall continues to be a problem in criminal identification procedures. Shepherd and Ellis (1993: 141) state that 'compared with our ability to recognise faces, we are rather poor at recalling them'. They suggest that it could be that people are quite able to form a mental image of someone, but that they have difficulty externalising or expressing that image in a useful way.

Work which has taken place in the Psychology Department at Aberdeen University has been used to improve on the PhotoFIT system by taking this problem into account. The problem with PhotoFIT may have been that in being asked to focus on the details of a face, the witness loses the mental image of the face as a whole. If features which are most easily recalled – face shape, hair and age – could be continually displayed then perhaps the mental image could be retained. This calls for an ability to manipulate images more easily than in PhotoFIT or Identikit: 'to achieve an adequate range of both feature and configural manipulations computer imaging, display and control techniques seem essential' (Shepherd and Ellis 1993: 141). So computerised recall systems such as E-FIT assist recall in this way.

Before a witness is asked to generate an image with PhotoFIT or on the computer screen, he or she is interviewed and asked to provide a verbal description. This is a crucial stage in the process of facial recall, but it was not until the mid-1980s that an interview technique was devised in order to 'increase the completeness of a witness's report' (Fisher *et al.* 1989: 722).

The cognitive interview aims to help the witness to regenerate the

context of the original crime and to search through memory in a systematic way. The main task of this technique is to bring the scene more fully into consciousness. According to Fisher *et al.*, the main components of the cognitive interview are directed towards enhancing memory retrieval 'by making witnesses consciously aware of the events that transpired' (*ibid.*: 723).

The witness is made more consciously aware when the whole context of the crime is recreated in memory (for example, what the weather was like, what kind of emotions and thoughts the witness had) and when the interviewer is able to devise questions which are compatible with the witness's own mental representation, rather than using a rigid and uniform style of questioning. The cognitive interview is based on what psychologists understand of the laws of memory and free recall, and it is designed to avoid leading questions which might contaminate the witness's evidence.

Face-recall systems such as PhotoFIT and E-FIT are less likely to contaminate the witness's evidence than the use of mug shot albums, which obviously offer an existing image for recognition purposes. The identification procedures followed by the police are informed by the Police and Criminal Evidence Act (PACE) and it is clear from this that there are careful guidelines covering the use of photographs. Because PACE points quite clearly to the dangers of implanting ideas and images in the witness's mind, and because suggestion is more closely associated with photography, then police forces will tend to use face-recall methods before face-recognition methods and not the other way round. A witness would not be asked to look at a photograph and then proceed to generate an image with PhotoFIT or E-FIT. It is interesting in this context that there are more dangers associated with photographs than with computers (and composites).

The computer composites used in facial recall include ComphotoFIT, E-FIT and CD-FIT. ComphotoFIT is a computerised photofit system with a database of gender and racial types. It consists of digitised photographs and like all of the other computer composite systems it has a paint-over facility. It also has a split screen to allow for the display of 'before' and 'after' images. The paint-over facility enables alterations to be made seamlessly and the photographs can be artificially coloured.

E-FIT (electronic facial identification technique) currently has a smaller database than ComphotoFIT but was designed to take account of the psychological aspects of witness recall and suspect identification.

It draws on the psychology research undertaken at Aberdeen University, and uses a syntactic feature-coding system similar to that used in FRAME and based on the notion of the average man (figure 3). It is also designed to take account of the cognitive interview procedure.

CD-FIT is similar in design and has its own portable mug-shot retrieval system, 'Photofile'. This has an image-capture module capable of importing images directly from a video camera situated in a police interview room and filing them on a compact-disc master system.

Despite the extra facilities and witness-friendly capability of computer composites, Shepherd and Ellis remain sceptical about the level of improvement in criminal identification which is actually achieved. Making reference to their own comparative research on PhotoFIT and a computerised system based on PhotoFIT, they conclude that:

> Despite the infinitely greater flexibility of the computer system, it did not produce more accurate composites than the Photofit system. This finding may have occurred as a result of limitations at the witness end which meant that no amount of technical sophistication can improve facial composites, or it may be attributable to the fact that the operators assisting the two groups of subjects had vastly different degrees of experience. (Shepherd and Ellis 1993: 142)

Limitations at the witness end or operator end are not fully overcome by new technologies, the steady advance of which is implicitly attributed to market forces. Shepherd and Ellis maintain that computerised identification systems 'that will attract the attention of police forces throughout the world' continue to be produced despite the fact that they are not proven to be significantly better than earlier, less sophisticated systems like PhotoFIT or Identikit (*ibid.*: 142).

There are, however, other users of such systems whose findings and opinions differ. Detective Sergeant John Royle of Merseyside Police reported that facial recall systems such as E-FIT offer approximately a 30-per-cent successful identification rate and generally offer a better and quicker means of identification than earlier techniques such as PhotoFIT (interview, May 1994). He argues that the speed with which images can be produced and circulated is effective in leading police to a suspect and enabling them to find conclusive corroborative evidence needed for prosecution. He cites several examples where E-FIT has led to successful

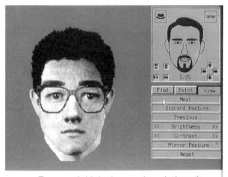

From an initial witness description, the image is defined and items such as glasses added.

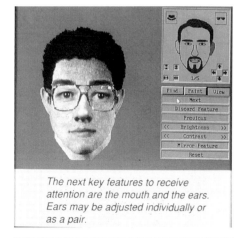

The next key features to receive attention are the mouth and the ears. Ears may be adjusted individually or as a pair.

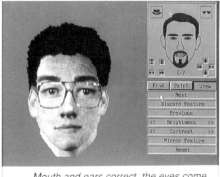

Mouth and ears correct, the eyes come in for attention. They may be moved, re-sized, lightened or darkened.

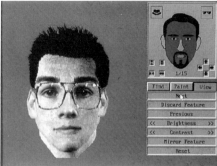

Changes to the hair, followed by the final face shape adjustments completes the image.

Fig. 4 Constructing a face using CD-FIT (above and opposite)

identification, including some in the James Bulger case where witnesses were interviewed using E-FIT and helped to isolate the correct perpetrators of the crime against James Bulger from other possible suspects. The reason why computer systems were not used in other recent high-profile media cases, such as that of the kidnapping of baby Abbie Humphries in Nottingham, July 1994 (where PhotoFIT was used), was attributed to the fact that the Nottingham police force has no composite computer retrieval system. John Royle also pointed to the importance of computer systems which enable users to age the faces of missing persons and so help police in their search for them. What happens here is that photographic portraits are imported into the computer, which averages the features (sometimes with the aid of

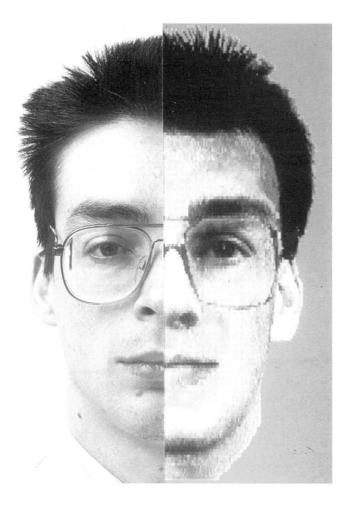

photographs of older family members) and enables the user to age them. This kind of technology has been used in the search for Ben Needham, missing since 24 July 1991 from the island of Kos, where he was on holiday with his family.

Peter Bennett, formerly of the Metropolitan Police and currently developing the E-FIT system, is similarly in no doubt about the value of new imaging technologies to criminal identification, and he is at odds with the view currently held by the police that the role of the eyewitness is limited. He argues that 'police need to realise that eyewitness identification at the beginning of the investigation could lead them to the suspect whilst he is still in possession of property, or there is forensic evidence to prove guilt' (Bennett 1993: 352). He draws his vision of a

totally effective system from that of Bertillon and suggests that the technology is now available to realise it:

> 100 years ago, Bertillon had a vision of a complete suspect identification system, but he lacked the technology to produce it. Today we have the technology, but will we have to wait a further 100 years for police and the security industry to share his vision? (*ibid.*: 352)

Here, technology is cited as the means to overcome limitations in police procedure and limitations of the eyewitness. The criminal body may once again be surrendered to total optical surveillance and control, and technology is regarded as the means of fulfilling a vision of the future.

My own feeling, having experienced both E-FIT and CD-FIT systems firsthand, is more in line with the views expressed by Shepherd and Ellis. The E-FIT system, used in conjuction with the cognitive interview technique (and incorporating the Aberdeen Feature Index, which is geared to actual witness descriptions and based on ten years' research), attempts to be highly witness-friendly. The user manual even incorporates a section on how to 'Revitalise a tired witness'. CD-FIT is certainly user-friendly as a piece of imaging technology (figure 4) but in my role as a pretend witness I found it very difficult to recall a friend's face, let alone a face witnessed in an inevitably stressful crime situation.

These systems undoubtedly produce useful likenesses which help to secure convictions, but they, like other forms of surveillance technology, are no panacea for crime. They are in many fundamental ways similar to earlier and more obviously limited forms of imaging and may be seen as technologically fetishistic (as well as commercially successful) systems which compensate (to an extent) for the failures of the human eye (or subject) and for the persistent ability of the – in this case criminal – object to elude actual, visual and epistemological capture.

Current medical imaging technologies

> In medicine, digitised imaging, particularly in conjunction with CAT scans and ultrasound, is producing a new type of representation of bodily innards. (Rosler 1991: 59)

This new type of representation may be said to be analogical – the most remote new surfaces of the body's interior appearing like pictures from

what if..?
e se..?

Plate 1. Benetton's computer-manipulated image of the Queen, *Guardian*, Saturday 27 March 1993

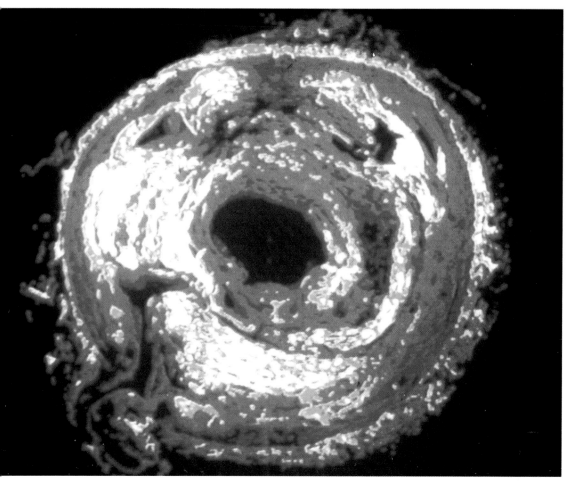

Plate 2. Cross-section of a clogged human artery, from Howard Sochurek, *Medicine's New Vision*, 1988

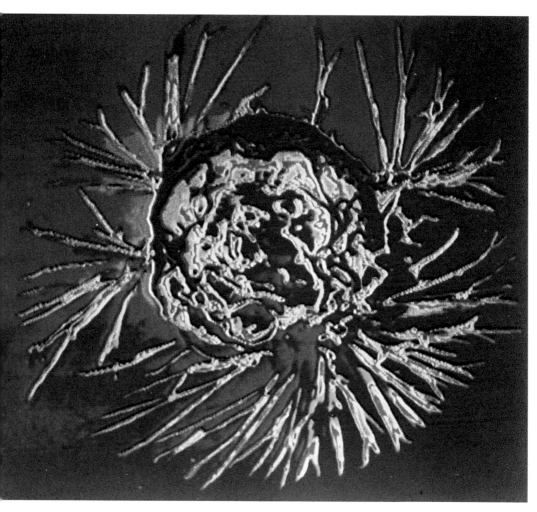

Plate 3. Single cancer cell making up a stellate lesion, from Howard Sochurek, *Medicine's New Vision*, 1988

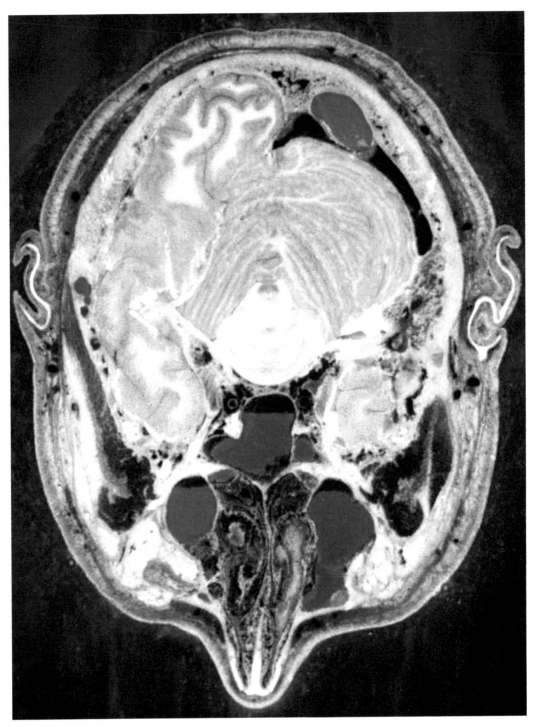

Plate 4. Photograph of Adam's head, Visible Human Project

outer space. An artery can look like a planet, and a cancer cell can look like a star (plates 2 and 3). What is the significance of this to medical epistemology, to the relation between subject and object, or to a culture in which digital and electronic images of the body are proliferating? And what is the significance of the development and implementation of technologies which supersede the capacity of the clinical eye in diagnosis? A recent case history in medical imaging tells of a man who had a brain scan which revealed the presence of a large tumour. A famous brain surgeon looked at the images and prepared to operate, but on opening the skull of the patient he could not see the tumour. Despite the reassurances of an imaging specialist, he declined to continue on the basis that he had been a surgeon for over thirty years and had never removed a tumour he could not see. The imaging specialist insisted on the accuracy of his scan and suggested a biopsy. The biopsy confirmed the presence of a tumour and the surgeon was obliged to operate blind (Sochurek 1988: 20).

Such case histories are not uncommon in contemporary medicine, which is undergoing a period of crisis and transition in anatomical investigation. The crisis is centred on the sovereignty of the empirical eye, which is fetishised in global patterns of analogy just as it is seen to be lost in the fragmentary process of anatomy. What the eye fails to see by opening up bodies is (over)compensated for in the total optical machine of computer imaging, but as a fetish the machine system functions not only as a compensation for, but as a reminder of, this lack.

The technical development of medical imaging began with the digitalisation and computerisation of traditional X-ray techniques, which had not previously changed significantly for the eighty years since their invention by Roentgen. It is continuing now with a process called magnetic resonance imaging (MRI) which is capable of detailing not only the body's anatomy (structure) but also its physiology (function). The body can now be anatomised 'live' and functioning because the process of imaging can replace the practice of dissection in the search for medical knowledge.

Diagnosis is carried out within a massive optical system which literally encloses the body as its object. The body is subjected to the transmission, reflection or emission of energy in the form of radiation. Transmission imaging is centred on the traditional X-ray and its enhanced form known as computed tomography (CT). X-rays are produced when electrons from a single source make contact with a

Fig. 5 Astrological Zodiac and Vein Man, from Harry Bober, 'The Zodiacal Miniature of the Tres
Riches Heures of the Duke of Berry – Its Sources and Meaning', *Journal of the Warburg and
Courtauld Instititues*, vol. 11, 1948

target or receptor made of tungsten. They are directed straight through the body but are absorbed to varying extents. Bone absorbs more of the beam than soft tissue, air or body gas. Obviously, where the X-rays are absorbed there is less exposure or 'shadow' on the receptor film, which then yields a picture of bony structures.

Computed tomography

Where a conventional X-ray film provides a range of twenty to thirty grey-scale variations for interpretation, CT can differentiate over two hundred shades of grey. This is due to an advance in the way the X-rays are taken, and to a process of translation whereby X-ray information is digitalised by computer and then visualised. In CT the body is enclosed within the X-ray mechanism or scanner, which is generally described as 'doughnut-like'. The scanner containing the source and receptor is rotated around the stationary body, penetrating it with a thin, fan-shaped beam which provides a cross-sectional image or 'slice' from any given angle. Conventional radiographs view the body from only one angle and so the shadows of bone, muscle and organs are superimposed.

From a cultural perspective, one of the more important features of computed tomography is that it overcomes the limitations of viewpoint, and also intervenes in the process of interpretation. The transmission of X-rays through the patient is measured with electronic sensors, converted to digital form and then sent to the computer, where the signals are processed by a reconstruction algorithm to yield an image of the anatomy.

The computer provides a matrix of numbers which are used to represent different tissues. The numbers are converted to a specific video grey level and represented at the correct position in the video display. Although the computer can provide two thousand number levels, the human eye can only detect around twenty grey levels, and so data is 'binned' into displayable levels which are controlled by the user in order to optimise visibility. An alternative to this radical concession to the limitations of the human eye is colour enhancement. The eye is reputed to be better at colour perception, being able to differentiate around two hundred colour variants in a spectrum that runs from red to violet. In this case, each number density is assigned a colour in a way which can be either arbitrary or standardised.

CT has significantly improved the imaging of small bones and some soft tissue, but where the details are still represented two-dimensionally,

they can be difficult to conceptualise in three-dimensional form. This has led to the development of three-dimensional reconstructive imaging, whereby all the slices taken of a particular area are reassembled in order to give a more complete view on the screen. The screen object can then be used as a model or simulation of the real object, for example, in reconstructive surgery.

In CT, the search for anatomical detail supersedes any that the human eye/scalpel is capable of and the computer processes of colour enhancement and three-dimensional reconstruction serve as a retrospective concession to the viewer's need for recognisable form. 'Tomography' is the word used to describe the way in which unwanted detail surrounding the target object is eliminated from the scanner's field of vision. It is eliminated by the blurring action of a moving X-ray tube with a fixed focus beam synchronised to a moving film cassette and targeted on a slice of the body as thin as one millimetre. All information of greater or lesser depth is obscured by the movement.

CT and MRI scanners attempt to visualise the invisible, but 'our ability to make pictures is greater than our ability to understand them, and our ability to find problems is greater than our ability to solve them' (Sochurek 1988: 151). Because of this growing disparity, the observer (or imaging specialist) has become part of the observed in the process of diagnosis. Attempts to include the observer in analysis have yielded various methods in the study of image perception, notably the construction of relative operating characteristic curves and concepts of sensitivity and specificity. The observer is incorporated into the computational system as a design fault, or design limitation. The observer's medical skill is, to an extent, conflated with his or her visual literacy and the process of diagnosis is therefore redefined within the field of the computer acting as the clinic.

Performance is measured against an ideal observer who would identify the presence of a subtle lesion wherever it is visually distinct from the background noise pattern. 'Noise' is the term used to describe extraneous information generated by the computer which is unrelated to the diagnostic problem and interferes with interpretation. Ideal observers would be able to detect computer noise and have no internal 'noise' of their own. As it stands, the all-too-human eye of the observer functions as the bug in the machine, and that which signals the fetishistic and compensatory nature of technologically enhanced vision.

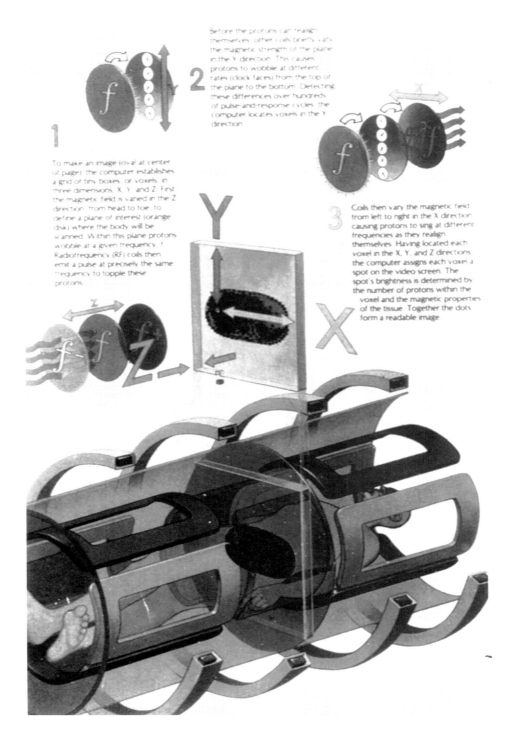

Fig. 6 Diagram of body in MRI scanner, by Davis Meltzer, from Howard Sochurek *Medicine's New Vision*, 1988

Magnetic resonance imaging

Magnetic resonance is a form of emission imaging (reflection imaging is principally characterised by ultrasound, which has been in use for about twenty years and is relatively limited) consisting of a tunnel-like magnet which sets up a magnetic field around the patient, and of image-processing equipment generally similar to that used in CT. The magnetic field causes hydrogen atoms in the body to line up while a radio frequency signal is transmitted briefly in order to upset the uniformity of the formation. When it is turned off, the hydrogen atoms (it is actually the protons which are imaged) return to the line-up and in doing so discharge a small electric current. The computer measures the speed and volume with which the atoms return and translates this information into an image on a screen. Detail can be enhanced using surface coils placed on an exact area of the body, and contrast material introduced intravenously.

Because magnetic resonance does not rely on the detection (by a radiologist) of variations in density on film, and is centred on areas of high water (rather than bone) content, it is able to depict fine details of soft tissue including blood vessels and tumours. According to Howard Sochurek in *Medicine's New Vision* (1988) the use and development of MRI heralds a 'Golden Age' of diagnostic medicine.

Magnetic resonance is shown to be an immensely complex process and one which yields extraordinary images – extraordinary because of their diagnostic accuracy and their aesthetic appeal. In Sochurek's book (1988) and elsewhere[1] the more-than-global dimensions of this imaging process are described in the language of science fiction. The magnetic field is '30,000 times stronger than the earth's', is 'supercooled with liquid helium to minus 452 [degrees]' or '4 [degrees] above the coldest temperature possible anywhere in the universe' and it could 'propel a family car at 100mph'. The whole unit weighs fifteen tons and costs one and a half million pounds to buy. Magnetic resonance is evidently daunting from the point of view of the patient, who experiences considerable noise and must keep very still or be sedated. Nevertheless, the reward is of moving pictures from inside the body, which are used by Sochurek as evidence of the glory of the new scientific order and the redemption of its new scientific object.

Sochurek's book (1988) of colour-enhanced images and imaging techniques is interspersed with narrative – that of his own discovery of diagnostic imaging, and that of his case histories. The young and old,

ordinary working men and women, indigenous subjects and foreigners are all seen to be encompassed by this benevolent, semi-autonomous, extra-global optic machine. Through it, or through having been in it, they are not only cured physically, but reformed morally and transformed aesthetically – on the whole. A soldier turned photojournalist turned documentarist, Sochurek is described in *Photography* magazine (Ang 1988: 30) as 'the epitome of a perfect opportunist' who, on a mission for *Life* magazine, was told to investigate state-of-the-art imaging and 'spent his last buck' on a computer that NASA was throwing out. The computer had been used to process and project information from spy, weather and survey satellites. He used it to tap into the latest advances in diagnostic imaging.

There are significant links between medical and astro-military imaging. Sochurek describes the computer graphics employed in CT as 'similar to those used to reassemble pictures beamed back from distant space probes like Voyager' (*ibid.*). In California, the 'equipment once used to create the mind-boggling effects for movies such as George Lucas' *Star Wars* is now being used to save human lives' (*ibid.*). The Lucas computer designed to process graphic images is apparently sold in modified form to hospitals needing a quickly processed three-dimensional image from their CT scans. Moreover, Sochurek (1988) claims that the Department of Defense (in the United States) has long used image enhancement in evaluating aerial pictures for camouflage detection, and now this equipment is used in medical imaging.

The electronic imaging technologies used in medicine construct a new way of looking at the body in relation to space. But do they structure a new way of knowing the body, or represent a paradigm shift in medical epistemology? These questions will be addressed in chapter 4.

Where photo-mechanical images fragment the body in the process of diagnosis and identification, computer images can re-form the body and, through placing it in an analogical relation with space, make it whole. In this sense, medical epistemology – at least in as far as it is structured through representation – seems to be reincorporating aspects of the medieval concept of microcosm/macrocosm in which the body and the cosmos were analogically mapped. This mapping was represented through figures such as the astrological Zodiac in which the body and the planets were enclosed within a system of concentric spheres, with 'man' at the centre (figure 5).

Sochurek's labelled photographs and annotated drawings of the body lying within the scanner appear to literalise this pre-modern concept, recentring the subject as a stationary object in a rotating global system (figure 6). The revolving scanner corresponds with the celestial spheres as a semi-autonomous universe or scientific heaven. In Sochurek's illustration of a magnetic resonance scanner there is an outer and an inner circle, an external anatomy and a cross-section of the body revealing the inner organs. In place of the primary elements, qualities and humours are the protons, atoms and tissues, and in place of astrological symbols there are biochemical symbols which relate to the body but which are nevertheless independent.

What is at stake is whether medicine's 'new' analogical vision constitutes a different way of knowing the body, and a different relation of power between the subject and object of that knowledge. In other words, is the Foucauldian reading of photography as a panoptic instrument of surveillance also applicable to electronic forms of imaging in medicine? Is the body still subjected to the same monolithic operation of power/knowledge?

Howard Sochurek takes a utopian view of medicine's new visionary status, but within feminist debates on medical science and technology there is a concern with the extent to which imaging technologies facilitate a better form of panopticism and social control.

Note
1 See Channel 4, 'Invasion of the Body Scanners', *Equinox*, November 1989. This is the source for the quotations that follow.

3

Surveillance, technology and crime: the James Bulger case

Media reports on the James Bulger case produced conflicting and often confused ideas about childhood. On one level this can be explained by the extreme nature of the case, which involved the abduction and murder of a two-year-old boy by two ten-year-old boys. Child crime of this nature is rare, and while there are precedents (as in the case of Mary Bell),[1] there are not many. On this level it was difficult to know what to think about children who could do something so shocking.

However extreme the case, neither it nor the images and narratives constructed around it exist in a cultural vacuum. Once located in a wider cultural context, the representation of children in the James Bulger case can be seen to yield certain identifiable discourses – the most notable of which is a discourse of control.

Surveillance images produced by two security cameras which 'captured' the abduction played a central role in the investigation and reporting of the crime. The images were striking not only because of what they showed, but because of how inadequately they showed it. In one image it was hard even to make out the shapes of the children. These were not conventional surveillance images, and they raised issues about control in relation to surveillance technology.

In addition, the whole case became part of a pre-existing moral panic about child crime being out of control, and one of the arguments made in this chapter is that this moral panic is connected to issues about

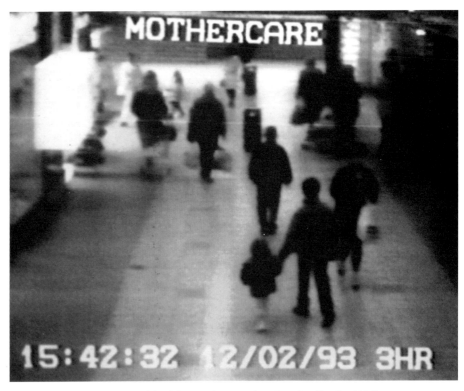

Fig. 7 Security camera image of the abduction of James Bulger, *Guardian*, Tuesday 16 February, 1993

new technology, and the relation between children and technology. In contemporary society, children are perceived not only to be more computer literate than most adults, but to be the perpetrators of computer crimes (teenage hackers) and other excesses including addiction (gameboy junkies). As in the relation between women and technology, that between children and technology seems to unsettle and reformulate ideas about both. In relation to technology, children are seen not as being innocent but as worrying, dangerous, out of control.

The crime against James Bulger was reported in relation to surveillance technology and, less directly, in relation to child crime and computer-game addiction in the Strand shopping centre where the abduction took place. The surveillance images bring up issues of control which are to do not purely with the children and their actions but also with the relation between the surveiller and the surveilled. The surveiller expects to be in a relation of power over what he or she surveilles. The security-camera images in the James Bulger case challenge that power

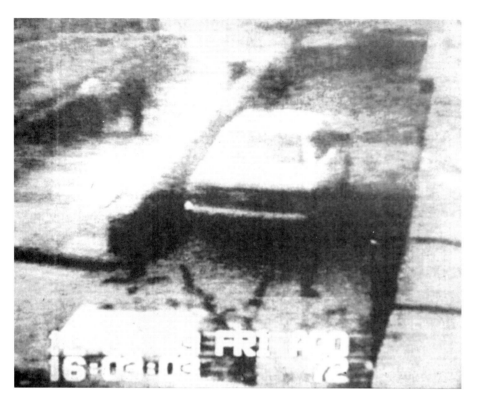

Fig. 8 Still from security camera outside construction firm, *Guardian*, Wednesday 17 February 1993

and present the viewer with a scene and with a subject over which they have no control. It is hard to see what is going on and it is impossible to prevent it – it has already happened.

As in the context of new medical imaging technologies, the challenge to the viewer is not just a technological one – it goes beyond indistinct and unfamiliar images which fail to offer up a visible and docile object. Control is problematised by the gendered and unconscious relation between the viewing subject and the object.

Concepts of gender and sexuality have received little attention in this case. Both here, and in the wider moral panic about children and crime, it is primarily the deviance of boys which is at stake – moreover, the focus is on boys who are approaching adolescence. Concerns about masculinity and sexuality lurk at the margins of the narratives. Only the later reports on the James Bulger case brought up the suggestion that the crime was sexually motivated. James may have been led towards the older boys' den. The attack took place in the dark. James was found

naked from the waist down. A hard object – probably a battery – had been forced into his mouth and possibly into his anus. Earlier reports made no mention of these facts.

Whether or not they were suppressed for legal reasons, there is a sense in which they could not be tolerated in relation to a crime which was already so hard to understand or accept. It is not simply that this case disrupts conventional ideas about what a child is or is not. It also evokes and problematises the adult–child relationship as it exists in both the social and psychic spheres. That relationship is conventionally, though not invariably, a benevolent one in which adult society and its institutions (the law, education, the family) serve to discipline and protect more than to discipline and punish children. In some instances, the reporting of this case shows that in order to punish children severely, to be less benevolent, adult society seems to need to make them sound older (describing them as 'youths' for example) or simply inhuman ('evil' monsters).

This need is in part an unconscious one. The murder of two-year-old James Bulger by two older boys evoked feelings of hatred and anger mixed with those of love and grief. These are powerful yet 'primitive' emotions which characteristically get played out by an infant in the early stages of development (Klein 1988). The emotions are played out in relation to the infant's mother, who, by a process of projection and splitting, is seen alternately as good or bad. Splitting is a defence against the anxiety caused by conflicting emotions.

The James Bulger case recreates anxiety and conflict in relation to children. In this case it is childhood identity which is split in an unconscious scenario in which the adult–child relationship is reversed. Splitting provides for the adult/child a fantasy of control over its other.

The development of imaging technology in the detection and prevention of crime is historically and institutionally related to the development of imaging technology in the detection and prevention of disease. The technology in both institutions developed along the panoptic principle of surveillance and control, and now incorporates both photo-mechanical and computer imaging. The use of computers has not made photography redundant or completely revolutionised representation in a disciplinary context. Medical computer images of the body may look revolutionary, but may also inherit the same desire for knowledge and mastery encoded within photographic images and inscribed in medical

epistemology from the Renaissance onwards. This desire centres on the female body of nature and is never finally fulfilled. Current medical images are marked both by the desire for mastery and by the frustration of that desire.

The surveillance technology used by the police is as varied and advanced as that used in medicine, and its object can be equally evasive. In *The Policing Revolution*, Sarah Manwaring-White (1983) argues that the use of video surveillance and the advance in television technology have not only transformed police methods but extended the role of policing further into the community. Many shops and businesses employ surveillance technology in the attempt to prevent or detect thefts and intrusion. Although there is 'no legislation to cover [the use of] this new type of surveillance' (*ibid.*: 94), video tapes can be accepted as evidence in court. Dandeker (1990) points out how the rise of bureaucratic surveillance is linked to the military, police and business enterprise, and how it generates a degree of conflict between the security and regulation of individuals and communities. When surveillance becomes an intrinsic part of capitalist bureaucracy, its power is at least in part the property of the public, and its role is intended to be pre-emptive.

These issues around surveillance and policing arise in press reports concerning the abduction and murder of James Bulger in February 1993. The case received, and continues to receive, media attention because it figured a violent crime committed against a young child (two years old) by other young children (ten years old at the time). In addition, the children were 'captured' on two different security cameras located in a shopping centre and outside a construction firm. James Bulger was lured away by two boys and later found murdered after he had become separated from his mother in a shopping precinct in Bootle. A security video camera in the precinct recorded James's abduction. The press printed a still showing a small child and an older child holding hands and walking away from the camera (figure 7). They also showed a still from the camera of a construction firm near the shopping centre which shows James apparently struggling or being swung between the two youths who led him away (figure 8). There was little detail on the first reproduced still and virtually no definition on the second. Both needed to be computer enhanced. According to the *Guardian* at least some of the anger aroused by this crime was directed at the overall inadequacy of the recorded images. Journalists wrote about 'heartless security video cameras' and 'the demonstrable fact that such "security" devices are

clearly anything but' (Phillips and Kettle 1993). Another journalist reported on the reactions of one particular local resident speaking on behalf of others:

> We are all totally frustrated. James Bulger didn't belong to his mother, he belonged to the people of Liverpool. Why are those video pictures so crap? Why didn't they go into Dixons and buy one of those home videos [sic] machines? (O'Kane 1993)

This woman expressed the sense of a community which mourned its losses, but which also failed to protect one of its own most vulnerable members. The article which ran this comment is entitled: 'Heysel, Hillsborough and Now This'. The detective who led the investigation was reported as saying 'that he was "horrified" that no one had tried to intervene as James was being taken away' (Sharratt and Myers 1993). Bootle was also a community which felt failed by policing and security methods which were to all intents and purposes designed to protect the owners and perhaps the employees of business enterprise against theft or intrusion. The cameras failed to pre-empt the crime, and although they contributed to the detection of the culprits they could not identify them clearly, and in the manner expected. It is not just a question of poor equipment or the lack of a clear frontal image of the boys' faces. As represented in the reports, this crime seemed to unsettle the whole process of surveillance and classification.

It should be noted that there are marked similarities and some differences in the way in which various papers reported on the crime and on the role of surveillance technology. The differences indicate to an extent the different political agendas of sections of the press. For example, *The Times* consistently employed a narrative of resolution – one which placed emphasis on the role of the authorities in capturing the offenders and in restoring law and order (Tendler and Faux 1993). The role of the surveillance cameras was incorporated into this narrative and suppressed any discourse of anxiety around children and technology. *The Times* acknowledged that the quality of the images – especially the ones taken from the video outside the construction firm – was poor, but once subject to computer enhancement it claimed that they 'have been a vital and unexpected source of information in the investigation of James's murder'. Nevertheless, anxiety creeps in at the margins of this narrative, as, for example, when *The Times* made a link between child crime and children's 'addiction' to computer games:

Police have also visited the video game arcades near the Strand centre, popular with young people who hang around there. Police say that a lot of petty theft takes place in the shopping precinct to finance an addiction for the computer games available in the arcade. Two boys were reported to have accosted an elderly woman in the Strand centre earlier on Friday. (Tendler and Faux 1993)

The *Independent* and *The Times* reproduced the same sets of surveillance images as the *Guardian*, with the *Independent* adding more emotive photographs, including the flowers and toys left near the site of James's death and people mourning. The reporting in the *Independent* was relatively personalised – 'Coroner shaken by details of boy's murder' – and paid attention to the emotional responses of other parents and professionals. A law lecturer from the London School of Economics was reported to have said that the images from the security cameras were one factor which 'had elevated the Bulger murder in the minds of other parents' (Tendler and Faux 1993). The *Independent* reported that the images were of poor quality and added that the space agency NASA had offered its help in the process of image enhancement.

The tabloids also concentrated on the surveillance images and photographs of James, and contributed to the moral panic with headlines such as 'For goodness sake hold tight to your kids' (Troup 1993). The *Daily Mirror* gave quite detailed technical accounts of the first security-camera sighting of the abuction (15 February), which John Stalker writing for the *Sun* described as 'fuzzy' and 'near useless' (16 February). Both papers contrasted the 'cherub-like' face of one of the abductors which finally emerges from these images with the 'evil' crime which had been committed.

The surveillance images of James's abduction disturb the viewer on a number of levels which relate to common notions about children and about this sort of technology. What they actually depict is a familiar scene of protection – a small boy holding hands with older boys. Witnesses thought they were brothers. But we know they were not brothers and that the older boys did the very opposite of protecting James. Child murderers are rare, and it is hard to understand what motivates them. Any attempt to understand their actions forces us to think beyond our normative categories of childhood identity and

behaviour. The images make us the witnesses of a horrible event before it has happened – producing a sense of impotence and guilt. We are in a sense involved but can do nothing because it is already too late. The 'security' cameras have tricked us, have failed to protect James on our behalf and cannot even offer us – capture – a clear image of the culprits. We become angry at a technology which failed to police our own boundaries between who, in society, is responsible and who is not; who is to be protected and who is to be protected against.

In an article on electronic surveillance, Bertrand Giraud (1988) suggests that the process of surveillance effects a means of social control through the construction and regulation of boundaries between the watching and the watched. The efficacy of this means of control is weakened when the boundary is questioned or blurred. Giraud argues that 'to shut out, exclude, map out frontiers' is neither a simple nor a straightforward operation and begs the question of 'who is left within the circle?' and 'who is shut out?' (*ibid.*: 121). According to Giraud, the traditional spatial model of protection is of a centre (fortress or abbey) from its periphery, but modern surveillance technologies have shown this model to be too simplistic. The video cameras installed in shops and supermarkets are as likely to identify losses which stem from internal causes as those from external ones. So 'calling in a security firm often brings its own perverse effects' (*ibid.*: 122). This spatial model of protection depends on a clearly defined interior and exterior, centre and periphery. But:

> How do you shut the sheepfold when the wolf is already inside? ... The circle now becomes a knot, the frontier crossing and recrossing the internal space it has defined. Any simple partition is finished. The centre no longer exists; it has been expelled. (*ibid.*: 122)

Without wishing to detract at all from the individual tragedy of James Bulger's death, this is one aspect of the wider dilemma it raises: how, given the widespread classification of children as centre and interior (as that which society protects, not protects against) does society protect them against each other? When, in the nineteenth century, disciplinary and surveillance institutions and technologies were new, urchins, orphans and petty criminals were shown to be brought back into the fold relatively easily. But the image of the child criminal is now more persistently wolfish. The *Guardian* hesitates to name them as children at

all, tending to advance them in age to the status of 'youths' or adults. Some of the social factors which deprive children of their innocence today were clearly at least as prevalent in the nineteeth century; poverty, deprivation and abuse, for example. There were child murderers then as well as now (and probably as few). One of the key areas which has informed the change in perception has been the relationship children have to the mass media and technology. Of interest here is not the contention that the mass media or technology 'corrupts' children (although this was raised by the judge in the James Bulger trial), but that there is possibly a new alliance being constructed between children and technology which shifts and disrupts the categorisation of both.

In 'Childhood and the Uses of Photography' Patricia Holland describes the relationship between photography and childhood in the nineteenth century as 'the innocent eye in search of the innocent subject' (Holland 1992: 17). These ideologies of innocence developed around the Romantic association of children and nature and the indexical qualities of photography. Holland argues that child poverty was aestheticised and even sexualised, and that an 'iconography of pathos' developed around the poor despite the harshness of their living conditions and treatment in Victorian society. Child criminals had, until this time, been treated in the same way as adults and could be hanged or imprisoned – often for trivial offences. 'Ragged schools' were among the new disciplinary and reformative institutions which helped to establish 'the legal recognition of childhood as a separate state' (Holland and Dewdney 1992: 17). In the nineteenth century, British society became increasingly disciplined and there was an attempt to bring the 'wild children' under control. What is more, children came to symbolise all that was wrong with society and could be put right.

Holland describes how children remain the focal point for social change, and tend to symbolise different qualities in different historical periods. While in the post-war period children tended to symbolise 'stability and cohesion,' by the 1960s 'children are at the cutting edge of progressive consumerism':

> The advertising industry developed an image of exuberant children with mobile bodies and ubiquitous smiles, their desires easily satisfied by the monster in the cereal packet or the latest in sweat shirts and trainers. (Holland 1992: 35)

Holland also points to a nostalgia for the street urchin and a pre-technological age which is 'palpable' in the publications of the Children's Liberation Movement in the 1970s. It is the deconstructive work of photographers such as Jo Spence in the 1970s and 1980s which, according to Holland, brought about photography's loss of innocence. This work realised the constructedness of the medium, critiqued its truth status, and highlighted the relations of power between the photographer and photographed. Jo Spence in particular demonstrated how the image of the child as natural and innocent is an individual, cultural and ultimately commercial fantasy – the privilege of those with the power to represent those who do not have access to the means of self-representation. Photography is seen as a mechanism of power and ideology. What is more, Holland argues that the technological revolution involving computer enhancement and manipulation of photographic images 'makes the idea that photography has a true nature to express even more difficult to sustain' (*ibid.*: 39).

Holland isolates a predominantly domestic image of childhood at the end of the twentieth century: a childhood 'secure in the cosy heart of the family'. She defends the narrowness of this image as a possible and understandable reaction against horrific news images of war and famine. She thereby argues that there is now an iconography of childhood based on the need to protect children from a hostile world. What then of the relation between children and crime, and the way in which a medium which is no longer constructed as being innocent represents it?

Reporting on the crime against James Bulger, the *Guardian* highlights a climate of fear around children and crime – crime committed against children and by children: 'Young people are being simultaneously mourned and demonised' (Phillips and Kettle 1993). There is also a growing perception 'that teenage crime is now utterly out of control', a view supported by the government in its wish to imprison young offenders between twelve and fifteen years of age. Melanie Phillips and Martin Kettle argue that 'the impression is being created' that children and teenagers commit the majority of crimes today and are exploiting a criminal justice system which is reluctant to lock them up. They suggest that the current social climate paints young people 'as the perpetrators, rather than the victims, of a culture of moral degeneracy' (Phillips and Kettle 1993). It is interesting to consider this argument in light of the fact that James's murderers, Robert Thompson and Jon

Venables, were tried and sentenced as if they were adults (old enough to be responsible in law) and were subsequently sent to a juvenile detention centre.

According to the report presented by Phillips and Kettle, the representation of childhood and crime in the media seems to be subject to a process of splitting; on the one hand children are mourned and on the other they are demonised: 'The problem is that few people are prepared to put these two halves of the picture together. The antisocial, delinquent child is – almost always – the abused, damaged or neglected child' (*ibid.*). Melanie Klein (1988) describes the process of splitting in psychological development as a reaction against conflicting emotions. Feelings of love and hatred towards one person or object are difficult to assimilate, and so they may be split and assigned to two people or objects. The splitting process is not fixed and eventually gives way to a process of assimilation which Klein refers to as 'depressive anxiety'. Assimilation is painful and unstable but represents a stage of relatively advanced development or 'psychic reality' within which reparation can be made to the same person or object who is hated (*ibid.*).

As Andrew Ross (1991) has pointed out, technology is also subject to this process of splitting in the way in which it is represented. It too has been idolised and demonised and felt to be out of control. Since children started using computers in school there has been a prevailing notion that they are more computer literate than most adults. An early 1990s *World in Action* programme entitled 'Welcome to the Danger Zone' investigated the idea that children – especially boys – are addicted to computer games, and did little to dispel the mythical association of technology and corruption. A *World in Action* school survey showed that 60 per cent of teenage boys were addicted to computer games and 30 per cent of girls: 'If I couldn't play for like a month I would be so mad I would scream around the house' (girl); 'I would just rip my hair out' (boy). One boy was asked if he had tried out any of the moves he had seen in a fighter game: 'I tried to grab me brother, jump, spin and land ... on him, on his head.' Humorous on some level (at least in the way the comments were presented), this relation between children and technology raises conflicting emotions and reactions about both.

While there can be no doubt that James Bulger was the tragic and totally blameless victim of a horrible crime, the images reproduced in the press follow the process of splitting which is criticised by one of the *Guardian* journalists. The video stills from the shopping precinct and

construction firm represent demonised childhood and technology: threatening, indistinct, illegible and unconventional. In contrast, on the cover page of the tabloid section of the *Guardian* and in virtually all of the other papers is a large family portrait photograph of James (figure 9) (16 February 1993). It is actually quite hard to write about; the knowledge of his death seems to overlay his features, which are those of an attractive small child whose gaze is slightly lowered to avoid the glare of the camera flash and whose expression is if anything quite blank. It is impossible not to read this as the image of the innocent victim which James Bulger was. It says little to nothing of who he was before his death, and rather like Barthes's photograph of a man who is about to be executed it seems to offer a 'certain but fugitive testimony'. Barthes writes:

> The photograph is handsome, as is the boy: that is the studium. But the punctum is: he is going to die. I read at the same time: This will be and this has been; I observe with horror an anterior future of which death is the stake. (Barthes 1980: 96)

The certain testimony of the image is that his death will be and has been. What is fugitive about it, in Barthes's terms, is the death accorded to the photograph itself. Barthes writes about a photograph of his parents together:

> What is it that will be done away with, along with this photograph which yellows, fades, and will someday be thrown out, if not by me – too superstitious for that – at least when I die? Not only 'life' (this was alive, this posed live in front of the lens), but also, sometimes – how to put it? – love. (Barthes 1980: 94)

As a representation of childhood and technology, the image of James Bulger is in every sense opposite to those of his abduction. This photograph inspires love and grief where the others inspire hatred and anger. The moral and legal distinction between James as innocent and his abductors as guilty informs the construction of childhood and technology in these images. Where photography connotes innocence, the computer-enhanced video stills connote guilt. This does not, of course, preclude the use of stills as evidence in law – the authority of images is a measure of the authority of the institution which employs them – but what it does is to facilitate and to consolidate in representation a process

Fig. 9 Photograph of James Bulger, *Guardian*, Tuesday 16 February 1993

of splitting which occurs in relation to the subject, children. This process also occurs in relation to the published photographs of the abductors themselves once they have been found guilty of murder and named. On Thursday 25 November 1993 school photographs of Jon Venables and Robert Thompson were printed on the front page of all of the national daily papers (figure 10). Robert Thompson is the one with the cherub-like face and he is also the one who is supposed to have taken the lead in murdering James Bulger. Jon Venables is presented as being the weak one who was led astray by his friend. Their age and innocent appearance in these photographs cannot be assimilated with their 'evil' act, and the one who appears most innocent is presented as being the most evil. The almost frantic search for social and psychological explanations strives, but does not seem in any way, to bridge this gap. What is evidenced in

Fig. 10 Photographs of Robert Thompson and Jon Venables,
Daily Mirror, Thursday 25 November 1993

the media's use of photography and electronic images in this case is that conflicting attitudes towards children and technology are too difficult and too chaotic to assimilate. Splitting facilitates a semblance of control.

In conclusion, I have argued that media representations of the James Bulger case generated an image of children and technology out of control and presented James's murderers as being decidedly other than the norm in terms of childhood identity and subjectivity. Robert Thompson and Jon Venables were construed as evil, inhuman, monstrous others.

What follows is an analysis of the construction of metaphorical monsters in a medical rather than legal context, and a shift in focus from the subjectivities of children to women. The traditional object of criminal science is masculine and by no means exclusively adult. Boys were the focus of some aspects of the legal reforms in the nineteenth century and there has been a concern with deviance, delinquency and youth since the 1950s. While there is always a degree of media interest in crimes committed by women and girls, they are still not regarded as the 'natural' objects of criminal science. Women are, however, the traditional objects of medicine in so far as nature has historically been feminised. The institutions of medicine and law are linked not least through the construction of discourses and practices of reform and control in relation to their traditional objects, and these discourses

interact with, and inform, the media.

I have argued that the idea of children being out of conrol was conflated with the notion of technology being out of control in representations of the James Bulger case. I also argued that the anxiety provoked by the crime stimulated defensive psycho-social processes of splitting and projection.

The following chapter looks at the conflation of women and technology out of control and at virtual anxiety which is defended against by means of (technological) fetishism and masculine fantasies of omnipotence. In contemporary medical science, particularly reproductive medicine, omnipotence fantasies are concentrated on the quest for autonomous creation and the effective obsolesence of the monstrous maternal body.

Note

1 See Sereny (1995).

4

NITS and NRTS: medical science and the Frankenstein factor

This chapter aims to bring together debates on new imaging and reproductive technologies (NITS and NRTS), and to view them jointly in the light of medicine's desire to father itself. Sarah Franklin points out that 'visualizing and imaging technologies are critical to the theoretical and discursive apparatus of assisted reproduction' (Franklin 1993: 536). Ultrasound scans, laparoscopy and microscopy are some of the technologies she cites as being essential in reproductive medicine, and as being a most effective means for generating ideas and imagery about reproduction in the media. I would add to this by suggesting that the use of NITS in medicine generally (and not necessarily reproductive medicine) is currently creating a sense of reproductive autonomy. Not only do we have scanned images of foetuses which effectively eliminate the mother's body from view (Treichler 1990) and present reproduction as an interaction between the foetus and the doctor, but we have a whole array of imaging processes such as CT, MRI, PET (positron emission tomography) scans and so on which can render the whole or any part of the human body newly visible and newly present to the medical gaze. Medicine can now simulate, capture and seemingly re-create the human body in cyberspace, and this, for me, is another facet of autonomous reproduction.

In a recent television programme entitled 'The Cyborg Cometh' (*Equinox*, Channel 4, 1994) a doctor discussed the technical abilities of

CT and MRI scanners and looked forward to a future in which body scanners would be able to incorporate a complete human being in a computer. In November 1994 the US National Library of Medicine launched the Visible Human Project by putting 'Adam' on the internet. Adam is the name given by the organisers of the project to a complete, electronically scanned and archived male body. More than a year later, Adam was joined by Eve.

In the section of this chapter entitled 'Adam and Eve in cyberspace' I will discuss the Visible Human Project in detail. I will make a comparison between this and the Human Genome Project as two exercises in mapping the whole human body, but I have chosen to focus more closely on the connections between NRTS, the Visible Human Project and the story of Frankenstein. This is partly due to the mechanics of the Visible Human Project. Adam and Eve were created from cut-up and reassembled bodies. Like Dr Frankenstein's creation, they are monsters – only this time, cyborg monsters. The fact that one of the doctors working on the project is called Victor actually has little do to with it. For me, the Visible Human Project, like *Frankenstein*, is a story of autonomous creation and of medicine's attempt to father itself. What is more, *Frankenstein* is a cautionary tale, written by a woman, Mary Shelley. Like the best of current feminist writing on science and technology, *Frankenstein* combines a critique of science and its current or potential abilities with an imaginary tale – or political fiction – which has, at its heart, a sympathy with and care for the (monstrous) other.

Mary Shelley's tale, which has been described as 'the masterpiece of the [Gothic] genre' or 'the cornerstone of another, science fiction', is dystopian (Johnson 1981: vii). It emerges from the context of her discussions with Byron and others about 'galvanism and the reanimation of corpses', and it also derives from her attempt to tell a ghost story. While on holiday near Geneva the Shelleys, Lord Byron and Polidori (Byron's doctor) were forced to spend time indoors due to bad weather. They spent their time reading ghost stories and discussing philosophical ideas such as 'the nature of the principle of life' and 'whether there was any probability of its ever being discovered and communicated' (Johnson 1981: viii).

This party of writers all agreed to tell a ghost story, but Mary Shelley struggled to come up with one until one night when she was disturbed by their discussion of scientific and philosophical ideas. The story of Frankenstein came to her in a state somewhere between sleep

and waking and 'far beyond the usual bounds of reverie' (Johnson 1981: ix). According to Diane Johnson it is 'one of the most complete accounts of the emergence of a literary work from the unconscious into the conscious mind' (*ibid.*: ix). In a preface to the book written for Mary by Percy Shelley in 1817, it becomes clear that *Frankenstein* is a fiction situated between imagination and possibility, and that it is no mere ghost story. Percy Shelley draws on the authority of 'Dr Darwin and some of the physiological writers of Germany' in order to claim that the events on which the story of Frankenstein is based are 'not of impossible occurrence'. Writing as Mary in the preface to the book, he states that although he does not place any serious faith in the story, neither has he (meaning she) simply woven a tale 'of supernatural terrors' (Shelley 1817 in Johnson 1981: xxvii).

The preface goes on to assert that the story 'affords a point of view to the imagination for the delineating of human passions more comprehensive and commanding than any which the ordinary relations of existing events can yield' (*ibid.*: xxvii). So this semi-dream text hovers between two worlds: the social world of human relations and scientific progress, and the world of (the author's) unconcious fears and desires. For Diane Johnson, *Frankenstein* reflects the education, experience and psyche of its author. It also illuminates some modern archetypal anxieties such as family conflict, scepticism about science and technology and 'our sympathy with mankind abandoned by its creator' (Johnson 1981: x).

Frankenstein – like other gothic novels – is resonantly intertextual and informed by many literary references. Mary Shelley's mother was the feminist writer Mary Wollestonecraft and her father the Gothic novelist and political philosopher William Godwin. Through her parents she became familiar with the poetry of the Romantics and with the standard Gothic novels. Milton's *Paradise Lost* was also a major influence, and the story of Frankenstein is on one level another allegory of the Fall which is led as much by a fascination with Satan as by a sympathy for Adam and Eve.

Frankenstein has biographical as well as literary touchstones, and these concern childbirth and loss. Mary Shelley had one child that lived, but suffered a miscarriage and the loss of three children – one of whom died before the book was written. There were suicides and other dramatic deaths in her family – including that of her husband, who drowned in 1822. But it was her experience of successive pregnancies,

childbirth and the death of her children which 'form a central motif of her novel' (Johnson 1981: viii).

In this way, Mary Shelley's dream work, her political fiction is embodied; it is rooted in her own experience and expresses her unconscious and conscious fears and desires. I am inclined to ascribe to it a certain affinity with current feminist political fictions, especially Donna Haraway's dream text 'The Cyborg Manifesto' (in Haraway 1991a). Both are works of the imagination as well as being critiques of science and social relations. Both embody a feminist standpoint on knowledge and power, and both have issues of creation and responsibility at their core. They tell of the emergence of a monstrous creation into a world of hierarchies and social division and are clear about the moral and political consequences of abdicating responsibility for its fate. What Shelley does not imagine, and Haraway does, is a more utopian scenario in which responsibility for the monster is taken and signals a shift or transformation in the terms of scientific knowledge and human relations.

Conversely, what Shelley demonstrates more effectively than Haraway is the unconscious dynamic behind the creation of a monstrous other. *Frankenstein*, like other Gothic novels, deals with issues of repression, splitting and projection.[1] The main characters of the novel represent the human psyche in allegorical form and Johnson argues that they are a way of acting out or dramatising concepts which had no official language at the time, 'although today the language of psychoanalysis would seem appropriate ... for discussing them' (Johnson 1981: xvi).

Repressed desires and unconscious conflicts are explored and acted out in alien places and attics. One of the key tropes of the Gothic novel and certainly of *Frankenstein* is the creation of a double who is the repository of the repressed or undesirable elements of the self. The monster is therefore a split and projected part of ourselves. It can say or do what we may desire but fear to say or do: 'We send our monster to do our work – that which we wish or fear to wish to do ourselves' (Johnson 1981: xvii). The monster in *Frankenstein* may therefore be seen as Victor's other – a split and projected part of himself. It is no coincidence, perhaps, that in the many reworkings of the story in popular culture, he acquires his maker's name but has no name of his own. Frankenstein vacillates in his sense of responsibility for his creation but never assimilates the monster as part of himself. What Mary Shelley

seems to do in the story, partly through her sympathy with the monster and her sense of the injustice done to him, is to approximate an assimilation whereby Frankenstein and the monster seem during the course of the narrative to exchange places. Frankenstein as the embodiment of reason and knowledge becomes increasingly deranged and experiences something like a breakdown. On the other hand, for all his outbursts of destruction, the monster's actions appear to be based on reason and 'fine sensations' (Shelley 1981: 131).

Another way in which Shelley comments on Frankenstein's actions is to demonstrate through the course of the narrative how his failure to take responsibility for his monstrous other leads to tragedy and destruction and is the main cause of his downfall. Certainly, as Johnson suggests, Shelley's sympathy with the devil stems from her Romantic stance on the human condition in nineteenth-century society. Shelley and the Romantic poets admired Milton's Satan and considered him to be the true hero of *Paradise Lost*. Like Satan, the people of the nineteenth century were alienated from God and vengeful because of this (Johnson 1981: xii).

Shelley's monster originally possesses a child-like innocence. He is unlearned, pure, 'natural'. He is corrupted by a society which rejects him and casts him out for no good reason, and only because he is different. The monster embodies Frankenstein's inner 'monstrosity' – aspects of himself which he finds dangerous or unacceptable. The monster, like Dorian Gray's picture, is ugly so that Frankenstein appears beautiful: 'my form is a filthy type of yours, more horrid even from the very resemblance' (Shelley 1981: 115). Shelley shows that it is on account of his appearance, his physical difference, that the monster originally appears monstrous and is rejected by society. He approaches a blind cottager and is received with warmth and sympathy. But when he is seen by the blind man's family he is attacked and driven out. So Shelley's sympathy with the monster is at least in part a sympathy with difference which is normally received in negative terms as monstrosity.

In her chapter on 'Mothers, Monsters and Machines', Rosi Braidotti comments on the negative status of difference within western thought and society: 'it can be argued that Western thought has a logic of binary oppositions that treats difference as that which is other-than the accepted norm' (Braidotti 1994: 78). The monster, she says, 'is the bodily incarnation of difference from the basic human norm; it is a deviant, an anomaly; it is abnormal' (*ibid.*: 78). She also argues that

there is a historical association between women (understood in biological or essentialist terms as mothers) and monsters, which she traces back to Aristotle. In *The Generation of Animals* Aristotle argues that the human norm is male, and so 'in reproduction, when everything goes according to the norm a boy is produced'. A girl only arrives when 'something goes wrong' in the reproductive process, and she then signifies as abnormal or at best 'a variation on the theme of mankind' (*ibid.*: 79).

Women are different and therefore deviant, monstrous, other. Their monstrosity is located in the body and in the biological function of reproduction and childbirth:

> The woman's body can change shape in pregnancy and childbearing; it is therefore capable of defeating the notion of fixed *bodily form,* of visible, recognizable, clear and distinct shapes as that which marks the contours of the body. She is morphologically dubious. (*ibid.*: 80)

Braidotti goes on to argue that 'the female body shares with the monster the privilege of bringing out a unique blend of *fascination and horror'* which 'psychoanalytic theory takes … as the fundamental structure of the mechanism of desire' (*ibid.*: 81). Here she refers to the work of Julia Kristeva and the concept of the maternal body as 'the site of the origin of life and consequently also of the insertion into mortality and death' (*ibid.*: 81). In psychoanalytic terms the mother is the original love object and her body represents 'the threshold of existence'. It is an ambiguous, and in Kristeva's terms 'abject', site of boundaries and bodily fluids, associated with both interior and exterior worlds, unity and separation, life and death. The state of unity with the mother's body gives it the connotations of death, of returning to the womb, of going back to a condition prior to separation and birth into individuality. Freud's Oedipus complex describes 'the psychic and cultural imperative to separate from the mother and accept the Law of the Father' (*ibid.*: 82), but anxiety about the female body as the site of origin is compounded for the male subject through the terms of castration:

> Freud connected this logic of attraction and repulsion to the sight of female genitalia; because there is *nothing to see* in that dark and mysterious region, the imagination goes haywire. Short of losing his head, the male gazer is certainly struck by castration anxiety. (*ibid.*: 82)

In this way, the difference of the female body signifies monstrosity. The connection between women, monsters and machines is made obvious for Braidotti in the context of NRTS where the maternal function is becoming mechanised, and where new cyborg monsters are emerging from experiments in genetic engineering and developments in biotechnology (*ibid.*: 78). Like Treichler, Franklin and others, Braidotti views the relation between women and these technologies with a degree of political urgency, and regards contemporary biotechnology as a conclusive sign of the power of science over women's bodies and as an instance of autonomous reproduction within the masculine scientific community.

In response Braidotti instigates a strategic feminist rethinking of the configuration 'mothers, monsters and machines' and of the concept of difference. In attempting to rethink the status of difference and therefore of women in western society, 'feminists are attempting to redefine the very meaning of thought' (*ibid.*: 94). In order to do this effectively, Braidotti advocates a style of 'epistemic nomadism' which is 'securely anchored in the "inbetween" zones' (*ibid.*: 93) of existing disciplines and academic discourses, and which is also rooted in experience. She insists on retaining a view of NRTS as politically contestable, but contestable in a society with strongly marked gender hierarchies. The contest is made doubly urgent by this imbalance of power and by the 'implosive peak' (*ibid.*: 94) already attained in science's quest to father itself.

Before going on to look at the Visible Human Project as an instance of autonomous reproduction and an illustration of science's desire for omnipotence and immortality, I want to consider in a little more detail the nature of the contest over NITS, NRTS and women's bodies within feminist discourse.

Braidotti makes it clear that her concern with epistemology and epistemological transformations is grounded in a historical materialism. For her, feminism must engage with the presence and the experience of real-life women who seek to change the structure of power in society.

Feminist epistemology has Marxist roots and grew out of the necessity of rethinking foundational but essentialist categories such as 'woman'. The category of woman needed to be divorced from its universalist and biological essence in order to represent adequately the diversity of women's lives and experiences. This of course renders the term inherently unstable and problematic within feminist discourse, and poses problems for the notion of feminism itself. Nevertheless, theorists

such as Braidotti retain a commitment to social change for women understood as a range of existing and potential subjectivities.

To the feminist epistemologist, social change is inseparable from, and indeed premised on, a grass-roots shift in the way in which categories such as 'woman', 'monster' and 'machine' are thought. If we continue to think of women as others and of others as threatening, intolerable or monstrous, then what difference does a development in machinery (for example) make? Will women not be represented and treated in the same way?

If there is no consensus of opinion over the status of the contest over NITS and NRTS in contemporary feminist research (over who is winning), then there seems to be a current of opinion that the nature of the contest is not strictly technological. But where there is a welcome shortage of technological determinism, there would seem to me to be a tendency towards a kind of technohistorical totalism where technology is part of a scenario in which either everything or nothing has changed.

Martha Rosler informs us that 'in medicine, digitised imagery, particularly in conjunction with CAT (Computer Aided Tomography) scans and ultrasound, is producing a new type of representation of bodily innards' (Rosler 1991: 59). Having addressed this in chapter 2, it now seems appropriate to consider what this new type of representation signifies. What is the connection between medical representations and structures of knowledge and power? Are these new too? Barbara Maria Stafford argues that they are, or at least could be, and that 'the marvels of non-invasive body scans are but one small instance in our culture of an undeniable pictorial power for the good' (Stafford 1991: 471). She suggests that they contribute to a shift in Enlightenment epistemology away from an intrusive, dualistic and anatomical model of knowing and towards 'a new and non-reductive model of knowing' which I have argued is analogical. Stafford connects Enlightenment epistemology with patriarchal power but maintains that in the new unified world of electronic imaging:

> the opportunity exists not only to free the image from patriarchal rule, but to liberate other, supposedly lesser orders of being from domination and a false sense of superiority. These 'inferior' forms of nature include any sex other than male, races other than white, creatures other than man, and environments other than industrial or corporative. (*ibid*.: 467)

Against this, Mary Jacobus, Sally Shuttleworth and Evelyn Fox Keller maintain that advances in technology contribute to the perpetuation and indeed fulfilment of Enlightenment structures of domination in modern medicine. They state that 'the last two centuries have witnessed an increasing literalization of one of the dominant metaphors which guided the development of early modern science' (Jacobus *et al.* 1990: 2). The metaphor which has been literalised through technological change and the professionalisation of science is, they suggest, Bacon's metaphor of scientific knowledge 'as the domination of the female body of nature' (*ibid.*: 3). Domination has developed into an explicit material and ideological practice, not least in the context of NRTS:

> Viewed as medical events, pregnancy and childbirth can be monitored and controlled by the latest technology, while in the laboratory, women's role in reproduction is increasingly open to question; IVF [*in vitro* fertilisation] and the burgeoning of genetic engineering offer to fulfil, with undreamt of specificity, earlier visions of science as the virile domination of the female body of nature. (*ibid.*: 3)

The authors point out that the reproductive autonomy of science is based on its construction of the female body as an inefficient mechanism of both production and reproduction. Science legitimises its practices on the basis that technology is merely helping or correcting deficiencies in nature. Technology therefore acquires 'the agency and [re]productive powers previously assigned only to human life'.

But, at the point where technology appears to be taking over the reproductive role of women, a new anxiety appears to arise within both medical and popular discourse and representation. If technological autonomy is already based on a fear of the maternal body and a construction of it as faulty, then, according to Mary Ann Doane, this fearful and faulty body may appear to infect the technology which is there to correct and control it. Where the promise of technology is to 'control, supervise, regulate' and 'limit' the maternal more strictly than any other means, it always fails to a certain extent. The threat of the maternal body lingers on and generates the fear that 'the maternal will contaminate the technological' (Doane 1990: 170).

Alternatively, Sarah Franklin argues that if the female body is regarded as being finally and fully delimited and controlled, then science and technology lack what she calls the 'foundational authority' of

nature – the status of being absolute, certain or real. Rather, 'the absolute provided by the belief in technological enablement, or scientific progress, is the promise of unbounded possibilities' (Franklin 1993: 541).

Either way, the authority of science and its epistemological categories (subject/object, nature/culture) is threatened, and the result according to both Doane and Franklin is a proliferation of anxiety-ridden images of bodies and machines in popular culture and particularly science fiction films such as *Alien* (*1, 2, 3* or *Resurrection*) where we are presented with the almost archetypal monstrous mother-machine.

For me, Constance Penley most accurately identifies the current status of bodies and machines in institutional and popular discourse by suggesting that there is a 'frequent conflation of women-out-of-control with technology-out-of-control' (Penley 1992: 180). She argues that the proliferation of stories and jokes about Christa McAuliffe, the school teacher killed in the 1986 *Challenger* explosion, is a key case in point. According to Penley, the story of Christa McAuliffe (partly because of what is not known about the disaster) 'has become densely inscribed in science fictional, mythical, folkloric, and ideological narratives about women, space, and catastrophe' (*ibid.*: 194). But at the same time she asks: 'How might some of these narratives be rewritten to shift or reshape their figuration of the woman as the embodiment of technological disaster, as someone who has no place in space?' (*ibid.*: 194). In answer to this she suggests that science, in this case NASA, ends its secrecy and allows all mourners to have empirical knowledge of the disaster so that a process of renarrativisation might take place. Penley points out that she is not opposing fantasy and fact but: 'Rather the issue is to demand better science while acknowledging the work of fantasy in everyday life, popular culture, and scientific practice, and recognizing that one can get at the empirical only through understanding the omnipresence of fantasmatic thought' (*ibid.*: 195).

The relation between feminist figurations and the demand for a better science will be discussed in the next chapter, but for the moment I want to pause on the point about acknowledging the work of fantasy in scientific, popular and everyday discourse. I want to suggest that the presence of the unconscious, of fantasy and particularly of anxiety is one factor which undermines the totality of scientific achievement in Enlightenment terms. Anxiety is precisely about subjects (not objects)

being or feeling uncontained and out of control. I would maintain that the construction of ideas and images about women and technology being out of control is a projection from the masculine subject's unconscious and there is no place for the unconscious, irrational *subject* in Enlightenment discourse. Where the presence of the unconscious acts as a form of resistance or at least sabotage, there is also the presence of conscious acts of resistance to scientific authority and inscription – acted out invariably by those who consider themselves to be at the receiving end of it. In two issues of *Camera Obscura*, the editors Paula A. Treichler and Lisa Cartwright (1992) incorporate work on various forms of political and representational activism against dominant medical inscriptions. Contributors look at how imaging (and reproductive) technologies 'are internally critiqued and retooled to produce technological innovations, to cultivate counterpractices, or to interrogate and disrupt institutional discourses of science and medicine' (Treichler and Cartwright 1992: 6, 28). A notable example is that of AIDS activism which incorporates practices of self-representation.

With these two forms of resistance in mind I want to argue that the prospect of a fully autonomous reproductive science and technology is a patriarchal fantasy which is enacted or acted out to an inevitably limited degree in the face of women's persistent ability to have children and in response to an ongoing and ever-present fear of the female body read in the essentialist terms of its maternal function. The fantasy of fathering offspring without women is a defence against the anxiety provoked by the ultimate limitation placed on this desire.

In the same way I will go on to argue that the re-creation of Adam and Eve in cyberspace is also an omnipotence fantasy enacted in the face of medicine's generative limitations and by means of a fetishistic use of technology. New imaging and reproductive technologies may be seen to compensate as much for a paternal lack (the inability to produce children) as for a maternal threat, but as Mary Ann Doane makes clear, the link between technological fetishism and the female body is a crucial one: 'Technological fetishism, through its alliance of technology with a process of concealing and revealing lack, is theoretically returned to the body of the mother' (Doane 1990: 174). Paradoxically, where the maternal body is feared it is also desired because it is 'the one site of certain origin' (Braidotti 1994: 90) and offers 'a certain amount of epistemological comfort' (Doane 1990: 175). The mother 'guarantees, at one level, the possibility of certitude in historical knowledge. Without

her, the story of origins vacillates, narrative vacillates' (*ibid*.: 175). And as Braidotti points out, 'psychoanalysts like Lacan and Irigaray argue that the epistem(ophil)ic question of the origin lies at the heart of *all* scientific investigation' (Braidotti 1994: 84).

So the mother's body will never be finally erased from the material, ideological or epistemological practices of contemporary science and (bio)technology because they cannot properly exist without it. It might, however, be argued that science has so far problematised and sought to erase the function of the maternal body that fears and desires which originally belong to it are experienced through forms of technophobia and technophilia respectively.

Fears and desires, technophobia and technophilia, are effectively the two sides of the same coin. The Visible Human Project and the Human Genome Project seem to me to be driven by an intensely ambitious desire to know, which combines a mixture of fear and fascination because 'The desire to know is, like all desires, related to the problem of representing one's origin, of answering the most childish and consequently fundamental of questions: "where did I come from?"' (*ibid*.: 90). What is more, according to Braidotti, scientific knowledge is actually 'an extremely perverted version of that original question'. For her, the desire for knowledge is related to primitive sadistic and scopophilic drives. The scientist wants to go and see how something works, but is also like 'the anxious little child who pulls apart his favourite toy to see how it's made inside' (*ibid*.: 90). Scientific knowledge is thus motivated by voyeurism and aggression towards the natural object.

Adam and Eve in cyberspace

The Visible Human Project uses state-of-the-art imaging technologies in a pioneering scheme to obtain a complete visual archive of the male and female body for medical research and training. In order to obtain the archive, the male body, nicknamed Adam, was scanned, sliced up and photographed at one-millimetre intervals and then recreated in cyberspace. For the purpose of better image resolution, Eve was subsequently put through the same process at one-third-of-a-millimetre intervals.

The project originated in the National Library of Medicine's (NLM's) 1986 Long-Range Plan, which recommended that the library

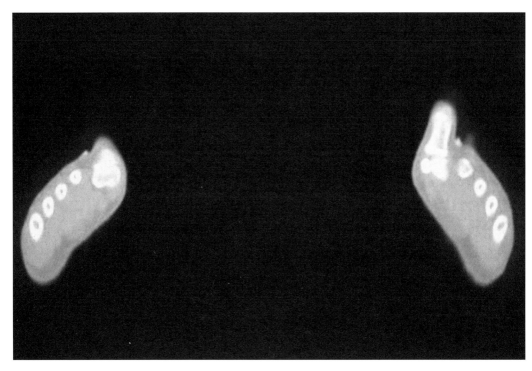

Fig. 11 CT scan of Adam's feet, Visible Human Project

should 'thoroughly and systematically investigate the technical requirements for and feasibility of instituting a biomedical images library' (NLM 1993). The image library would complement the library's stock of medical textbooks and would consist of digital images which could be distributed over high-speed computer networks. In 1989 a planning panel on electronic image libraries was formed and this recommended that 'NLM should undertake a first project building a digital image library of volumetric data representing a complete, normal adult male and female.' The Visible Human Project should 'include digitized photographic images for cryosectioning, digital images derived from computerized tomographic and digital magnetic resonance images of cadavers' (*ibid.*).

The candidates for the project were chosen with care, or as one journalist put it, they 'had to meet some pretty stiff requirements' (Kluger 1993). The criteria for 'normality' were set at being between twenty and sixty years of age, average weight for height, under six feet tall and without any visible abnormalities or significant surgery. They

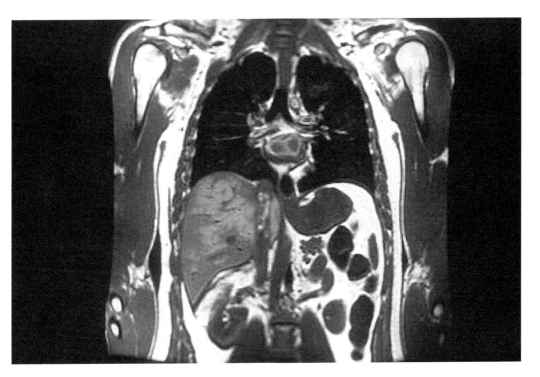

Fig. 12 MRI scan of Adam's abdomen, Visible Human Project

had to have died a 'non-violent' death so that the appearance of their bodies was not affected, and it was intended that they should remain anonymous.[2] The criteria did not cover the racial identity of prospective candidates, but it is consistent with a discourse of normalisation that the people who were chosen to play the role of both Adam and Eve were white. It is clear that this preference for whiteness was unstated and, arguably, taken for granted.

The contract for Adam and Eve was awarded to Dr Victor Spitzer and Dr David Whitlock at the University of Colorado. Dr Spitzer outlined Adam and Eve's principle role and the aptness of their nicknames: 'the bodies chosen for this project will become the archetypes for the human form. They'll be used for research and study for years to come' (*ibid.*).

Adam was scanned at one-millimetre cross-sectional intervals first as a fresh and then as a frozen corpse by CT (figure 11). The MRI scans were longitudinal (figure 12). In order to obtain photographs at the same interval, he was frozen to minus seventy degrees centigrade,

immersed in gelatin, cut into four sections and put through an industrial planer. Photographs were taken as each new surface was exposed (plate 4): 'We want to be as thorough as possible', Dr Spitzer said during the course of the project (Kluger 1993). The 1,878 computed tomography scans and congruent colour photographs can be restacked to define the human body in three dimensions and at every location in space. Body parts as small as blood vessels can be isolated and seen from any angle without visual obstruction.

So Adam and Eve are now available on the Internet and on digital audio tape as vast amounts (approximately twenty-one gigabytes or the equivalent of 35 CD-Roms for Adam alone) of raw data. It would take around two weeks to download Adam in his entirety (and presumably three times longer for Eve), and unless you were already trained in anatomy it would be hard to know what you were looking at. The Visible Human data set is as yet an unclassified, unlabelled archive, and the NLM is seeking a computer program which can outline and annotate Adam and Eve's organs. Recalling for a moment Bertillon's experience of classification and photography, it seems that once again (but now in the context of digital imaging) we have 'the fundamental problem of the archive, the problem of volume' (Sekula 1989: 358).

The current stage of the project entails the process of anatomical classification and annotation of the data. From there, the aim 'is to produce a system of knowledge structures that will transparently link the visual knowledge forms to symbolic knowledge formats' (NLM 1993). A method is needed for linking images to names and other textual information, and the project is considering the use of hypermedia 'where words can be used to find pictures, and pictures can be used as an index into relevant text'. There is as yet no method for linking image and text-based anatomical information or for linking structural/anatomical to functional/physiological knowledge, but the goal of the project 'is to make the print library and the image library a single, unified resource for medical information' (ibid.).

The applications of the Visible Human Data Set begin to sound futuristic, if not apocalyptic, quite quickly. They range from identifying anatomical structures on the cross-sections to ending the need for the practice of pathological anatomy and achieving 'interactive total body control and simulation (including simultaneous modeling of all the synergistic and antagonistic muscle motions)'. In other words, the project points the way towards virtual medicine and has started

investigating ways of simulating realistic muscle movement and resistance using Adam as a 'unique source of real human anatomy'. It is likely to be in the area of surgical simulation and three-dimensional reconstruction that Adam and Eve will come in to their own, and where virtual medicine will emerge. Though research is ongoing, virtual medicine is still a step or two away:

> For one thing, the three-dimensional images are nowhere near sharp enough. For another, though impressive, the speed with which they can be manipulated – turned, sectioned, coloured, made transparent or stripped away – still leaves a lot to be desired. (*Economist*, 5 March 1994)

As an exercise in advanced imaging, the Visible Human Project prefigures an era of virtual medicine which will undoubtedly arrive, and in doing so mark another milestone in scientific progress. But the project does not leave all of the old technologies (or values) behind. Photography still has a key role to play in the establishment of this archive, and the archive has been and is being constructed using many of the values that informed the earliest attempts at visually documenting and classifying the human form.

Dr Michael Ackerman, project organiser at the NLM, pointed out that all of the digital data is transferred onto photographic film because film provides greater image resolution and storage capacity even though it is less effective at retrieval and distribution (interview, September 1994). For him, film is the ultimate archival unit and as such all film produced for the project is kept in a vault.

As a computer imaging and archiving project, the Visible Human Project demonstrates that photography is far from dead. Neither are the ideologies of the earliest photographic projects aimed at archiving the human body. It is clear that the selection of Adam and Eve was typological and subject to a process of normalisation. Where Adam represents the average man, Eve represents the average woman. They are therefore (again) fictional archetypes against which (real) others will be measured and defined.

As R. C. Lewontin points out in 'The Dream of the Human Genome' (1994), the Human Genome Project is also premised on a concept of the average man and sets standards for normalisation. This project aims to map 'the complete ordered sequence of As, Ts, Cs and Gs – the four nucleotides – that make up all the genes in the human

genome' (Lewontin 1994: 107), and like the Visible Human Project will generate a huge archive of information or 'a string of letters that will be three billion elements long' (*ibid.*: 108).

Information about the human genome is intended for use in isolating and eliminating defective genes and gene disorders such as cystic fibrosis. But Lewontin suggests that a knowledge of DNA sequence does not necessarily help in tracing the cause of a disorder and therefore in generating a cure. Beyond the limitations of a diagnostic approach at this level, he points to the wider problem of biological determinism which surrounds the project:

> The medical model that begins, for example with a genetic explanation of the extensive and irreversible degeneration of the central nervous system characteristic of Huntington's chorea, may end with an explanation of human intelligence, of how much people drink, how intolerable they find the social condition of their lives, whom they choose as sexual partners, and whether they get sick on the job. A medical model of all human variation makes a medical model of normality, including social normality, and dictates that we preemptively or through subsequent corrective therapy bring into line anyone who deviates from that norm. (*ibid.*: 111)

The Human Genome Project may become continuous with the ideology of eugenics and may also be said to be in keeping with a wider manifestation of biological determinism in contemporary technoscientific culture.[3] But if DNA sequences do not determine the cause of physical or social ills, then what else might this huge quest for knowledge be about? It might be argued that the project is cloaked in metaphysics and 'the conviction that DNA contains the secret of human life' (*ibid.*: 108).

A successful attempt to map the human genome and 'compute the organism' (*ibid.*: 109) would therefore lead scientists to enlightenment and beyond. Rather like re-creating Adam and Eve in cyberspace, discovering the human genome is something of a god-like act. In literary terms (and from Satan to Faustus to Frankenstein), when men act like gods they are called overreachers, and as Lewontin suggests, those who have sought to know the secret of life 'have exchanged something a good deal more precious' (*ibid.*: 109) than time and effort or power and money.

'Prepare to hear of occurrences which are usually deemed marvellous'

Rather like the story of Frankenstein, the Visible Human Project and the Human Genome Project illustrate the 'omnipresence of fantasmatic thought' in science, or rather, they demonstrate that the realms of fact and fantasy are co-existent. A piece of Gothic fiction, a state-of-the-art medical imaging project and a pioneering exercise in biotechnology would appear to be driven by a similar metaphysics and to exist in the perhaps not so separate worlds of science and the supernatural, the social and the psychic. Where the Visible Human Project clearly represents progress in medical research and will undoubtedly benefit human life, it is also, I would suggest, the epitome of what Donna Haraway (1991b) refers to as the 'god-trick'. It would seem to be a product of infinite vision and can be said to express an unconscious desire for omnipotence, immortality and transcendence. In terms of the relationship between medical science and the human body, the project represents everything seen from nowhere. It is the product of a disembodied knowledge and power. The organisers of the project have recreated Adam and Eve in cyberspace without a trace of self-consciousness or irony, but with a rather contagious and uneasy fascination with the more macabre aspects of the process and an obvious sense of technological achievement. With the right technology anyone can download the sample data set from the Visible Human Project, and it is necessary only to sign a licence agreement with the NLM in order to publish or reproduce the images. Given the level of excitement and expectation concerning the Internet within medicine and elsewhere, there is a sense in which Adam and Eve will be set loose in a technological Eden. Who or what is responsible for their fate has yet to be determined, as the library's primary objective has been fulfilled and they are now set to be parcelled off into various commercial ventures which can further develop and promote their potential. Adam and Eve may signal the start of a new race in cyberspace, as there have been suggestions of cyborg offspring.

So in the Visible Human Project medical science would seem to have pulled off the god-trick of infinite vision, and simulated autonomous creation. I want now to return to *Frankenstein* in order to develop the notion of autonomous creation as a fantasy enacted in the face of generative limitations and a fear of the female body. As it is a

fantasy which is also enacted by means of technological fetishism, however, I want to suggest that Dr Frankensteins everywhere are inevitably returned to the point of origin and that their fears and fascinations ultimately concern the mother's body even if they come to be expressed as fears and fascinations about science and technology itself.

Frankenstein tells his story in order to prevent the downfall of another potential overreacher who is on a mission of discovery to the North Pole and will stop at nothing in order to 'boldly go where no man has gone before', to confer 'inestimable benefit' on mankind and to 'accomplish some great purpose'. Frankenstein tells Walton that 'knowledge and wisdom' can be 'a serpent to sting you' and he begins his story at the beginning – with his origins and his mother (a 'virtuous woman'). He describes his early quest for knowledge in terms that are both sadistic and sexual. His interest in the world was of the 'rip it apart and see how it works' variety, which is contrasted with Elizabeth's, his 'more than sister' and soon to be wife's, gentle contemplations. He describes it as a channel for his anger which elevates him to the realms of metaphysics:

> My temper was sometimes violent, and my passions vehement; but by some law in my temperament they were turned not towards childish pursuits but to an eager desire to learn, and not to learn all things indiscriminately ... It was the secrets of heaven and earth that I desired to learn ... my inquiries were directed to the metaphysical, or in the highest sense, the physical secrets of the world. (Shelley 1981: 23)

Frankenstein also tells of the birth of a passion which arose 'from ignoble and almost forgotten sources ... swelling as it proceeded' until it 'became the torment which, in its course, has swept away all my hopes and joys' (*ibid*.: 24). Knowledge and desire are presented as being linked at the point of his origin. He is specific about the nature of the scientific knowledge which engages him, describing it ultimately as a bringing together of pre-modern (alchemical) science and its lofty metaphysical leanings with the mechanical and instrumental science of the Enlightenment. Frankenstein completes his education away from home and after his mother's death. He resolves to 'pioneer a new way' and while training himself in anatomy and observing 'the natural decay and corruption of the human body' he succeeds in 'discovering the cause of

generation and life', and moreover finds himself 'capable of bestowing animation upon lifeless matter' (*ibid.*: 37). Frankenstein performs his god-trick in an attic but is clearly optimistic about the outcome at this stage: 'A new species would bless me as its creator and source; many happy and excellent natures would owe their being to me. No father could claim the gratitude of his child so completely as I should deserve theirs' (*ibid.*: 39). But he rather changes his mind once his ambition has been achieved and desire gives way to disgust: 'I had desired it with an ardour that far exceeded moderation; but now that I had finished, the beauty of the dream vanished, and breathless horror and disgust filled my heart' (*ibid.*: 42). Frankenstein shuts himself in his bedroom, dreams of embracing his lover who turns into his dead mother, and wakes up to find his very own monstrous creation at the side of his bed. Frankenstein reacts by running away, and his life deteriorates from this point onwards. His brother is murdered, he becomes a bit unhinged, but the monster returns to him with reasonable demands and criticisms and gives him another opportunity to take responsibility for his creation:

> I ought to be thy Adam, but I am rather the fallen angel, whom thou drivest from joy for no misdead. Everywhere I see bliss, from which I alone am irrevocably excluded. I was benevolent and good; misery made me a fiend. Make me happy, and I shall again be virtuous. (Shelley 1981: 84)

When the Satanic monster who should be Adam demands his Eve, Frankenstein agrees to create her. He delays his own wedding until he has done so, but having put her together he tears her apart again in front of the monster and without ever having given her life. The monster, not well pleased, warns him that 'I shall be with you on your wedding-night' (*ibid.*: 153). When that 'dreadful, very dreadful' night arrives (*ibid.*: 178), so does the monster, who kills Elizabeth before the marriage is consummated. From here, Victor pursues his monster to the death. He dies on the completion of his account to Walton and with the final admonition to 'Seek happiness in tranquility and avoid ambition, even if it be only the apparently innocent one of distinguishing yourself in science and discoveries' (*ibid.*: 200).

Science and knowledge in themselves appear to be what Frankenstein desires, then fears. They are the source of his sexual passion and his lesson to Walton. But the movement between desire and fear can be traced in the narrative by the love and loss of his mother and

his lover (who are interchangeable in his dream). The loss of his beloved mother prefigures his act of scientific creation and the loss of Elizabeth signals his/its final destruction. As his double, the monster embodies not merely Victor's scientific ambitions but his unconscious relation to the two central women characters – his wish to restore his mother to life and to prevent sexual contact with Elizabeth. It is Elizabeth who represents the maternal function of the female body in the narrative. It is she who could conceive. Victor's mother, having raised him, adopts an orphan – Elizabeth – and provides him with a substitute m/other in this way. The monster's destruction of Elizabeth on their wedding night is mirrored and prefigured by Frankenstein's destruction of Eve – the monster's bride-to-be. Frankenstein's act of autonomous fathering, his creation of the monster, is therefore accounted for in part by his wish to avoid involving a woman in the process of reproduction.

It is the monster, as Victor's other, who most clearly expresses and exposes the nature of scientific obsession and its connection to the question of origins. The monster is able to answer the question 'who am I, where did I come from?' by reading the papers in Frankenstein's journal:

> Everything is related in them which bears reference to my accursed origin; the whole detail of that series of disgusting circumstances which produced it is set in view; the minutest description of my odious and loathsome person is given, in language which painted your own horrors and rendered mine indelible. I sickened as I read. 'Hateful day when I received life!' I exclaimed in agony. 'Accursed creator! Why did you form a monster so hideous that even *you* turned from me in disgust?' (Shelley 1981: 115)

But the monster can answer the question of origins because he is a product of scientific creation – because he was created by men. In this sense he speaks the voice of difference, he speaks as the monstrous (feminine) other, and questions why he was constructed as such. Shelley's sympathy with the monster is most evident at this point, and it is from here that she imagines but is forced to reject a scenario in which Frankenstein accepts his monster as himself, and in which difference might be tolerated in society.

Conclusion

By using the story of Frankenstein in my analysis of NITS and NRTS, I have attempted to underline the interaction between science and myth, fact and fantasy, and to raise the issues of creation and responsibility which surround the relationship between self and other in this context. The Gothic novel offers the useful trope of the double – the other or monster who is clearly related to the central character (or self) of the novel. When faced with the dominant configuration of the monstrous mother–machine, and with feminist attempts to reconfigure the relationship between women and technology, it seems to me to be important to remember and acknowledge that what we construct as monstrous and other refers directly to a split-off and projected part of ourselves. The enduring tale of Frankenstein's monster leads us reliably back from a preoccupation with the fascinating and fearsome creations of science to the masculine scientific subject who made them so.

In the following chapter I explore the idea of a feminist figuration; an image, myth or metaphor such as the cyborg which redefines the relationship between women and technology and which occupies the position of both self and other, subject and object of technoscientific knowledge and practice. I also refer to another Gothic horror, Dracula, in order to present the vampire as a semi-serious feminist figuration of the monstrous, desiring self (not other).

Notes

1 For example, James Hogg's *The Private Memoirs and Confessions of a Justified Sinner* (1983) and *Dr Jekyll and Mr Hyde* (Stevenson 1987), where splitting and projection lead to the creation of the double or alter ego. Oscar Wilde's *The Picture of Dorian Gray* (1980) is another case in point.

2 But due to media interest, 'Adam' has been revealed as Joseph Jernigan, who was executed by lethal injection for the crime of murder in Texas, 1993. 'Eve', as yet unnamed, died of a heart attack at the age of 57.

3 I am thinking of Andrew Ross's work on social Darwinism in North America (1994), Kevin Kelly's new biology of machines (1994) and the critical analysis of Darwinian theories of art and technology by, for example, Tiziana Terranova and Simon Penny, in Berland and Kember (1996).

5

'The blood is the life': cybersubjects and the myth of the vampire

Life, undeath and a Satanic view of technology

> Despite all the confident extrapolations of techno-futurists (and the dystopian fantasies too), technology hardly ever works – not the way you want, at least. Privately everyone knows this, but officially you can always overlook it by the selective perception with which I have endowed you. Technology is all about learning to forget things, so that I can remind you of them later. (Satan in Dexter 1996: 296)

In his engaging '(forked) tailpiece' to *FutureNatural*, Frank Dexter sets up an interview with Satan in order to discuss the future of nature and technology, and the meaning of life in general. In this Satan reveals that technological determinism is a fantasy based on our futile attempts to predict and control the future. For the devil (or through the devil) technology helps us to forget what we already know. Knowledge here is of course inevitably related to sin and consequent pain, suffering, torment and so on. Technology is then a means of denial which, like other means, is effective until the point at which its strategic value (psychological or social) is recognised – or exposed.

When asked to expand his views on technology, Satan comments on

how it is facilitating the elision of life and information, and will ultimately – under his direction – replace life with a kind of undeath or individualised hell on earth. I think he is worth quoting at length here:

> What I'm working on at the moment is phasing out Life into something new. Until recently living has been a necessary preparatory phase for being dead, a period for programming in all the information and experience you need for the afterlife. Now it's becoming technically obsolete. With the new levels of acceleration available, it hardly takes any time at all to download an individually-customised eternal damnation package. So, it's no longer necessary for people to be 'alive', strictly speaking, before dying.
>
> *This is the Virtual Hell we've heard so much about?*
>
> That's right. (Dexter 1996: 301)

Virtual hell is where 'the mind will be able to inhabit a reality entirely of its own making', and this of course is 'what the old Hell was really all about; living forever with everything you wanted to forget' (*ibid.*: 301).

This chapter is about life and undeath seen from the perspective of a Satanic view of technology. Satan, in this case, is what Andrew Ross might refer to as a technosceptic: 'technoscepticism, while not a *sufficient* condition for social change, is nonetheless a *necessary* condition'. Satan is happily 'eroding the legitimacy of those cultural values that prepare the way for new technological developments: values and principles such as the inevitability of material progress ... and the linear juggernaut of liberal Enlightenment rationality' (Ross 1991: 98). As a technosceptic, Satan also recognises the rootedness of ideologies and technologies 'in the structure of popular needs and desires' and in 'already existing intentions and demands that may be perceived as "subjective"' (*ibid.*: 98).

However, Satan being Satan has no investment in social change. He rarely gives interviews and generally keeps his scepticism to himself, preferring the fulfilment of the Enlightenment project (whose practice is technology) as the means of acquiring the maximum number of souls.

In this chapter, I want to examine the elision of life and information in contemporary debates on technology by using the myth of the vampire – or the undead. For me, this elision occurs by means of the

suspension of scepticism and perhaps through a collective undeath wish (a desire to go to virtual hell).

The distinction between life and information has collapsed in the 1990s through the idea of synergism or connectionism, which is derived from the biological and computer sciences (particularly artificial intelligence and artificial life research) and maintains that complex systems such as minds and machines are connected by the way in which they are organised, evolve and process information. Connectionism is the context in which 'economics, organisms, and ecosystems can equally be studied, defined and researched as self-organising assemblages' (Plant 1996: 210). Connectionism breaks down the boundaries between natural systems such as organisms, and socially constructed systems such as economies, and looks at the processes which are common to both. The most significant of these processes appear to be learning or intelligence, and evolution. What is more, the fact that these processes are 'piecemeal, discontinuous and bottom up' is central to the theoretical and anti-political stance of connectionism (Plant 1996: 210). I am referring to the anti-politics of connectionism because it seems to me that it essentially proclaims the autonomy of organic and inorganic systems from external, socio-historical forms of control. It is able to do this because it accepts that the concept of evolution can be transferred from organisms to computers (the basis of artificial life research), and has then gone on to apply it to social systems where it functions as a universal metaphor for change.

I am interested in relating the contemporary idea of connectionism back to the discourse of contagion which prevailed during the late 1980s. The discourse of contagion was centred on hacking and the transmission of computer viruses. There may seem to be an ideological transformation in the shift from contagion to connectionism (between fearing and desiring to connect systems), but it seems to me that this requires further analysis not least because both concepts carry connotations of intersubjective relations and of the absolute fluidity of information (its disrespect for boundaries). If information is to be regarded as being synonymous with life, then its fluidity is surely life-blood.

Going back to Satan's point about utopianism and dystopianism, it might be argued that connectionism and contagion(ism) are both forms of technological determinism – fantasies which mask (and develop) pre-existing fears and desires about our relationship to others, which is

symbolised in the exchange and flow of blood.

From contagion to connectionism via the cyborg

Contagious information

During the 1980s, computer hacking became metaphorically associated with viral attacks on the human body – and specifically with AIDS. In the United States in 1988 Robert Morris hacked into the Internet, created something like an epidemic – 'the virus rapidly infected an estimated six thousand computers around the country' – and 'helped to generate a moral panic' that 'all but transformed everyday "computer culture"' (Ross 1991: 75). The extent of the perceived threat to the national body could be gauged by the enlistment of the combined forces of the medical, military and legal institutions. Government and defence agencies reacted with the establishment of 'antivirus response centres', new legislation was proposed 'that would call for prison sentences of up to ten years for the "crime" of sophisticated hacking' and a planned Center for Virus Control was modelled on Atlanta's Centers for Disease Control. The media, as Andrew Ross and Susan Sontag (1988) have pointed out, took the AIDS metaphor and ran with it, underlining the moral message that it is no safer to trust your best friend's software than his or her bodily fluids: 'safe software or no software at all!' (Ross 1991: 76).

This emphasis on high-risk personal/PC contact led to increased profits for software producers and strengthened the ideology of privatisation, with a resulting 'psychosocial closing of the ranks around fortified private spheres' (*ibid*.: 80). This ideology may also be seen to inform representations of cybernetic organisms (cyborgs) in popular culture (Springer 1991).

The hacker phenomenon emerged in the context of an accelerating convergence of biological and computer sciences within which humans are regarded as information-processing systems and computers are regarded as organisms not least because they are susceptible to disease. Andrew Ross also shows how the hacker phenomenon helped to legitimise government attempts to limit and control the free flow of information made possible by new technologies such as the Internet. Hackers were constructed and defined as a deviant social class and as 'enemies of the state' in order to justify 'a general law-and-order clampdown on free and open information exchange' (Ross 1991: 80–1).

The unregulated exchange of knowledge and information made possible by the Internet constitutes a challenge to established forms of government and power which, by means of the 'hacker as social menace', could reassert some authority.

Paradoxically, this attempt by the US government to crack down on the free flow of information by promoting the spectre of viral contagion may have contributed to the emergence of connectionism as a rhetoric of resistance. Tiziana Terranova associates what she calls 'cyberevolutionism' with resistance on the part of electronic communities to the US government's attempts to regulate the Internet. Cyberevolutionism:

> is based on the assumption that the 'veil between the organic and the manufactured has crumpled to reveal that the two really are, and have always been, of one being'. Both natural and artificial systems (including culture and society) are ruled by the same principles and are directed by the same evolutionary force. (Terranova 1996a: 69).

Cyberevolutionism clearly has strong connectionist foundations, and for Terranova it constitutes part of the politics of the Net: 'One of the most urgent problems for the burgeoning politics of the Net is to find a viable strategy to vindicate the autonomy of electronic communication from supra-imposed government regulations' (*ibid*.: 69). She goes on to describe the Clipper Chip clause as a failed attempt at government regulation (and privatisation) of the information superhighway. The Clipper Chip is described as 'an encryption device which would have allowed the individual user to code and decode his/her messages, but would have also provided the Government with a universal key of access' (*ibid*.: 70). In response to this proposal, Terranova argues that electronic communities mobilised a biological metaphor of the Net as an autonomous, self-regulating entity whose 'natural' evolutionary trajectory would render it immune to external forms of control.

Terranova traces the origins of the discourse of cyberevolutionism to a particular strain of Darwinism, and tracks its own evolution through the biological and computer sciences and through the authors of popular science, from Richard Dawkins to Kevin Kelly. In 1976 Dawkins published *The Selfish Gene*, and established the idea that the successful reproduction of information is central to the process of evolution. He argued that genes are the key unit of life, and genes consist

of information. Bodies and individuals are no more than the temporary hosts of mobile genetic information. Human organisms are information-processing systems akin to those which are studied in the computer sciences. What emerges from this, as Terranova points out, is an evolutionary theory which incorporates both natural and artificial systems.

To this end, Kevin Kelly 'eschews the language of competition and survivalism' which is prevalent in Dawkins's work and discusses the evolution of species in terms of interdependence, complexity and diversity:

> In particular Kelly's evolutionism is rooted in a rhetoric of abundance which in these troubled times could be born only inside the hyper-economy of electronic communication, ripe with images of limitless expansion and exponential rates of growth. This refreshing feeling of possibilities provides Kelly with the symbolic space to advocate not survivalism and hierachical distribution of control but 'co-evolution, co-learning, complexity, diversity, flexibility' under the aegis of a new paradigm of total 'interconnectivity'. (Terranova 1996a: 76)

Kelly's information- and system-based evolutionism is consistent with that of Dawkins in so far as it extends from technology to culture and society in general. In this scenario, genes are regarded as being equivalent to 'memes' or the cultural units of information which Dawkins regards as being relatively new kinds of replicators. Examples of memes include ideas, fashions, tunes and skills such as 'making pots or building arches' (*ibid*.: 192). Dawkins argues that, just as genes propagate themselves 'in the gene pool' by transferring from body to body, so memes reproduce 'in the meme pool' by transferring from one brain to another. Genes travel via sperms and eggs, and memes by a process he calls 'imitation' (Dawkins 1989: 192).

As a prelude to asserting the autonomy and agency of memes, Dawkins emphasises the point that 'memes should be regarded as living structures, not just metaphorically but technically'; they are 'realized physically' within the structure of the nervous system. For him, God and Hell/Satan are memes which replicate in the meme pool of human culture 'by the spoken and written word, aided by great music and great art'. They have a high survival value because of their 'great

psychological appeal' (*ibid.*: 193, 198). To qualify as a meme, a cultural entity must have not only a degree of 'longevity' and 'fecundity', but also 'copying-fidelity'. That is, it must be capable of being transmitted with its essential basis intact, and be immune to differences in the way in which it is represented. Memes, like genes, are 'selfish' and committed to their own survival. Kelly endorses this idea inasmuch as it supports his commitment to the concept of culture as a self-organising system: 'I assign no higher motive to a cultural entity than the primitive drive to reproduce itself and modify its environment to aid its spread' (Kelly 1994: 360).

What seems to have been lost, or represented differently, in the replication of Dawkins's ideas by Kelly and others is his reminder that, first, the ascription of agency to genes and memes is only a metaphor – 'in both cases the idea of purpose is only a metaphor' (Dawkins 1989: 196) – and, second, it does not override conscious choice, political will or what is generally referred to as human agency:

> We have the power to defy the selfish genes of our birth and, if necessary, the selfish memes of our indoctrination. We can even discuss ways of deliberately cultivating and nurturing pure, disinterested altruism ... We are built as gene machines and cultured as meme machines, but we have the power to turn against our creators. We, alone on the earth, can rebel against the tyranny of the selfish replicators. (*ibid.*: 201)

One of the aims of this chapter is to consider what is at stake in the abdication of human agency to an imagined cultural and technological organism which may not be so much alive as a repository for, or projection of, our own feared and wished for undeath. To what extent does this organ(ism) re-present merging or union in the womb as connection(ism)? In so far as we are all (arguably) cyborgs now, are we (therefore) also vampires – hooked on the flow (blood) of information (life)? Is all this Satan's doing, or is he just a feature of our (memetic) indoctrination?

All of life connected: connectionism as the new non-theory of everything

Sadie Plant upholds the model of culture as an organic, self-organising system and presents connectionism as a new interdisciplinary/anti-disciplinary way of thinking which has a special connection to cultural

studies: 'Of all the areas with which connectionism connects, cultural studies has the greatest potential for dealing with both the specificities and broad implications of such vast interconnectivity' (Plant 1996: 211). It is, she maintains, already interdisciplinary, it has started to analyse new technologies, and it is sufficiently sensitive to the relationship between theory and its subject/object to make it receptive to the connectionist ethos. However, one of its major drawbacks for her is its ongoing commitment to some notion of human agency and its investment in 'the educational and ethical project' of the humanities: 'It is this which gives both culture and its students a sense of purpose, autonomy and unified direction, and places the whole area at odds with a connectionist approach' (*ibid.*: 212). Where I would be sympathetic to Plant's critique of the educational and pedagogical project of cultural studies were it developed alongside her general comments on the 'top-down imposition of knowledge' and the 'inadequacy of the old paradigms which divided media, disciplined knowledges, restricted access and closed exploration down', it should be noted that the ethical or humanist project of cultural studies has been, and continues to be, problematised from within. Where Plant asserts that connectionism complicates and perplexes the concept of agency, it should be remembered not only that agency has been debated within the structuralist/culturalist division in cultural studies[1] but that it has been thoroughly perplexed by the introduction of anti-humanist, post-structuralist and psychoanalytic approaches – all of which have taken 'the ground from under the feet of the modern integrated, unified individual' (*ibid.*: 214). I would add to this the relatively recent introduction of feminist debates on science and technology, some of which – following Donna Haraway – have opened out the concept of agency to include (at least potentially) entities other than human, and have been careful not to collapse 'the immense complexity and fine detail of the interwoven lines and circuitries into the singular will of individual and collective agency' (*ibid.*: 213). Elsewhere, my own discussion of Haraway's work has demonstrated its connection to feminist post-structuralist epistemologies which, while in no way connectionist, seek to trouble and revise the restricted rationality of conventional western forms of knowledge (Kember 1996a).

Plant's cultural connectionism, rather like chaos theory, seems to operate within a principle of self-similarity across scale and to become something of an anti-theory of everything: 'It becomes possible to look

at cities, cultures and subcultures of every scale and variety as self-organising systems.' There is no hierarchy of systems and no privilege of scale or ontology. 'States, societies, members and things' are levelled by the similarity of their organisational and evolutionary processes. And 'there is nothing exclusively human about it', as culture emerges from complex interactions between such seemingly diverse elements as the media, the weather, brains, cities, organisms, markets, bacteria and so on. Culture, for Plant, is everywhere, everything '*and* the kitchen sink' (Plant 1996: 214).

Connectionism is not only universalised in Plant's account, it is, rather more insidiously, naturalised. It is presented not as an idea but as a fact or phenomenon of all complex systems everywhere. It is in this way detached from the motivations of its author(s), divested of responsibility, dehistoricised and depoliticised. Ideologically, therefore, it functions in accordance with the sciences from which it originated and from which Plant seeks to dissociate it. It is in its own way a 'god-trick', which Haraway (1991b) refers to as the trick of appearing to see everything from nowhere. As a form of knowledge it is regrettably disembodied. From Plant's point of view I may appear guilty of condemning 'as "naturalization" any attempt to introduce ... natural processes to the study of social, political or cultural developments' (Plant 1996: 212). In which case, my own work on chaos theory will render me guilty of hypocrisy. I do not, in fact, believe that applying natural processes to the study of cultural processes inevitably results in naturalisation. Indeed I would prefer to place both nature and culture in inverted commas, and recognise them as concepts which are neither homogeneous nor clearly divided. It seems to me that what is important in extending a 'natural' or scientific paradigm to 'culture' in general is that it is recognised as having strategic rather than descriptive value. This recognition constitutes a form of ownership and responsibility which embodies, historicises and politicises knowledge. The problem with connectionism is, ironically, similar to the problem which Plant identifies in 'research projects such as sociobiology [which] have often been woefully blind to their own cultural functioning' (*ibid.*: 212). While I consider connectionism to be unstrategic, it clearly offers a rhetoric of resistance to control and authority which is based on the destruction of boundaries, the denial of external (socio-economic) forces, the dissolution of difference, and the consequent merging or assimilation of

individual entities whether they be 'natural' or 'cultural', human or machinic.

Bearing in mind that the historical transition from contagion to connectionism has taken place via the concept of the cybernetic organism (cyborg), I think it would be useful at this point to consider the relationship between these apparently opposing discourses of technology and the human/machine entity which may or may not embody them but which has certainly stimulated much of the debate about current and future forms of knowledge, power and subjectivity.

Cyborgs, cyborgs everywhere

It should be said at the outset that a cyborg is a rather slippery thing. Beyond the notion that on some level it combines both natural and cultural, organic and artificial elements, there is no consensus of opinion as to exactly what it is, or indeed, if it is. There is some question as to whether it exists in the material world or in the realms of the symbolic and imaginary. From the representations currently available we can identify the cyborg as a pilot, a person with a pacemaker, anyone using a computer and/or the Terminator. The editors of *The Cyborg Handbook* also point to a certain indeterminacy concerning 'types of cyborgs and cyborgian relations' which has arisen because 'cyborgs are everywhere and multiplying'. They offer their book not as an answer to the cyborg question but as 'an initial map of the important cyborg questions, anxieties, problems and possibilities' (Hables Grey *et al.* 1995: 2). As a helpful guide the editors identify four main contexts or 'cyborgology centers' within which cyborg technology has originated and developed: military, medical, work and entertainment. They then claim that distinct types of cyborg can be identified with the different contexts. Cyborgs can be 'restorative' in that they restore lost or failing functions, organs and limbs. They can also be 'normative' or 'reconfiguring'. The reconfiguring cyborgs are linked to posthumanism and the creation of new creatures which are 'equal to but different from humans'. Finally, cyborgs can be 'enhancing', which is 'the aim of most military and industrial research' (*ibid.*: 3).

Although I would suggest that there is considerable potential overlap between these types – medicine, for example, might at times encompass all of them – I would agree with the editors that the differences are important in ethical terms. Their categories militate against the hazards of cyborg ubiquity, and help to maintain awareness

of the social and political significance of cyborg technology: '"Cyborg" is as specific, general, powerful, and useless, a term as "tool" or "machine". And it is just as important.' Some of the important questions they outline include agency, subjectivity, ethics and epistemology. The cyborg holds a myriad of familiar dualisms – nature/culture, human/machine, organic/artificial – in constant tension and consequently embodies a challenge to western either/or epistemology. The editors of *The Cyborg Handbook* maintain that there is, in fact, an 'epistemology of cyborg: thesis, antithesis, synthesis, prosthesis' (*ibid.*: 6, 13).

For me, the most useful and authoritative account of the cyborg is Donna Haraway's, and this is because her cyborg (at least her imaginary cyborg) refigures the terms of knowledge, power and subjectivity. It makes a highly strategic intervention into theories of western epistemology, multinational capitalism and humanism and it does so from a socialist-feminist standpoint. The key to Haraway's standpoint lies in the productive conflict of its allegiance to science (and objectivity) and to postmodern theory and the politics of difference. Where she rejects the universalism and disembodiment of traditional scientific accounts of the world, she is also critical of the (radical) relativism which underlies postmodernism: 'Feminists have to insist on a better account of the world; it is not enough to show radical historical contingency and modes of construction for everything' (Haraway 1991a: 187). Because of her commitment to feminism, to science and to postmodernism Haraway takes on the task of bringing the theory and philosophy of science and anti-science into useful dialogue. This task is facilitated by, and grounded in, earlier feminist work on science and technology and particularly the concept of a feminist successor science and a feminist standpoints epistemology:

> So, I think my problem and 'our' problem is how to have *simultaneously* an account of radical historical contingency for all knowledge claims and knowing subjects, a critical practice for recognizing our own 'semiotic technologies' for making meanings, *and* a no-nonsense commitment to faithful accounts of a 'real' world, one that can be partially shared and friendly to earth-wide projects of finite freedom, adequate material abundance, modest meaning in suffering, and limited happiness. Harding calls this necessary multiple desire a need for a successor science project and a postmodern insistence on

irreducible difference and radical multiplicity of local knowledges. (*ibid.*: 187)

A successor science is quite simply a feminist alternative to mainstream masculinist science which is premised not only on totalism but on domination (of the female body of nature). Standpoints epistemologies incorporate multiple, partial and situated feminist knowledges which embody a more generous and responsible relationship to nature not least because they refuse to privilege culture and whatever else lies on the masculine side of epistemological dualism. It is, according to Haraway, 'only partial perspective [that] promises objective vision' (*ibid.*: 190), and it is the mobility of perspective (the ability to see from another's standpoint as from one's own) which implies a shift in the terms of (unitary) subjectivity and is represented in the figure of the cyborg. The cyborg, above all else, embodies difference in tension – 'irreducible difference'.

The illegitimate ontology and epistemology of this fictional cyborg render it unfaithful to its parent organisms in industry, in medicine and in the military. These are the cyborgs for scientific progress which Hables Gray, Figueroa-Sarriera and Mentor would refer to as restorative, normalising, reconfiguring or enhancing. For Haraway they reinforce the matrices of domination that exist within economics, social relations and science itself. In the marketplace these cyborgs ensure greater efficiency, competitiveness and profit. In science they help to pull off the god-trick and in terms of social relations they intensify hierarchies of gender, race and class. Haraway details the place of 'women in the integrated circuit' of home, market, paid workplace, state, school, clinic–hospital and church by saying that 'there is no "place" for women in these networks'. Instead there are 'only geometries of difference and contradiction' which are central to the cyborg identity of women. By acknowledging and learning to read these networks of social relations and power, it becomes possible to 'learn new couplings, new coalitions' (Haraway 1991a: 170).

Cyborg contagion and connectionism
It is here in the webs, networks and circuits of power that the discourses of contagion and connectionism contest for and inform the figure of the cyborg in so far as it is perceived as being either a fortified and defended individual, or a network of interconnected entities. Where one cyborg

fears viral contagion and contact, the other seeks to establish veinous networks. They are premised on either a fear of, or desire for, the other – which is symbolised in the blood-like flow of information. Fears are rationalised through violence or domination (macho cyborgs), and desires through fantasies of assimilation into the matrix/mother/womb.

In 'The Pleasure of the Interface' Claudia Springer (1991) suggests that information technology offers the 'thrill of escape from the confines of the body' while at the same time preserving and protecting the (humanist) self. The thrill of 'jacking in' is a sexual thrill – solitary, masturbatory and specifically safe. Sex at the interface carries familiar associations of death or assimilation of the self by the m/other. Reminding us of the origins of the word matrix 'in the Latin *mater* (meaning both mother and womb)' (*ibid.*: 306) Springer argues that in the cyborg imagery of popular culture and science fiction, computers 'extend to us the thrill of metaphoric escape into the comforting security of our mother's womb' (*ibid.*: 306). For Freud, the womb is the first 'Heim' or home and an *unheimlich* or uncanny feeling is characterised by 'the simultaneous attraction and dread evoked by the womb' (*ibid.*: 306). In the memory and imagination of adults, the womb signifies both life and death, or the place where we both were and were not properly alive: living but insentient (Springer 1991: 306).

Through cyborg imagery, popular culture plays out our fears of contagion by offering a fantasy of safe sex, and it acts out a collective (un)death wish by playing on our fears and fascinations with the matrix/mother/womb. The thrill of escaping from the human body by experiencing simulated orgasm and death is identified by Springer as a paradoxical way to preserve life and the self in a hostile social environment. When the human body is under the threat of AIDS, nuclear disasters and environmental apocalypses, popular culture acts out our (death) drive to abandon it while preserving consciousness and redefining the self as, perhaps, posthuman, cyborgian, immortal or undead (Springer 1991: 322).

This (almost) evolutionary survivalism applies not only to images of disembodiment, such as the Lawnmower Man, but also to images of re-embodiment, such as Robocop and the Terminator, all from science fiction films of the 1980s and 1990s. Macho cyborgs opt for fight over flight, and they (too) are indestructible. For them, sexual contact – connection with others – is displaced or made safe through violence rather than escapism (*ibid.*: 316–17).

Cyborg images in all forms of entertainment have arisen in response to significant changes and technological developments in social institutions and social life. Our changing social environment, often perceived as increasingly hostile (dystopian), seems to have stimulated a concern for human evolution and survival which is based on Darwinian principles of individualism and competitiveness. As Tiziana Terranova has pointed out, posthumanism is in part an image of evolutionary adaptation to an increasingly competitive and technologised marketplace (Terranova 1996b). Certainly, Springer is right to point out that cyborg images in popular culture are masculinised and fail to live up to Haraway's genderless, feminist and socialist ideal whose *modus operandi* might be said to be connection if not connectionist. The fight-or-flight cyborgs of popular culture constitute the immortal undead by either violently resisting or enthusiastically embracing immersion in the technological organism which is – symbolically – the m/other. These cyborgs, like the discourses which inform them, perpetuate a masculine unconscious and a masculine fear and fascination with the monstrous feminine other.

Cyborg connections

Although connectionists of course claim the cyborg as their own, Haraway's ideal eludes them by virtue of the fact that it is situated (historical and political) and strategic. It is constructed within the framework of systems theory but it is anti-evolutionary. Haraway argues that it is precisely because the competitive story of human evolution has reinforced social and economic structures of domination that feminists must intervene in the natural sciences and tell another story about origin:

> Feminists taking responsibility for modern origin stories – that is, for biology – may try to get the story right, to clean up shoddy science about evolution and brains and hormones ... Or feminists may more boldly announce a completely new birth. (Haraway 1991a: 72)

The cyborg, with its allegiance to the successor science projects, is a feminist offspring which radically revises traditional concepts of origin and evolution. An entity of both nature and culture, the cyborg was not born but constructed and it evolves only through connecting with other entities whose difference is valued and maintained. It connects by

transgressing rather than destroying boundaries and it seeks not the (un)death of the self but the transformation of subjectivity outside the terms of unity and wholeness. The cyborg is a non-unitary entity with non-unitary vision. It has no (complete) identity and prefers to build 'affinities' rather than identifications with others so as to avoid 'unity-through-domination' or 'unity-through-incorporation' (Haraway 1991a: 157). Its partial perspective helps to sustain 'the possibility of webs of connections called solidarity in politics and shared conversations in epistemology' (*ibid.*: 191). So this cyborg only 'is' in so far as it is strategic. Its ontology is problematised in favour of its transgressive epistemological function and the transformations in power and subjectivity which are then made possible. For me, the essence of Haraway's cyborg is a geometry which describes a non-dualistic, non-hierachical relationship (between points on a given scale), and which constitutes a model of intersubjectivity. In this sense it is still on the drawing board, not yet fully enlisted in the battle of the cyborgs for either global domination or earthly survival. Haraway's cyborg world is a utopia, an elsewhere which is here inasmuch as it is shared and exists (in essence) in the theories and practices of others.

I would argue that the cyborg has affinities with other geometries and that it exists through its connection with other feminist figurations of a better elsewhere. A figuration is 'a performative image of the future; performative to the extent that it embodies an epistemological and ontological shift which acts, albeit virtually in the present' (Kember 1996b: 256). In *Volatile Bodies*, Elizabeth Grosz undertakes to 'displace the centrality of mind, the psyche, interior, or consciousness (and even the unconscious) in conceptions of the subject through a reconfiguration of the body' (Grosz 1994: vii). As a project which entails rethinking subjectivity beyond dualistic conceptual constraints, it has a certain affinity with part of Haraway's project, although Haraway's cyborg figuration is implicitly rejected as a viable paradigm: 'I have tried to avoid many of the common metaphors that have been used to describe the interactions of mind and body, metaphors of embodiment, of containment, machinic metaphors' (*ibid.*: xii). Nevertheless Grosz offers a geometric model which I think describes a relationship similar to the kind described by the cyborg in as much as it is non-hierachical, non-dualistic and, in a real way, intersubjective. Following Lacan, who 'likens the subject to a Möbius strip, the inverted three-dimensional figure eight', she adopts the same model in order to represent her

figuration of the relationship between body and mind. The Möbius strip 'has the advantage of showing the inflection of mind into body and body into mind', and it demonstrates the ways in which 'through a kind of twisting or inversion, one side becomes another' (Grosz 1994: xii).

This is a model which functions as a metaphor for a new way of thinking about subjectivity, yet whatever its advangates there are also limitations. Grosz points to the inability of the Möbius strip to model difference or modes of becoming, and she identifies the need for further exploration and experimentation which involves 'taking theoretical risks in the hope that new methods and models, new techniques and contexts, may one day develop' (*ibid.*: 210).

It seems to me that among the most significant theoretical risks and hopes encountered within interdisciplinary feminisms today is that of transferring transformative geometric and epistemological models from the realms of the (political) imaginary into the symbolic or the realm of language and representation. One of the main questions which perplexes Haraway's cyborg is that of representation – what it looks like and where it can be seen (to operate). Another question concerns gender and the viability of a genderless ideal within feminism. A cyborg with 'no origin story in the Western sense' successfully eludes the Oedipal 'plot of original unity out of which difference must be produced and enlisted in a drama of escalating domination of woman/nature' (Haraway 1991a: 151). By the same token, this cyborg cannot properly attain to (gendered) subjectivity and therefore desire. Haraway reflects on this loss somewhat ruefully, and in a retrospective view of the cyborg manifesto she gestures toward the necessity of something like a successor psychoanalysis: 'At a certain point you ask if there isn't another set of stories you need to tell, another account of an unconscious. One that does a better job accounting for the subjects of history' (Haraway 1991b: 9). I would echo this gesture because I think there is a need for psychoanalysis as a story or set of stories which highlights the inextricable connection between science and myth, fact and fantasy – and there is a need to imagine how this connection can be made differently. By differently, I mean without recourse to myths of the monstrous feminine or to fantasies of domination and assimilation.

For me, Braidotti takes a greater theoretical risk than Haraway when Braidotti attempts to locate her figuration of the nomadic subject within the symbolic, and when she takes on the task of constructing new desiring subjects. In *Nomadic Subjects,* Braidotti (1994) argues that the

task of constructing new desiring subjects involves a reconciliation of history and agency with the unconscious. In order to establish an effective feminist politics, she maintains that it is necessary to recognise the distinctions and conflicts 'between willful political choices and unconscious desires' (*ibid.*: 31). In this way, the wish for radical social and technological change expressed within connectionism (and contagionism) may be denaturalised and distinguished from unconscious fears and desires concerning the other. Braidotti offers a theory of connection which works on the level of politics and desire to dismantle both social and psychological forms of domination without resorting to fantasies of assimilation. She offers it through her own figuration of the nomadic subject, which is like a cyborg with an unconscious:

> The nomad is a postmetaphysical, intensive, multiple entity, functioning in a net of interconnections. S/he cannot be reduced to a linear, teleological form of subjectivity but is rather the site of multiple connections. S/he is embodied, and therefore cultural; as an artefact, s/he is a technological compound of human and post-human; s/he is complex, endowed with multiple capacities for interconnectedness in the impersonal mode. S/he is a cyborg, but equipped also with an unconscious. (*ibid.*: 36)

Part of the price the nomadic subject pays for retaining his/her gender identity and being in the symbolic is the necessary recognition that 'I am not new yet.' Braidotti is rightly circumspect about the pace of social change and she describes it rather like a ritualised dance between the old and the new. Where desire and the unconscious are involved, change is inevitably slow and difficult: 'The case of psychoanalysis rests precisely on the demand that the pain involved in the process of change and transformation be recognised and respected' (*ibid.*: 31). What is more, the argument for apocalyptic or revolutionary change collapses in the face of the historical constraints of power and social division. Like Haraway, Braidotti balances her utopianism with a recognition of the presence of socio-economic forces. Like the cyborg, the nomadic subject battles for change from within 'the belly of the monster'. They are both mimetic or parodic images and 'work through established forms of representation, consuming them from within' (*ibid.*: 38). For Braidotti, the virtue of parody is that it opens up space for change. However

provisional the nomadic subject's existence is, s/he is a step ahead of the cyborg in the task of restoring 'a sense of intersubjectivity that would allow for the recognition of differences to create a new kind of bonding' (*ibid.*: 36). S/he brings a desire to transgress and perhaps a transgressive desire into the symbolic. Nomadism is not about mobility or fluidity without boundaries, but it represents the 'intense desire to go on trespassing, transgressing' (*ibid.*: 36).

Without constructing a theory of desire (a psychoanalysis), Braidotti draws on a number of sources (including Irigaray and Deleuze) in order to describe desire through the terms of intersubjectivity. For Jessica Benjamin, intersubjectivity constitutes a non-Oedipal theory of desire: 'she ... attempts to replace the mediation by the phallus with the capacity for interconnectedness and agency, so that desire need not be conceptualised according to the murderous logic of dialectical opposites' (Braidotti 1994: 201). Intersubjectivity exists in opposition to the master/slave register of desire in which the gendered relation between self and other is based on domination and submission and on the male subject's violently defensive assertion of his differentiation from the m/other. Intersubjectivity works through mutual recognition and obviates the necessity for overassertion. It 'refers to the experience *between and within* individuals, rather than just *within*' and to a sense of self and other maintained through mutual recognition (Benjamin 1988: 125).

Intersubjectivity is a way of seeing from another's standpoint as well as from one's own. It carries a transformative epistemology into the register of desire. Knowledge and desire, as Braidotti points out (and as discussed in chapter 4), are inextricably linked at the point of origin, and so what intersubjectivity does is describe a different way of knowing and relating to the original m/other (nature). This may also be said of other non-Oedipal theories of desire including perhaps Teresa De Lauretis's theory of 'perverse desire', which rewrites fetishism in the context of lesbian sexuality, and presents it as a desire for the absent presence of the maternal body rather than for its disavowal by the phallus. In so far as lesbianism is the practice of desiring subjects who are female, De Lauretis also argues that lesbianism functions as a figuration within feminist theory (1994). In 'Feminist Figuration and the Question of Origin' (Kember 1996b) I argue that figurations are not only performative images of the future but transformative ways of re-remembering the past. Figurations concerned with science and

subjectivity also embody a relationship to nature and origin, and in this sense they are somewhat mythical. Figurations may be like myths in the sense that they are ideological (Barthes), epistemological (Lévi-Strauss) and psychological (Jung); but they are not like them in the sense of being naturalised, rationalised or universalised. They have a deep structure which is like the unthought known (chapter 1) but which is premised more on a technology of the self than on the concept of a true self. Figurations embody ways of being and thinking which are transgressive and transformative, and one of their tasks is to disrupt the teleological evolution of both humans and machines, nature and culture. Figurations are like myths with seams in – or myths turned inside out. They are unnatural, irrational and very partial. Like De Lauretis's theory of perverse desire, they are passionate fictions, or like Adam Phillips's concept of a psychoanalytic theory they are stories about 'where the wild things are' (Phillips 1993: 18). They must remain partial, located and fictional in order to be politically effective or 'operationally real' (Braidotti 1994: 36). Transformative geometries such as the strange attractor in chaos theory (which also describes a different relation to origin (Kember 1996b: 266–7)) and potential myth systems such as connectionism ultimately relinquish their political promise by being buried within a totalising theory. Haraway's cyborg is an effective figuration to the extent that its mythical status is grounded in a political language:

> There is no drive in cyborgs to produce total theory, but there is an intimate experience of boundaries, their construction and deconstruction. There is a myth system waiting to become a political language to ground one way of looking at science and technology and challenging the informatics of domination – in order to act potently. (Haraway 1991a: 181)

From cyborgs to vampires, or, I would rather be a vampire than a goddess

I have examined the elision of life and information in the discourses of contagion and connectionism, and I have traced the evolution of a new cyborgian species of the undead – of metaphorical vampires, hooked on the life-blood of information. Having indicated that the cyborgian vampire myth is based on a fear of, and desire for, the monstrous

feminine other, I now want to explore the vampire myth turned inside out as a figuration. In doing this I am rejecting the traditional opposition between myth and science and arguing that there is an affinity between mythical and scientific frameworks for thinking (about the future) with. Science and myth are interconnected, they speak to and through each other especially at times of significant social change. As Chris Baldick states, the myth of Frankenstein's monster addresses the 'new problems of an age in which humanity seizes responsibility for re-creating the world, for violently reshaping its natural environment and its inherited social and political forms, for remaking itself' (Baldick 1987: 5). Similarly, Jennifer Gonzalez maintains that 'the image of the cyborg has historically recurred at moments of radical social and cultural change' and that like a symptom of a culture in transformation 'it represents that which cannot otherwise be represented' (Gonzalez 1995: 268). It is not simply that myth is brought in to fill the gaps in science – to explain what science cannot – but rather that it has 'an integral role in organizing and intensifying perceptions of the natural world' (Bann 1994: 6). The integration of science and myth comments on the non-linearity of history (precisely, the myth of progress) and on the bogus separation of the rational and irrational (of madness and civilisation) in modern systems of thought. Vampires are mythical monsters, symptoms of irrationality, but I would suggest that they are integral to a supposedly rational scientific culture in which the distinction between life and information has collapsed and in which the flow of information is the life-blood of economics, communications and intersubjective relations.

I will start by looking at vampirism through the terms of contagion and connection, and as the myth of the undead. Dracula (who signs himself simply 'D' in his correspondence), rather like Satan, stands for (un)death, bodily transcendence, and desire which leads directly to (virtual) hell. In *Dracula* blood symbolises either contagious life/information or merging through connection. By considering a more recent version of the vampire myth (*Interview with the Vampire*), I will then present my ideal vampire as the embodiment of transgressive desire and transformative subjectivity. The vampire as a figuration is parodic and strategically inclined towards a different kind of connection with the other and a different register of (fear and) desire, hatred and love. I am offering my vampire figuration as a seriously playful, passionately fictional technology of the self. For Elspeth Probyn, technologising the self involves finding a 'mode of speaking one's difference that does

change matters both personal and social/theoretical' (Probyn 1992: 504). I want my vampire to speak for my investment in a concept of difference which celebrates transgressive desires and transformative subjectivities, and I want it to highlight the irrational dimension within current theories of information technology. I do not wish to offer a politics of vampire identity or to reify the vampire as self, but rather I want to follow Probyn's homage to campness by employing the vampire tactically. It is not possible to be a vampire in the same way that it is not possible to be a cyborg, but just as Haraway recognises the inextricable connection between transformative figurations and myths of transcendence – 'bound in the spiral dance' (Haraway 1991b: 181) – I must say (and with due deference and apologies to Haraway) that I would rather be a vampire than a goddess.[2]

The story of *Dracula* is told in epistolary form and presents a collection of standpoints which aspire to factualness and the erasure of memory, imagination and madness – the irrational dimension which encroaches inexorably upon it. The prologue announces that: 'All needless matters have been eliminated, so that a history almost at variance with the possibilities of latter-day belief may stand forth as simple fact' (Stoker 1988: 8). Once inside Dracula's castle, Jonathan Harker writes: 'Let me be prosaic so far as facts can be; it will help me to bear up, and imagination must not run riot with me. If it does I am lost' (*ibid*.: 37). Harker begins to lose his battle against irrationality on entering *Transylvania, 'just on the borders of three states' and 'one of the wildest and least known portions of Europe'. On approaching the castle he feels 'a sort of paralysis of fear' which is compounded by the strange appearance of his host. Harker is struck by the strength and coldness of Dracula's handshake and by his 'very marked physiognomy' which combines elements of nobility with a most disturbing animalism: 'His face was a strong – a very strong – aquiline, with high bridge of the thin nose and ... lofty domed forehead.' Yet his mouth 'was fixed and rather cruel-looking, with peculiarly sharp white teeth,' his 'ears were pale and at the tops extremely pointed' and his hands were coarse with 'hairs in the centre of the palm' and long pointed nails. Not only that but 'his breath was rank' (*ibid*.: 28). For all his nobility the Count's appearance clearly resonates with the wolves that Harker hears while making his observation.

According to D. Pick, the novel refers to late nineteenth-century theories of degeneration and atavism, which 'wavered between a

taxonomy of visible stigmata and the horror of invisible maladies, between the desired image of a specific, identifiable criminal type (marked out by ancestry) and the wider representation of a society in crisis, threatened by waves of degenerate blood and moral contagion' (Pick 1988: 79). The classificatory sciences of physiognomy and eugenics employed within a medico-legal discourse attempted to regulate and control an imagined threat brought about by urbanisation and industrialisation – a kind of evolution in reverse. On one level, the novel has a reassuring function 'displacing perceived social and political dangers on to the horror story of a foreign Count finally staked through the heart', but this function is 'undermined by the simultaneous suggestion of an invisible and remorseless morbid accumulation within, distorting the name and the body of the West (Lucy Westenra), transmitting unknown poisons from blood to blood' (*ibid.*: 75). Dracula is described in evolutionary terms which, as Pick has suggested of the novel as a whole, veer simultaneously towards and away from 'a new conception of subjectivity and science' (*ibid.*: 72) such as psychoanalysis.

Dracula 'was in life a most wonderful man'. He was a soldier, a statesman and an alchemist ' – which latter was the highest development of the science-knowledge of his time'. He was intelligent and fearless 'and there was no branch of knowledge of his time that he did not essay'. After his physical death, his mind regressed, but 'he is growing' and experimenting effectively 'and if it had not been that we have crossed his path he would be yet – he may be yet if we fail – the father or furtherer of a new order of beings, whose road must lead through Death, not Life' (Stoker 1988: 360). As to the cause of this mutation or transformation, the novel provides little indication – except that Dracula is marked by loss – 'my heart, through weary years of mourning over the dead, is not attuned to mirth' – and that amidst his hateful acts he retains a capacity for love: 'Yes, I too can love; you yourselves can tell it from the past.' Coppola's 1992 film version effectively fills in the gaps in the narrative by having Dracula take revenge on God for the loss of his wife Elizabetha, and then meet a tragic end having rediscovered his love in the form of Mina Murray/Harker.

What is clear in the novel is that Dracula's capacity for love is marred by his quest for power over others, and the desire – like the blood – that flows from him is for mastery: 'I have been so long master that I would be master still – or at least that none other should be master

of me' (*ibid*.: 31). The 'absolutely open minded' (*ibid*.: 137) philosopher and metaphysician Van Helsing challenges Dracula for mastery over the specifically female subjects who are shown to be vulnerable to corruption and contamination. The novel reveals an association between sex and blood (transfusion) and a distinct fear of female sexuality. Dracula's contagious life-blood makes vamps out of Victorian ladies and Van Helsing seeks to cure them and restore them to virtue. In Dracula's castle Harker encounters 'three young women, ladies by their dress and manner' with 'voluptuous lips' and experiences 'some longing and at the same time some deadly fear. I felt in my heart a wicked, burning desire that they would kiss me with those red lips' (*ibid*.: 53). When the nature of their kiss becomes apparent, Harker declares that nothing – even the Count – 'can be more dreadful than those awful women, who were – who *are* – waiting to suck my blood' (*ibid*.: 54). Lucy Westenra succumbs to Dracula's charms while sleepwalking. Mina finds her in her nightdress, 'a half-reclining figure' with something dark – 'whether man or beast, I could not tell' (*ibid*.: 112) – leaning over her, and worries for her reputation. Lucy's skin is pierced and from then on she becomes increasingly weak and languid and has to be locked in her room in order to prevent her succumbing again. Her deterioration and degeneration are fought with the transfused blood 'of four strong men' including her lover and two former suitors: 'No man knows till he experiences it, what it is to feel his own life-blood drawn away into the veins of the woman he loves' (*ibid*.: 156). But Dracula's influence over Lucy is stronger, she dies, and her transformation as a vamp(ire) is complete: 'The sweetness was turned to adamantine, heartless cruelty, and the purity to voluptuous wantonness' (*ibid*.: 252).

As a vampire she is undead and it is Van Helsing who associates the undead with a form of unconscious or repressed realm (of sexuality) which Dracula controls and which he subsequently reaches through hypnotism. Lucy 'was bitten by the vampire when she was in a trance ... and in a trance could he best come to take more blood. In trance she died, and in trance she is Un-Dead too' (*ibid*.: 241). The undead are cursed with immortality and caught in an ever widening circle of contagion from which the only release is a ritualised destruction of the body. Lucy is released from undeath by the man who, since giving his blood, felt 'as if they two had been really married, and that she was his wife in the sight of God' (*ibid*.: 209). Death is brought about by an act of consummation – driving a stake through her heart:

> The Thing in the coffin writhed, and a hideous, blood-curdling screech came from the opened red lips. The body shook and quivered and twisted in wild contortions; the sharp white teeth champed together till the lips were cut and the mouth was smeared with a crimson foam. But Arthur never faltered. (*ibid.*: 259)

Sex/death by stake is perhaps the most overtly sexualised image in a novel in which desire, like history (and superstition), functions as the return of the repressed. Desire is feared like the contagious blood of the monstrous other, but once the body's boundary is broken and the blood starts to flow then the other becomes known or connected to the self, and difference collapses. Robert Olorenshaw argues that 'the circulation of blood and the realization of desire are achieved at one and the same stroke'. For him, blood is a 'potent and dangerous fluid' in the novel not because it symbolises anything to do with race, religion or social rank, but 'because it is libidinal and real, dissolving symbolic and social distinctions in an unstoppable haemorrhage' (Olorenshaw 1994: 171).

Dracula is a vampire whose desire consumes other lives and dissolves differences. Olorenshaw points out that he makes 'no distinction between the upper-class Lucy Westenra, the "petite bourgeoise" Mina Harker or even the millions of potential victims thronging the metropolis' (Olorenshaw 1994: 173). Dracula's desire is for mastery or omnipotence through (sexual/blood) knowledge of, and intimate connection with, his victims. Within the narrative, Mina Harker (not Van Helsing) is the agent of his downfall because she uses that connection against him. Mina is a virtuous woman who marries the very respectable Jonathan Harker, he who had a close brush with temptation but more or less resisted it, albeit at the cost of a violent brain fever. Mina is an assistant school mistress who wants to be useful to Jonathan in his legal studies by learning shorthand and practising on a typewriter while he is in Transylvania. He keeps a record of his experiences but wants his union with Mina to be in a shared ignorance of its contents:

> Are you willing, Wilhelmina, to share my ignorance? Here is the book. Take it and keep it, read it if you will, but never let me know; unless, indeed, some solemn duty should come upon me to go back to the bitter hours, asleep or awake, sane or mad, recorded here. (Stoker 1988: 129)

At the point when Jonathan encounters Dracula in London, transformed and 'grown young', Mina decides to end her ignorance and 'learn the facts of his journey abroad' (*ibid.*: 208). Mina's openness to her husband's story of desire and transgression is presented as her infidelity with Dracula in Coppola's film. In the film, Dracula in his youthful incarnation is dashing – and has particularly cool sunglasses. She takes him to see the new cinematograph in London, and although he is a bit rough with her, she is seduced when he tames the big white wolf which escaped from the zoo ('he likes you') and abandons herself to the subliminal awareness that she is the reincarnation of his dead wife ('I know you'). Once she is married to Jonathan 'the nature of my feelings for my strange friend' become apparent. Sadly, the novel renounces lust and passion, and Mina's decision to read the journal is made in the name of solemn duty. Mina prepares herself for her duty in the knowledge that Dracula is on his way to London where 'teeming millions' (Stoker 1988: 215) may be at risk from his contagious degeneracy. In order to prepare herself she resolves to 'get my typewriter this very hour and begin transcribing' (*ibid.*: 215).

Mina transcribes not only Jonathan's but her own journal, and that of Dr Seward, who attended Lucy during her illness and was one of her suitors. Seward's journal is kept on a phonograph and the novel establishes an important contrast between this and the newer form of technology. Having decided that 'the diary of a doctor who attended Lucy might have something to add to the sum of our knowledge of that terrible Being', Mina listens to the recording and declares that the phonograph 'is a wonderful machine,' but that 'it is cruelly true'. Through it she could hear and feel Seward's emotional anguish, and she declares that no one should be able to do this again. To this end, she copies out his words on her typewriter where 'none other need ... hear your heart beat, as I did' (*ibid.*: 266).

It becomes clear that Mina's typewriter is used to circulate information in a form and manner which aims to sanitise and eventually staunch the circulation of blood and desire. Her transcriptions distance the effects of all those transfusions. In this sense it could be argued that as the computer is to the camera, so the typewriter is to the phonograph. Olorenshaw argues that the phonograph, like the photograph, is 'an unmediated form of duplication' and that through Mina we are shown that typewriting 'is a form of recording that distances the individual from himself and others'. The typewriter

functions as 'a positive form of dispossession or depersonalisation' in the novel (Olorenshaw 1994: 175).

Although the circulation of information in *Dracula* constitutes a form of connection with others, it is intended to displace and deny the intimate flow of blood and desire with which it is associated. According to Olorenshaw, 'knowledge of the inner life of other people circulates in exactly the same way as do blood and desire' and 'it is in such a way that the characters become vampires to one another, needing to digest and exchange their inner lives in an unbroken circulation' (*ibid*.: 174). But Mina's transcriptions facilitate a bond between her and the men who seek to destroy the vampire, and it is a bond which gets broken and is only partially effective. Having collated and presented all of the available information about Dracula's powers and limitations, Mina is excluded from the first assault on the grounds that it is men's work. Dracula comes for Mina during her exclusion, and takes her while her husband sleeps beside her. Where Coppola presents an erotic love scene, the novel depicts something more like rape:

> he pulled open his shirt, and with his long sharp nails opened a vein in his breast. When the blood began to spurt out, he took my hands in one of his, holding them tight, and with the other seized my neck and pressed my mouth to the wound, so that I must either suffocate or swallow some of the – oh, my God, my God! What have I done? (Stoker 1988: 343)

Dracula regards his conquest of Mina as a punishment: 'You have aided in thwarting me; now you shall come to my call' (*ibid*.: 343). Even though her companions bring her back into the fold, from this point onwards she is connected (physically and psychically) to Dracula. Van Helsing hypnotises her and uses her psychic connection with Dracula to track him back to Transylvania and finish the battle which was always about more than just life and death, virtue and vice. The battle ends in and through Mina's heart and mind, but the outcome is not conclusive. Dracula is killed and Mina is restored to a virtuous life with her husband, but the 'vivid and terrible memories' (*ibid*.: 449) are not erased and the transcripts stand as an inadequately mediated and distanced account of a wild story of desire and transgression, told 'in the midst of our scientific, sceptical, matter-of-fact nineteenth century':

> We were struck with the fact that, in all the mass of material of which the record is composed, there is hardly one authentic

document; nothing but a mass of type-writing ... We could hardly ask anyone, even did we wish to, to accept these as proofs of so wild a story. (*ibid*.: 449)

In *Dracula*, science, technology and rationality combat but fail to contain the forces of superstition, nature and irrationality. For me, the story usefully highlights the irrational dimensions of fear and desire which underlie the contagious/connectionist discourses of new information technologies in which, metaphorically speaking, 'the blood is the life', and in which there seems to be a desire for undeath. I would argue that in *Interview with the Vampire* (Rice 1976) the irrational dimension is embraced, and that undeath is refigured as the nemesis of desire. There is no investment in objectivity in this story, which is offered as the autobiography of a very beautiful vampire called Louis who was born in the eighteenth century but comes to embody the spirit of the nineteenth century by being 'at odds with everything' and reflecting 'its broken heart' (*ibid*.: 309). Louis's story begins with the loss of his brother and his own invitation to death, which is answered by the vampire Lestat – an outright hedonist with a particular taste for young men. Lestat 'drained me almost to the point of death' and then made an offer which Louis could not refuse – the offer of a different kind of life(style): 'I forgot myself totally. And in the same instant knew totally the meaning of possibility ... As he talked to me and told me of what I might become ... my past shrank to embers' (Rice 1976: 17). Louis has some difficulty describing how he became a vampire: 'I can't tell you exactly, any more than I could tell you exactly what is the experience of sex if you have never had it' (*ibid*.: 18). Lestat 'made me think of a lover' and as Louis describes the act of his transformation, the 'boy' interviewing him experiences 'a welter of excitement' (*ibid*.: 24). For Anne Rice, the condition of being a vampire tends to be that of heightened desire which in itself takes a number of forms: awakened senses ('it was as if I had only just been able to see colours and shapes for the first time', *ibid*.: 24); lust for life (blood); transgression (homosexuality); passion (love and hate, revenge and reparation); and insatiable longing. Rice dispenses with whatever myth and religion surround vampires in order, it seems, to concentrate on what they are essentially and existentially. Her vampires are monstrous desire, and I would argue that they are open to the campest interpretation. As monsters, Rice's vampires seek knowledge only in its original sense:

'which of you made me what I am?' (*ibid*.: 120). Dracula is dismissed during a visit to the Carpathians – 'the myths of men are not your myths' – and the old world vampires of Eastern Europe are described as vulgar revenants. Louis's attempt to discover who he is culminates in his encounter with Armand, master of a covenant and of a 'mortal boy', who declares that he knows nothing of either God or Satan: 'Is this the only question you bring to me, is this the only power that obsesses you, so that you must make us gods and devils yourself when the only power that exists is inside ourselves?' (*ibid*.: 258). From this point onwards, and in the absence of the law, Louis recognises that rather than know who he is, he can only be what he is. He has only his transformative self.

Having made and ended a life with Lestat – which included endless tiffs, tasteful decor, and having a child in order to stay together – Louis realises his monstrous desire in relation to the rather more contemplative Armand. Loving Armand entails leaving his daughter Claudia – 'You would leave me, and he wants you as you want him' (Rice 1976: 269) – and so Louis creates a vampire mother for her out of guilt. In doing so, he compromises his 'high regard for the life of others', which was part of his residual humanity and integral to his passion. When Claudia is killed in retaliation for breaking the one principal vampire law (vampicide – she is thought to have killed Lestat, her other father), Louis loses his balance altogether and gives vent to a passion which is free of love, reparation or responsibility. His passion is then lost as he becomes consumed by Armand, leaving him lifeless, or more accurately, undead: 'you're dead inside to me, you're cold and beyond my reach. It is as if I'm not there, beside you. And, not being here with you, I have the dreadful feeling that I don't exist at all' (*ibid*.: 361). Louis is left only with a sense of his own destructiveness, of being 'simply a mirror' of Armand for whom he has no more use or desire. His story ends with their separation: 'I wanted to be where there was nothing familiar to me. And nothing mattered. And that's the end of it. There's nothing else' (*ibid*.: 363).

For me, Louis represents transgressive desire which is not masked by knowledge. In his story, unlike Dracula's, the flow of blood is unrestricted by information. But Louis also demonstrates that unfettered desire – monstrous desire – is somewhat hard to handle. He struggles to live with the pain of insatiability, strives but fails to connect with others without merging or mastery, and is unable to maintain a passion balanced by love and hate. And so his interview is intended to provide

a cautionary tale, and he is appalled when he realises that his mortal interviewer/reader hears something else altogether and declares that 'it didn't have to end like that!' With his own desires awakened, the boy will not accept disappointment, despair or denial:

> 'You talk about passion, you talk about longing! You talk about things that millions of us won't ever taste or come to understand. And then you tell me it ends like that. I tell you ...
> ' And he stood over the vampire now, his hands outstretched before him. 'If you were to give me that power! The power to see and feel and live forever!' (Rice 1976: 365)

Louis makes one last effort to teach him a lesson – he drinks his blood and leaves him with the decision he himself once made, between human death or vampire life. The boy chooses to search for Lestat, who at the last account was dying, but not undead.

Conclusion

It is Lestat who is given narrative prominence in the remainder of Rice's vampire chronicles. Lestat the hedonist becomes more three-dimensional and perhaps more human through centuries of experience, which culminate in his encounter with God and the Devil, heaven and hell, which may or may not be real but which he experiences as such (Rice 1996). Despite his sympathy with the Devil, Lestat refuses to be his lieutenant and escapes from (his own experience of) hell. He does not choose salvation in heaven either. It is clear that the distinction between God and the Devil and between heaven and hell is fragile. Rather, Lestat clings instinctively to his monstrous life, his own passion and his own failures and contradictions.

I would argue (still in a seriously playful way) that the vampire Lestat is a worthy figuration, not least because he resists the temptation of being subsumed by knowledge and chooses the limited pleasures and powers of self-transformation over the lure of transcendence and omnipotence. As a vampire, Lestat is immortal, but the immortality of vampires is contingent on their environment (darkness over daylight, blood in place of food and water) and seems to me to be largely a feature or figment of a rather monstrous human ego: 'I am the vampire Lestat. Let me pass now from fiction into legend' (*ibid.*: 401).

I have chosen to use vampire fiction rather than science fiction as a

means of exploring contemporary debates on information technology because it is the stuff of myth or legend – specifically myths about desire and transgression which cast a shadowy but suggestive light on current and potential social and psychological investments in new technology. I have argued that the discourses of contagion and connectionism which surround information technology collapse the distinction between life and information, and that the flow of information symbolises the exchange of life-blood. In so far as individuals and societies are hooked on the flow of information/the blood of life, they may be regarded as vampiric. By looking at the story of Dracula I have shown how vampire fiction and vampiric relationships to technology are marked by fears and desires concerning the monstrous other which are resolved or rationalised through narratives of domination (contagion) and assimilation (connectionism). But through the concept of figuration (myth turned inside out) I have attempted to show how vampirism also offers an image of transgression and of a transformative relation to the self and other which embraces difference and allows for the possibility of a monstrous (desiring) self.

Notes
The chapter title is taken from Stoker (1988).
1 See Hall (1981).
2 See 'I would rather be a cyborg than a goddess' in Haraway (1991a: 181).

Conclusion: the importance of *as if*

It is *as if* some experiences were reminiscent or evocative of others; this ability to flow from one set of experiences to another is a quality of interconnectedness that I value highly. (Braidotti 1994: 5)

There's an idea that some children are uniquely damaged, a race apart. I understand this idea, but I don't like it. There's too much Us and Them in it, a denial of shared humanity. (Morrison 1997: 243)

Braidotti and Morrison write about 'as if' in different contexts and in very different ways, but to me their meaning is similar. Braidotti, a feminist academic, refers to the philosophy and practice of 'as if' as a means of parodying, subverting and transforming dominant structures of power, representation and subjectivity. 'As if' becomes part of her strategy for change and is embodied in her figuration of the nomadic subject who transgresses boundaries such as that between self and other and establishes a new form of connectedness. This new form is based not on the appropriation or assimilation of other's experience, but rather on what Haraway might refer to as 'affinity' or what I have referred to (after Benjamin) as intersubjectivity based on mutuality and recognition (rather than the pattern of domination and subjection

familiar to subject–object dualism). So my understanding of 'as if' is supported by the framework of psychoanalysis and specifically by the concept of intersubjectivity (Benjamin 1988). It is also supported by the framework of feminist post-structuralist epistemologies and specifically by Haraway's concept of situated knowledge and partial perspective embodied in the figuration of the cyborg. To practise 'as if' (another's experience or standpoint were your own) involves sacrificing the illusion of a unified and coherent identity and of universal, transcendent or disembodied knowledge. In other words, it involves putting 'yourself' on the line, and this, I believe, is what Blake Morrison (1997) does in his book on the James Bulger case, *As If*. Morrison is a writer and poet, not an academic, and *As If* is not an academic text. It has recently received a degree of media attention and has caused some controversy not least, I think, because Morrison was prepared to put the masculine and heterosexual components of himself on the line when discussing the possibly sexual nature of a crime committed by two young boys against another. Morrison, like many others, myself included, found himself both intrigued and appalled by the abduction and murder of James Bulger. Where my interest in the case was framed and to an extent circumscribed by my role as an academic and theorist of the media and new technologies, Morrison allows himself to be less defended and in closer proximity to what the media were calling evil monsters. He explores his own childhood and his feelings towards his own children not just in order to help him understand what he refers to as the 'why' of the murder, but because they are, in some way, relevant to the murder. In doing so, he crosses the boundary of what it is and is not all right (for men) to feel – or specifically to say they feel – about children. Morrison talks about having an erection while a child sits on his lap. He also talks about babies who will not stop crying and about wanting to 'put them down'. Family life, he says, 'is mostly banality in front of the telly'. But 'loving children and hurting them, dreading them dying and wanting them never to stir: all that is there too' (Morrison 1997: 186).

Morrison talks about family life as being somewhere on a continuum with crime, and about parental love/hate as being on a continuum with the sexual abuse of children. They are clearly not the same, but they are not wholly separate either. They are rightly distinguished by law, but wrongly polarised. I am not surprised that his approach is controversial, and I applaud it. It is so much easier, as I hope I have shown, to deal in the binaries of good and evil, black and white, right and wrong. And

while recognising the dangers of 'moral relativism', Morrison refuses to give in to the false reassurances afforded by making artificial divisions between 'Us and Them':

> I prefer to look at Robert and Jon in another way: as children I recognize from my own childhood, and as children I recognize from being a parent. There are dangers in this approach, too: liberal goo, moral relativism. But I don't think we can understand these boys and what they did unless we look within, at our own lives. (Morrison 1997: 243)

Morrison makes a new kind of connection with these others primarily by recognising them. Jessica Benjamin argues that the ability to recognise and be recognised obviates the need for the violence of overassertion, and challenges the structure of subject–object domination (Benjamin 1988). Morrison's act of recognition has a cost. He has to live with a lot of confusion and emotional discomfort. His questions do not get answered. Despite attending the trial, he never gets to the 'why' of the murder, not least because the law was only interested in whether or not they did it, and whether they were mature enough to know what they were doing, and to know the difference between right and wrong (*doli incapax*). Family backgrounds, psychological backgrounds, relationships and so on constituted inadmissible evidence. And yet, summing up, the judge could and did make a quite unsubstantiated reference to the effects of violent videos: 'It is not for me to pass judgement on their upbringing, but I suspect that exposure to violent video films may in part be an explanation' (Morrison 1997: 229). After weeks of pretty harrowing evidence, we are offered a mouldy old straw to grasp on to. Morrison, like the rest of us, gets no real answers from the trial. Unlike most of us, he gets the details not only of the crime against James Bulger but of the 'battering' of two other little boys tried as adults by the British legal justice system. He has a lot to assimilate, not least his own 'complicity and shame' (*ibid.*: 232). In so far as he is prepared to live with confusion, discomfort and anxiety, Morrison's response to the case and the trial is resolutely grown up. He actively avoids and consciously rejects what I have referred to as the comforting (and literally infantile) mechanisms of splitting and projection. He will not accept that there simply are good and evil children, but places them and us together on one infinitely long, precarious and indistinctly marked line.

Melanie Klein (1988) argues that splitting is an early mechanism for dealing with ambivalent feelings towards the (original) object, the m/other. I have identified it not only with media reports on the James Bulger case, but with the construction of technology and subjectivity especially in periods of rapid change or transition which involves the disruption of familiar categories of thought. The advent of digital and electronic forms of imaging has, for example, brought about another crisis in the status of photographic realism and the division between good, reliable and trustworthy (analogue) technologies and bad, unreliable and untrustworthy (digital) technologies.

The provisional title for this book was *Women and Children First*, and this related to the idea that the subjectivities of women and children (or youths) were the first to be targeted and problematised when a dominant technoscientific culture becomes unsure of itself. The notion that women and/or children are out of control is related to, or conflated with, the idea that technology is out of control (Penley 1992) and this, I have suggested, is a projection from the masculine subject whose sense of control is threatened and who has the most to lose. This subject constructs threatening and monstrous others out of virtual anxiety. The monsters are fictions, myths, fantasies, and the mechanisms which produce them are originally and literally infantile and unconscious. They are the products of early and irrational fears and desires. Monsters belong to children but children are not monsters.

Feminists have responded to the construction of monstrous mother–machines with attempts to reconfigure the relationship between women and technology. For me, the most interesting and persuasive of these attempts take into account the interaction between science and fiction, fact and fantasy – and the role of the unconscious in the production of knowledge (Doane 1990, Penley 1992, Haraway 1991a, Braidotti 1994). Haraway's 'Cyborg Manifesto' (like Shelley's *Frankenstein*) is a dream work. Not only does she account for the role of fiction in enabling feminists to imagine a better elsewhere, but she engages in writing which is part theoretical and part fictional. Her cyborg feminism is 'a myth system waiting to become a political language' (Haraway 1991a: 181). The cyborg is a figuration, a grounded utopia, both here and not here, fact and fiction. Dick Hebdige has associated figurations with 'the virtual power of metaphor' (Hebdige 1993: 270) and Rosi Braidotti has argued for the value of metaphor and myth-making as a means to think differently. Embodied

within myth, metaphor and figuration is the practice and philosophy of 'as if'.

Blake Morrison describes 'as if' in two different ways; in a way which signals possibility and imagination like the way children believe in fairy tales, and in a way which signals a more adult cynicism:

> The trope used to be enlarging, wondrous, a means of seeing beyond our noses, an escape from the prison house of fact. *As If*: it was the sound the swing made as it scythed us upward through the air, the whisper of dreams and lovely promises. Much virtue in *as if*. Now, in kid's mouths, it means the opposite. Earthbound scepticism and diminution: tell me about it, dream on, get real. Not hope but the extinction of hope. *As If*: not a candle to light us to bed, but a chopper to chop off our heads. (Morrison 1997: 13)

What gives Morrison's comments on the trial of Robert Thompson and Jon Venables their critical edge is, I believe, the way in which they express both kinds of 'as if'. He is more than aware of the way in which society and the legal system failed Robert, Jon and of course James – and will go on failing them and other boys. And yet his most effective criticism comes from doing what society and the law failed to do – from thinking as if they were him or his children. Instead of making monsters – constructing Thompson and Venables as monsters – Morrison puts himself in their position or imagines them as part of himself. He allows himself to become the monster in order to dispel it. This, for me, is a political act as well as an act of the imagination. And it is far from liberal.

'As if' is an act of the imagination which can lead to the strategic relocation of subjects. It is embodied within the cyborg and the nomadic subject; key figurations which enabled me to figure the vampire as a parody of the masculine unconscious in debates on information technology and as a way of thinking differently about knowledge and power, subjectivity and desire, in this context. I 'as if'ed the vampire because it is the monster which lurks in the depths of contemporary thinking about (and investments in) information technology. Information is the new commodity and the new currency of exchange at all levels of society from economics and communications to interpersonal relations. It is the life-blood of contemporary societies and none of us can now live without it. The fluidity of information has

become synonymous with the flow of blood, turning us all into (metaphorical) vampires – or so it would seem. For me, vampirism is the irrational monster myth which is (the stake) at the heart of the supposedly rational convergence of biological and computer sciences. It is, precisely, their unconscious. It betrays what science both fears and desires, and what science has always feared and desired. Vampirism, I would argue, is one manifestation of a masculinist science and culture and its age-old fear of, and desire for, the monstrous feminine other – that is, the female body of nature which provides its point of origin. Where I (and others) have suggested that the myth of Frankenstein aptly uncovers the irrational dimension of contemporary medical and reproductive science, the myth of the vampire exposes the unconscious investments in making biology and technology converge and creating the technological organism.

The new biology of machines – the unstoppable metaphorical blood flows of the networks and the womb-like spaces of the matrix – resonate with masculine heterosexual desires, based as they are on a love-hate relationship with the female body. The monstrosity of the feminine other has been associated with anatomical deficiency, morphological uncertainty (due to pregnancy) and libidinal excess. One reason for turning the vampire myth into a figuration is that vampires are also perceived as licentious, strange-looking shape shifters. Vampires transgress, their desires are illicit and unbound by the conventions of human sexuality.

One of the difficulties with this figuration entails being able to see the space which is opened up by parody. It is difficult to imagine a way clear of the familiar myths and images. Having read the articles in Sunday supplements about vampire gatherings in New York (which I suspect are no more than S/M cults in subterranean clubs) it also seemed important to avoid any hint of literalism. For me, vampires exist only as myths, and the dominant myth (like the story of Dracula) embodies all that we think of as monstrous and other – that is, something which is historically and structurally always feminine, transgressive, transformative and desiring. I was inspired by the passion in Anne Rice's novels which seemed at times to offer vampires with a difference. Her vampire Armand dismisses *Dracula* as the myth of men, not vampires, and I too wanted to see from the vampire's point of view – or to take up an(other) position of monstrosity – by parodying the myth as a feminist figuration. I am in a sense simply celebrating the feminine, transgressive,

transformative, desiring – otherwise known as monstrous – self. The vampire as a figuration does not drink blood or bite people (at least not too hard). It will, and perhaps does, appear as we appear when we make illicit connections with others. These illicit connections are those which break with the conventions of patriarchal, heterosexual desires but which are nevertheless framed by the values and aspirations of socialist feminism. In other words, they are not totally lawless. My vampire is a seriously playful monster who, like some of Rice's characters, is both vamp and camp.

Having articulated what I thought were some strange connections between vampires and technology, I then discovered that I was not alone – although it could of course be argued that Bram Stoker set the trend when he made the connection between Lucy Westenra's many blood transfusions and Mina Harker's typewritten transcriptions, and set the circulation of information against the circulation of blood and desire. I was intrigued and baffled by the vampire connections in the book o[rphan]d[rift>] (Cyberpositive 1995), but found a more familiar argument in Allucquère Rosanne Stone's 'The Gaze of the Vampire' (in Stone 1996: 165–83). Similarly engaged by the most recent revival of vampires in popular culture, Stone was also attracted to Rice's novels, and particularly to the character Lestat. For her, Lestat is a 'liminal' creature, a cyborg who 'inhabits the boundaries between death and life, temporality and eternity, French and English, gay and straight, man and woman, good and evil' (ibid.: 178). Lestat embodies the vampire gaze or the ability to see 'subjectivity as possibility' and Stone declares that 'I have huge stakes in these arguments ... As a transgendered academic who lives by choice in the boundaries between subject positions, I share a portion of Lestat's vampire gaze' (ibid.: 180). Stone is engaged in finding a space for transgender theory and a space where the transgendered body is not deemed to be monstrous. This, like the existence of 'vampires of subjectivity', involves 'the disruption of classificatory schemata that calls traditional identity formation into question' (ibid.: 182). Stone employs a style of academic writing and performance which does not fit comfortably within the academy and refers to the 'opportunity to transform the way academic discourse in the humanities and social sciences works' (ibid.: 166). This opportunity is provided by new technologies such as the Internet.

In her recent book on feminism and technoscience Haraway (1997) uses the figure of the vampire to trouble questions of racial purity and

kinship in contemporary cyborg culture. Vampires, she argues, pollute racial lineage and 'effect category transformations by illegitimate passages of substance' (*ibid.*: 214). Historically associated with racist, sexist and homophobic ideologies, vampires offer 'the revivifying promise of what is supposed to be decadent and against nature' (*ibid.*: 215). Haraway finds it tempting to identify 'with the outlaws who have been the vampires in the perfervid imaginations of the upstanding members of the whole, natural, truly human, organic communities' even though the vampire must be recognised as a non-innocent figure (*ibid.*: 215). Vampires promote unholy alliances, and Haraway expresses strong support for at least some of these:

> I am sick to death of bonding through kinship and 'the family' ... Ties through blood – including blood recast in the coin of genes and information – have been bloody enough already. I believe there will be no racial or sexual peace, no liveable nature, until we learn to produce humanity through something more and less than kinship. I think I am on the side of the vampires, or at least some of them. But, then, since when does one get to choose which vampire will trouble one's dreams? (*ibid.*: 265)

I think perhaps if you are black or Jewish or gay or transgendered you know which vampire troubles your dreams. Whichever it is, the raising of the undead in technoscientific discourse signifies not only the validation of difference but the desire to effect new and illicit kinds of connection within and across academic and disciplinary boundaries as well as organic and inorganic realms. Vampires in this context are about difference, technology and writing linked by the possibilities of '*as if*'. They are a facet of feminist figurative writing in academic discourse which, tied to specific and declared investments, help to keep the monsters out of the closets and divert us from our virtual anxieties.

Bibliography

Ackroyd, C., Margolis, L., Rosenhead, J. and Shallice, T. (1977) *The Technology of Political Control*, London, Pluto Press

Alcoff, L. and Potter, E. (eds) (1993) *Feminist Epistemologies*, London, Routledge

Ang, T. (1988) 'Sochurek', *Photography*, August

Armstrong, P. (1987) *Diagnostic Imaging*, Oxford, Blackwell Scientific

Bacon, F. (1974) *The Advancement of Learning/New Atlantis*, Oxford, Clarendon Press

Baldick, Chris (1987) *In Frankenstein's Shadow. Myth, Monstrosity and Nineteenth-Century Writing*, Oxford, Clarendon Press

Balsamo, Anne (1996) *Technologies of the Gendered Body. Reading Cyborg Women*, Durham and London, Duke University Press

Bann, Stephen (ed.) (1994) *Frankenstein, Creation and Monstrosity*, London, Reaktion Books

Barrow, J. D. (1991) *Theories of Everything. The Quest for Ultimate Explanation*, Oxford, Clarendon Press

Barthes, Roland (1973) *Mythologies*, London, Paladin

Barthes, Roland (1977) *Image-Music-Text*, London, Fontana

Barthes, Roland (1980) *Camera Lucida*, London, Flamingo

Baudrillard, Jean (1983) *Simulations*, New York, Semiotext(e)

Becker, K. E. (1991) 'To Control Our Image: Photojournalists and New Technology', *Media, Culture and Society*, 13, 3, pp. 381–97

Bendedikt, M. (ed.) (1991) *Cyberspace. First Steps*, Cambridge MA, MIT Press

Bender, G. and Druckrey, T. (1994) *Culture on the Brink. Ideologies of Technology*, Seattle, Bay Press

Benjamin, Jessica (1988) *The Bonds of Love. Psychoanalysis, Feminism, and the Problem of Domination*, London, Virago

Benjamin, Walter (1968) 'The Work of Art in the Age of Mechanical Reproduction', in *Illuminations*, Schoken, pp. 217–51

Benjamin, Walter (1972) 'A Small History of Photography', *Screen*, 13, pp. 240–57

Bennett, Peter (1993) 'Putting a Name to the Face', *Instersec*, 2,10, pp. 351–2

Bennett, Peter (unpublished) 'The Development of Identification Systems Past, Present and Future'

Benson, Philip and Perrett, David (1991) 'Computer Averaging and the Manipulation of Faces', in Paul Wombell (ed.), *PhotoVideo. Photography in the Age of the Computer*, London, Rivers Oram Press, pp. 32–52

Berland, Jody and Kember, Sarah (eds) (1996) *Technoscience*, special issue of *New*

Formations, 29

Bird, J., Curtis, B., Putnam, T., Robertson, G. and Tickner, L. (eds) (1993) *Mapping the Futures*, London, Routledge

Bober, H. (1948) 'The Zodiacal Miniature of the Très Riches Heures of the Duke of Berry – Its Sources and Meaning', *Journal of the Warburg and Courtauld Institutes*, 11, pp. 1–34

Bollas, Christopher (1987) *The Shadow of the Object. Psychoanalysis of the Unthought Known*, London, Free Association Books

Boyne, R. (1990) *Foucault and Derrida. The Other Side of Reason*, London, Unwin Hyman

Bradshaw, J. R. (1985) *Brain CT: An Introduction*, William Heinemann Medical Books

Braidotti, Rosi (1994) *Nomadic Subjects. Embodiment and Sexual Difference in Contemporary Feminist Theory*, New York, Columbia University Press

Braidotti, Rosi (1997) 'Cyberfeminism with a Difference', *Technoscience*, special issue of *New Formations*, 29, pp. 9–25

Brenan, T. (ed.) (1989) *Between Feminism and Psychoanalysis*, London, Routledge

Brighton Women and Science Group (1980) *Alice Through the Microscope*, London, Virago

Bruce, V. and Burton, M. (eds) (1993) *Processing Images of Faces*, Norwood NJ, Ablex

BSSRS Technology of Political Control Group with RAMPET (1985) *TechnoCop. New Police Technologies*, London, Free Association Books

Burgin, Victor (ed.) (1982) *Thinking Photography*, Basingstoke, Macmillan

Burgin, Victor (1990) 'Geometry and Abjection', in J. Fletcher and A. Benjamin (eds), *Abjection, Melancholia and Love. The Work of Julia Kristeva*, London, Routledge, pp. 104–23

Burgin, V., Donald, J. and Kaplan, C. (eds) (1986) *Formations of Fantasy*, Cambridge, Polity Press

Cameron, A. (1991) 'Digital Dialogues: An Introduction', *Ten.8 Digital Dialogues. Photography in the Age of Cyberspace*, 2, 2, pp. 4–7

Chaudhary, V. (1993) 'Benetton "Black Queen" Raises Palace Hackles', *Guardian*, Saturday 27 March

Chiv, L. C. (1980) *Atlas of Computed Body Tomography: Normal and Abnormal Anatomy*, Pitman Medical

Cohen, S. (1980) *Folk Devils and Moral Panics. The Creation of Mods and Rockers*, Oxford, Martin Robertson

Cousins, Mark (1996) 'Security as Danger', in T. Atkinson, M. Cousins, R. Hamilton, and J.Wagg, (eds), *15:42:32, 12/02/93*, History Painting Press

Curran, James, Morley, David and Walkerdine, Valerie (eds) (1996) *Cultural Studies and Communications*, London, Arnold

Cyberpositive (1995) *o[rphan]d[rift>]*, London, Cabinet Editions

Dandeker, C. (1990) *Surveillance, Power and Modernity*, Cambridge, Polity Press

Dawkins, Richard (1989) *The Selfish Gene*, Oxford, Oxford University Press (1st edn 1976)

De Lauretis, Teresa (1994) *The Practice of Love. Lesbian Sexuality and Perverse Desire*, Bloomington and Indianapolis, Indiana University Press

Dery, Mark (ed.) (1994) *Flame Wars. The Discourse of Cyberculture*, Durham and London, Duke University Press

Descartes, René (1992) *A Discourse on Method*, London, Dent (1st edn 1637)

Dexter, Frank (1996) 'An Interview with Satan', in George Robertson, Melinda Mash, Lisa Tickner, Jon Bird, Barry Curtis and Tim Putnam (eds), *FutureNatural*, London, Routledge, pp. 293–302

Dixon, A. K. (1983) *Body CT: A Handbook*, Churchill Livingstone

Doane, Mary Ann (1990) 'Technophilia: Technology, Representation and the Feminine', in Mary Jacobus, Evelyn Fox Keller and Sally Shuttleworth (eds), *Body/Politics. Women and the Discourses of Science*, London, Routledge, pp. 163–76

Dovey, Jon (ed.) (1996) *Fractal Dreams. New Media in Social Context*, London, Lawrence and Wishart

Doyle, Edward (1994) 'NLM Strides Toward the Electronic Frontier', *ACP Observer* (Information for Internists, American College of Physicians), May, 14, 5, pp. 13–14

Druckrey, T. (1991) 'Deadly Representations', *Ten.8 Digital Dialogues. Photography in*

the Age of Cyberspace, 2, 2, pp. 16–27

Easlea, B. (1983) *Fathering the Unthinkable: Masculinity, Scientists and the Nuclear Arms Race*, London, Pluto Press

Ehrenreich, B. and English, D. (1979) *For Her Own Good: 150 Years of the Expert's Advice to Women*, London, Pluto Press

Evans, H. (1978) *Pictures on a Page. Photojournalism, Graphics and Picture Editing*, London, Heinemann

Faulkner, W. and Arnold, E. (eds) (1985) *Smothered by Invention*, London, Pluto Press

Featherstone, Mike and Burrows, Roger (eds) (1995) *Cyberspace, Cyberbodies, Cyberpunk. Cultures of Technological Embodiment*, London, Sage

Fisher, R. P., Geiselman, R. E. and Amador, M. (1989) 'Field Test of the Cognitive Interview: Enhancing the Recollection of Actual Victims and Witnesses of Crime', *Journal of Applied Psychology*, 74, 5, pp. 722–7

Flax, Jane (1990) *Thinking Fragments: Psychoanalysis, Feminism and Postmodernism in the Contemporary West*, Berkeley, University of California Press

Fletcher, J. (1988) 'Versions of the Masquerade', *Screen*, 29, 3, pp. 43–69

Foucault, Michel (1961) *Madness and Civilization. A History of Insanity in the Age of Reason*, London, Tavistock

Foucault, Michel (1973) *The Birth of the Clinic*, London, Tavistock

Foucault, Michel (1977) *Discipline and Punish. The Birth of the Prison*, London, Penguin

Foucault, Michel (1978) *The History of Sexuality: An Introduction*, Harmondsworth, Penguin

Fox Keller, Evelyn (1985) *Reflections on Gender and Science*, New Haven CT, Yale University Press

Franklin, Sarah (1993) 'Post-Modern Procreation, Representing Reproductive Practice', *Science as Culture*, 3, 4, 17, pp. 522–59

Freud, Sigmund (1974) *Beyond the Pleasure Principle*, London, Hogarth Press and Institute of Psycho-Analysis (1st edn 1920)

Freud, Sigmund (1976) *The Interpretation of Dreams*, Pelican Freud Library, 4 Harmondsworth, Penguin (1st edn 1900)

Freud, Sigmund (1977) 'Fetishism', *On Sexuality*, Pelican Freud Library, 7 Harmondsworth, Penguin, (1st edn 1927), pp. 345–59

Gelder, Ken (1994) *Reading the Vampire*, London, Routledge

Gernsheim, A. (1961) 'Medical Photography in the Nineteenth Century', *Medical and Biological Illustrated*, 2

Giraud, B. (1988) 'Electronic Surveillance – Or Security Perverted', *Science as Culture*, 2, pp. 120–9

Gleick, James (1988) *Chaos. Making a New Science*, London, Cardinal

Greene, Seth (1994) 'The Digital Fantastic Voyage', *ID (International Design)*, New York, March–April, p. 16

Griffiths, Mark (1993) 'Are Computer Games Bad for Children?', *Psychologist*, 6, 9, pp. 401–7

Gonzalez, Jennifer (1995) 'Envisioning Cyborg Bodies: Notes From Current Research', in C. Hables Grey, with H. J. Figueroa-Sarriera and S. Mentor, *The Cyborg Handbook*, London, Routledge, pp. 267–80

Grosz, Elizabeth (1994) *Volatile Bodies. Toward a Corporeal Feminism*, Bloomington and Indianapolis, Indiana University Press

Hables Grey, C. with Figueroa-Sarriera, H. J. and Mentor, S. (1995) *The Cyborg Handbook*, London, Routledge

Hall, Stuart (1981) 'Cultural Studies: Two Paradigms', in T. Bennett, G. Martin, C. Mercer and J. Woollacott (eds), *Culture, Ideology and Social Process*, London, Open University Press, pp. 19–37

Haraway, Donna (1991a) *Simians, Cyborgs and Women*, London, Free Association Books

Haraway, Donna (1991b) 'Cyborgs at Large: An Interview with Donna Haraway', in Constance Penley and Andrew Ross (eds), *Technoculture*, Minneapolis, University of Minnesota Press, pp. 1–20

Haraway, Donna (1992) 'The Promises of Monsters: A Regenerative Politics for Inappropriate/d Others', in L. Grossberg, C. Nelson and P. A. Treichler (eds), *Cultural Studies*, London, Routledge, pp. 295–329

Haraway, Donna (1997) *Modest _Witness@Second_Millennium. FemaleMan©_Meets_OncoMouse™*, London, Routledge

Harding, Sandra (1986) *The Science Question in Feminism*, Ithica NY, Cornell University Press

Harding, S. and Hintikka, M. B. (eds) (1983) *Discovering Reality: Feminist Perspectives on Epistemology, Metaphysics, Methodology and Philosophy of Science*, Dordrecht, Reidel

Harding, S. and O'Barr, J. F. (eds) (1987) *Sex and Scientific Inquiry*, Chicago, University of Chicago Press

Hay, Colin (1995) 'Mobilization through Interpellation: James Bulger, Juvenile Crime and the Construction of a Moral Panic', *Social and Legal Studies*, 4, 2, pp. 197–223

Hayles, N. Katherine (1991) *Chaos and Order. Complex Dynamics in Literature and Science*, Chicago, University of Chicago Press

Hayward, Philip and Wollen, Tana (1993) *Future Visions, New Technologies of the Screen*, London, Arts Council of Great Britain and BFI Publishing

Hebdige, Dick (1993) 'Training Some Thoughts on the Future', in J. Bird, B. Curtis, T. Putnam, G. Robertson and L. Tickner (eds), *Mapping the Futures*, London, Routledge, pp. 270–9

Hodges, D. L. (1985) *Renaissance Fictions of Anatomy*, Amhurst, University of Massachusetts Press

Hogg, James (1983) *The Private Memoirs and Confessions of a Justified Sinner*, London, Penguin (1st edn 1824)

Holland, Patricia (1992) 'Childhood and the Uses of Photography', in Patricia Holland and Andrew Dewdney (eds), *Seen But Not Heard?*, Bristol, Watershed Media Centre, pp. 6–41

Holland, Patricia and Dewdney, Andrew (eds) (1992) *Seen But Not Heard?*, Bristol, Watershed Media Centre

Hutcheon, L. (1989) *The Politics of Postmodernism*, London, Routledge

Jacobus, M., Fox Keller, E. and Shuttleworth, S. (eds) (1990) *Body/Politics. Women and the Discourses of Science*, London, Routledge

Jardine, L. (1974) *Francis Bacon. Discovery and the Art of Discourse*, Cambridge, Cambridge University Press

Johnson, Diane (1981) 'Introduction', in Mary Shelley, *Frankenstein*, London, Bantam Books (1st edn 1818), pp. vii–xix

Jordanova, Ludmilla (1989) *Sexual Visions. Images of Gender in Science and Medicine between the Eighteenth and Twentieth Centuries*, Brighton, Harvester Wheatsheaf

Kean, D. and Smith, M. (1986) *Magnetic Resonance Imaging*, William Heinemann Medical Books

Kelly, Kevin (1994) *Out of Control. The New Biology of Machines*, London, Fourth Estate

Kember, Sarah (1991) 'Medical Diagnostic Imaging: The Geometry of Chaos', *New Formations*, 15, pp. 55–66

Kember, Sarah (1995) 'Medicine's New Vision?', in Martin Lister (ed.), *The Photographic Image in Digital Culture*, London, Routledge, pp. 95–114

Kember, Sarah (1996a) 'Feminism, Technology and Representation', in James Curran, David Morley and Valerie Walkerdine (eds), *Cultural Studies and Communications*, London, Arnold, pp. 229–47

Kember, Sarah (1996b) 'Feminist Figuration and the Question of Origin', in George Robertson, Melinda Mash, Lisa Tickner, Jon Bird, Barry Curtis and Tim Putnam (eds), *FutureNatural*, London, Routledge, pp. 256–69

Kieffer, S. A. (1983) *An Atlas of Cross-Sectional Anatomy, Computed Tomography, Ultrasound Radiography, Gross Anatomy*, London, Harper and Row

Kirkup, G. and Smith Keller, L. (eds) (1992) *Inventing Women*, London, Polity Press/ Open University Press

Klein, Melanie (1988) *Envy and Gratitude and Other Works 1946–1963*, London, Virago

Kluger, Jeffrey (1993) 'Rest in Pieces', *Discover*, October, pp. 38–42

Komesaroff, Paul A. (ed.) (1995) *Troubled Bodies. Critical Perspectives on Postmodernism, Medical Ethics, and the Body*, London, Duke University Press

Kramarae, C. (ed.) (1988) *Technology and Women's Voices*, New York, Routledge

Lacan, Jacques (1977a) *The Four Fundamental Concepts of Psycho-Analysis,* London, Peregrine

Lacan, Jacques (1977b) *Ecrits: A Selection,* London, Tavistock

Lewontin, R. C. (1994) 'The Dream of the Human Genome', in Gretchen Bender and Timothy Druckrey (eds), *Culture on the Brink. Ideologies of Technology,* Seattle, Bay Press, pp. 107–27

Lister, Martin (ed.) (1995) *The Photographic Image in Digital Culture,* London, Routledge

Lyon, D. (1994) *The Electronic Eye. The Rise of Surveillance Society,* Cambridge, Polity Press

Lyotard, J-F. (1979) *The Postmodern Condition: A Report on Knowledge,* Manchester, Manchester University Press

Manwaring-White, Sarah (1983) *The Policing Revolution,* Harvester Press

Marshall, Stuart (1990) 'Picturing Deviancy', in Tessa Boffin and Sunil Gupta (eds), *Ecstatic Antibodies. Resisting the AIDS Mythology,* London, Rivers Oram Press, pp. 19–36

Martin, L. H., Gutman, H. and Hutton, P. H. (1988) *Technologies of the Self. A Seminar with Michel Foucault ,* London, Tavistock

Mathews, T. J. (1989) 'A Bug in the Machine', *Correspondent Magazine,* 17 December

McGrath, Roberta (1984) 'Medical Police', *Ten.8,* 14, pp. 13–18

McNay, Lois (1992) *Foucault and Feminism,* Cambridge, Polity Press

McNeil, M., Varcoe, I. and Yearley, S. (eds) (1990) *The New Reproductive Technologies,* London, Macmillan

Mercer, Kobena (1986) 'Imaging the Black Man's Sex', in Patricia Holland, Jo Spence and Simon Watney (eds), *Photography/Politics: Two,* London, Comedia/Photography Workshop, pp. 61–9

Merchant, C. (1980) *The Death of Nature,* New York, Harper and Row

Merck, M. (1993) *Perversions: Deviant Readings,* London, Virago

Metz, Christian (1985) 'Photography and Fetish', *October,* 34, pp. 81–90

Mitchell, W. J. (1992) *The Reconfigured Eye. Visual Truth in the Post-Photographic Era,* Cambridge MA, MIT Press

Morrison, Blake (1997) *As If,* London, Granta Books

Mulvey, Laura (1975) 'Visual Pleasure and Narrative Cinema', *Screen,* 16, 3, pp. 6–87

NLM (1993) Hyperdoc / The Visible Human Project Factsheet / April

O'Kane, M. (1993) 'Heysel, Hillsborough and Now This', *Guardian,* 20 February

Olorenshaw, Robert (1994) 'Narrating the Monster: From Mary Shelley to Bram Stoker', in S. Bann, (ed.), *Frankenstein, Creation and Monstrosity,* London, Reaktion Books, pp. 158–76

Penley, Constance (1992) 'Spaced Out: Remembering Christa McAuliffe', in Paula A. Treichler and Lisa Cartwright (eds), *Camera Obscura. Imaging Technologies, Inscribing Science 2,* 29, pp. 179–213

Penry, Jacques (1971) *Looking at Faces and Remembering Them. A Guide to Facial Identification,* London, Elek Books

Phillips, Adam (1993) *On Kissing, Tickling and Being Bored,* London, Faber and Faber

Phillips, Adam (1995) *Terrors and Experts,* London, Faber and Faber

Phillips, M. and Kettle, M. (1993) 'The Murder of Innocence', *Guardian,* 16 February

Pick, D. (1988) 'Terrors of the Night: Dracula and "Degeneration" in the Late Nineteenth Century', *Critical Quarterly,* 30, 4, pp. 71–87

Plant, Sadie (1993) 'Beyond the Screens: Film, Cyberpunk and Cyberfeminism', *Variant,* 14, pp. 12–17

Plant, Sadie (1996) 'The Virtual Complexity of Culture', in George Robertson, Melinda Mash, Lisa Tickner, Jon Bird, Barry Curtis and Tim Putnam (eds), *FutureNatural,* London, Routledge, pp. 203–17

Plant, Sadie and Land, Nick (1994) 'Cyberpositive', in Mathew Fuller (ed.), *Unnatural. Techno-Theory for a Contaminated Culture,* London, Underground, pp. 1–8

Poster, Mark (1990) *The Mode of Information,* Oxford, Polity Press

Prigogine, I. and Stengers, I. (1985) *Order Out of Chaos,* London, Flamingo

Probyn, Elspeth (1992) 'Technologizing the Self', in L. Grossberg, C. Nelson and P. A. Treichler (eds), *Cultural Studies,* London, Routledge, pp. 501–11

Probyn, Elspeth (1993) *Sexing The Self. Gendered Positions in Cultural Studies,* London, Routledge

Provenzo, Eugene F., Jr (1991) *Video Kids. Making Sense of Nintendo*, Cambridge MA
 and London, Harvard University Press
Ramazanoglu, Caroline (ed.) (1993) *Up Against Foucault. Explorations of Some
 Tensions Between Foucault and Feminism*, London, Routledge
Rheingold, Howard (1991) *Virtual Reality*, London, Secker and Warburg
Rice, Anne (1976) *Interview with the Vampire*, London, Warner Books
Rice, Anne (1985) *The Vampire Lestat*, London, Warner Books
Rice, Anne (1988) *The Queen of the Damned*, London, Warner Books
Rice, Anne (1992) *The Tale of the Body Thief*, London, Penguin
Rice, Anne (1996) *Memnoch the Devil*, London, Arrow Books
Ritchin, Fred (1990) *In Our Own Image. The Coming Revolution in Photography*, New
 York, Aperture
Ritchin, Fred (1991) 'The End of Photography as We Have Known It', in Paul Wombell
 (ed.), *PhotoVideo. Photography in the Age of the Computer*, London, Rivers
 Oram Press, pp. 8–16
Robertson, G., Mash, M., Tickner, L., Bird, J., Curtis, B. and Putnam, T. (eds) (1996)
 FutureNatural, London, Routledge
Robins, Kevin (1991) 'Into the Image: Visual Technologies and Vision Cultures', in Paul
 Wombell (ed.), *PhotoVideo. Photography in the Age of the Computer*, London,
 Rivers Oram Press, pp. 52–78
Robins, Kevin (1992) 'The Virtual Unconscious in Post-Photography', *Science as
 Culture*, 3,1,14, pp. 99–115
Rose, Hilary (1994) *Love, Power and Knowledge*, Cambridge, Polity Press
Rose, J. (1986) *Sexuality in the Field of Vision*, London, Verso
Rosler, Martha (1991) 'Image Simulations, Computer Manipulations: Some
 Considerations', *Ten.8 Digital Dialogues. Photography in the Age of Cyberspace*,
 2, pp. 52–63
Ross, Andrew (1991) *Strange Weather. Culture, Science and Technology in the Age of
 Limits*, London, Verso
Ross, Andrew (1994) *The Chicago Gangster Theory of Life*, London and New York,
 Verso
Saunders, J. B. de C. M. and O'Malley, C. D. (1982) *The Anatomical Drawings of
 Andreas Vesalius*, New York, Bonanza Books
Sawicki, J. (1991) 'Disciplining Mothers: Feminism and the New Reproductive
 Technologies', *Disciplining Foucault*, London, Routledge, pp. 67–94
Sekula, Allan (1989) 'The Body and the Archive', in Richard Bolton (ed.), *The Contest
 of Meaning. Critical Histories of Photography*, Cambridge, MA and London, MIT
 Press, pp. 343–88
Sereny, Gitta (1995) *The Case of Mary Bell*, London, Pimlico
Sharratt, T. and Myers, P. (1993) 'Three Questioned Over Boy's Killing', *Guardian*, 17
 February
Shelley, Mary (1981) *Frankenstein*, London, Bantam Books (1st edn 1818)
Shepherd, J. and Ellis, H. (1993) 'Face Recognition and Recall Using Computer-
 Interactive Methods with Eye Witnesses', in V. Bruce and M. Burton (eds),
 Processing Images of Faces, Norwood NJ, Ablex, pp. 129–48
Showalter, E. (1995) *The Female Malady*, London, Pantheon
Silverstone, R. and Hirsch, E. (eds) (1992) *Consuming Technologies*, London, Routledge
Smith, Lindsay (1992) 'The Politics of Focus: Feminism and Photography Theory', in I.
 Armstrong (ed.), *New Feminist Discourses*, London, Routledge, pp. 238–57
Snitow, A., Stansell, C. and Thompson, S. (eds) (1984) *Desire: The Politics of Sexuality*,
 London, Virago
Sobchack, V. (1990) 'A Theory of Everything: Meditations on Total Chaos', *Artforum*,
 29, 2, pp. 148–55
Sochurek, Howard (1988) *Medicine's New Vision*, Easton PA, Mack
Solomonides, T. and Levidow, L. (eds) (1995) *Compulsive Technology. Computers as
 Culture*, London, Free Association Books
Sontag, Susan (1979) *On Photography*, London, Penguin
Sontag, Susan (1988) *AIDS and its Metaphors*, London, Penguin
Spence, Jo (1987) *Putting Myself in the Picture*, London, Camden Press
Springer, Claudia (1991) 'The Pleasure of the Interface', *Screen*, 32, 3, pp. 303–23
Squires, Judith (1996) 'Fabulous Feminist Futures and the Lure of Cyberculture', in Jon

Dovey (ed.), *Fractal Dreams. New Media in Social Context*, London, Lawrence and Wishart, pp. 194–216

Stafford, Barbara Maria (1991) *Body Criticism*, Cambridge MA, MIT Press

Stanley, L. (ed.) (1990) *Feminist Praxis*, London, Routledge

Stanworth, M. (ed.) (1987) *Reproductive Technologies: Gender, Motherhood and Medicine*, Cambridge, Polity Press

Stepney, Rob (1993) 'Anatomy without Scalpels', *Independent on Sunday*, 19 September

Stevenson, Robert Louis (1987) *Dr Jekyll and Mr Hyde*, Oxford University Press (1st edn 1886)

Stewart, I. (1989) *Does God Play Dice? The Mathematics of Chaos*, London, Penguin

Stix, Gary (1993) 'Habeas Corpus. Seeking Subjects to be a Digital Adam and Eve', *Scientific American*, January, pp. 146–7

Stoker, Bram (1988) *Dracula*, London, Penguin (1st edn 1897)

Stone, Allucquère Rosanne (1996) *The War of Desire and Technology at the Close of the Mechanical Age*, Cambridge MA and London, MIT Press

Tagg, John (1988) *The Burden of Representation*, Basingstoke, Macmillan Education

Tagg, John (1989) 'Totalled Machines. Criticism, Photography and Technological Change', *New Formations*, 7, pp. 21–34

Tan, Cecilia (1995) 'The Tale of Christina', in Pam Keesey (ed.), *Dark Angels. Lesbian Vampire Stories*, Pittsburgh PA and San Francisco, Cleis Press, pp. 77–87

Taylor, John (1989) 'The Bazaar of Death', *Ten.8*, 33, pp. 20–37

Taylor, Mark C. and Saarinen, Esa (1994) *Imagologies. Media Philosophy*, London, Routledge

Tendler, S. and Faux, R. (1993) 'Anatomy of a Child Murder Hunt', *The Times*, 17 February

Terranova, Tiziana (1996a) 'Digital Darwin: Nature, Evolution and Control in the Rhetoric of Electronic Communication', *Technoscience*, special issue of *New Formations*, 29, pp. 69–83

Terranova, Tiziana (1996b) 'Posthuman Unbounded: Artificial Evolution and High-Tech Subcultures', in George Robertson, Melinda Mash, Lisa Tickner, Jon Bird, Barry Curtis and Tim Putnam (eds), *FutureNatural*, London, Routledge, pp. 165–80

Treichler, Paula A. (1990) 'Feminism, Medicine and the Meaning of Childbirth', in Mary Jacobus, Evelyn Fox Keller and Sally Shuttleworth (eds), *Body/Politics. Women and the Discourses of Science*, London, Routledge, pp. 113–38

Treichler, Paula A. and Cartwright, Lisa (1992) *Camera Obscura. Imaging Technologies, Inscribing Science*, 28, and *Imaging Technologies, Inscribing Science 2*, 29

Troup, J. (1993) 'For Goodness Sake Hold Tight to Your Kids', *Sun*, 16 February

Turkle, S. (1984) *The Second Self: Computers and the Human Spirit*, London, Granada

Wagg, Jamie (1996) ' ... And Finally', in R. Hamilton, M. Cousins, T. Atkinson, and J. Wagg, (eds), *15:42:32, 12/02/93*, History Painting Press

Wajcman, Judy (1991) *Feminism Confronts Technology*, Cambridge, Polity Press

Walkerdine, Valerie (1990) *Schoolgirl Fictions*, London, Verso

Wilde, Oscar (1980) *The Picture of Dorian Gray*, in *Plays, Prose Writings and Poems*, London, Dent (1st edn 1890), pp. 69–254

Wombell, Paul (ed.) (1991) *PhotoVideo. Photography in the Age of the Computer*, London, Rivers Oram Press

Woolley, B. (1992) *Virtual Worlds. A Journey in Hype and Hyperreality*, Oxford, Blackwell

Young, S. W. (1984) *Nuclear Magnetic Resonance Imaging*, New York, Raven Press

Index